APPROACHING
ART AND DESIGN
A GUIDE FOR STUDENTS

ROD TAYLOR AND DOT TAYLOR

Longman

LONGMAN GROUP UK LIMITED
Longman House, Burnt Mill, Harlow, Essex, CM20 2JE, England
and Associated Companies throughout the World.

First published 1990
ISBN 0 582 004284

Set in Apollo 11/13 $\frac{1}{2}$ pt (Lasercomp)
Produced by Longman Group (FE) Ltd
Printed in Hong Kong.

British Library Cataloguing in Publication Data
Taylor, Rod
 Approaching art and design.
1. Visual arts
 I. Title II. Taylor, Dot
 700

 ISBN 0−582−00428−4

Contents

Acknowledgements

Approaching Art and Design could not have been written without the support of J.K. Hampson, the Metropolitan Wigan Director of Education. Thanks are also due to the Principals and all the supportive friends and colleagues of St John Rigby R.C. Sixth Form College, where Dot Taylor taught Art and Design from 1975 to 1985, and Winstanley Sixth Form College, where she has been Head of Art and Design since January 1986, and of the Drumcroon Education Art Centre in Wigan, where Rod Taylor is the Director.

We would also like to acknowledge the work of Angela Cusani-Turner who, as Angela Cusani, was artist-in-residence at Winstanley College for the year 1986–87 at a key formative stage in that College's establishment of the art and design principles set out in this book.

Finally, *Approaching Art and Design* is about students for students, and we must obviously pay tribute to the many students whose testimonies and practice are the central feature of this book.

The St John Rigby students featured are:-
Anita Binns, Rosemary Brooks, Anne-Marie Clayton, John Edwards, Anne Griffiths, Karen Hagan, Samantha Hall, Julie Hurst, Adrian Johnson, Sheila Lees, Joe Lydon, Anthony Lysycia, Anthony Lythgoe, Jennifer Masey, Mark Mason, Ann Prescott, Anne-Marie Quinn, Jane Rowson, Anthony Smith, David Storey, Richard Stringfellow, Ruth Turnbull, Nikki Wilson and Kathryn Winstanley.

The Winstanley College students featured are:-
Nicola Anson, Suzanne Ball, Kate Bentham, Carole Brown, Richard Bumby, Michael Cumberbach, Ian Cunliffe, Kathryn Cunliffe, Alan Davies, Sandra Davies, Rachel Hadwen, Michael Harrison, Viv Harrison, Eddie Haigh, Marnie Hewkin, Victoria Johnston, Stuart Jones, Louise Kilshaw, Alison Lammas, Helen Latham, Mark Lester, Sam Lloyd, Jen Long, Vicky Marsden, Joanne McLaughlin, Rachel Millar, Renu Modha, Jayne Moore, Michael Moore, Robert Murray, Debbie Park, Simon Pendry, Gary Pennington, Julie Pownall, Stephen Ranson, Erica Roby, Robert Sankey, Ian Skillicorn, Kathleen Smith, Adele Stach-Kevitz, Mandy Sumner, Jayne Tait, Caroline Wardle and Ann Wright.

Foreword

Approaching Art and Design has been written by Rod Taylor, but draws exclusively on the work and teaching of Dot Taylor. A husband and wife team, Rod and Dot share similar beliefs and philosophies tested out in that they both work for the same forward looking education authority, Metropolitan Wigan, with its long-standing commitment to the arts. The book therefore represents an unusual collaborative venture between two committed art educators working in close partnership. Rod Taylor directed the Critical Studies in Art Education Project which ran from 1981 to 1984 and gave rise to *Educating for Art* which was published in 1986. He is the founder and Director of Wigan's well known Drumcroon Education Art Centre and has been Art Adviser for Wigan since 1974. Dot Taylor has taught in the sixth-form sector since 1975, first at St John Rigby R.C. Sixth Form College, and since January 1986, as Head of Art and Design at Winstanley Sixth Form College, A very successful A—level teacher in examination terms, many of her students become highly motivated and go on to study the subject in higher education or retain a long-term interest in art. Dot has taught every student who features in this book, which means that the student perceptions and attitudes incorporated within the text form an important integral part of the philosophy and approaches outlined in these pages.

The student quotations have been extracted, primarily, from their writings. Some come from their notes, essays and studies about art and artists produced as an official component of their courses. Others are taken from their half-termly Personal Appraisals in which they reflect upon and evaluate their own work and attitudes. Introduced to give an extra critical studies dimension to courses, they also represent a Recording of Achievement model worthy of wider emulation, providing the students with ample opportunity to reflect upon ongoing and recently completed projects and their general progress. Secondly, a further body of material comes from a series of recorded conversations between the students and the author, frequently highlighting longer-term benefits gained from experiences which, in some cases, go back years. Plates have been carefully selected to illuminate and complement the text rather than because they are of the best available end-products. Inevitably there are gaps, a notable example being that no visual record exists of the study described by Michael in the Figure Drawing Section. What he has to say to the aspiring student is of sufficient interest to justify its place in its own right.

Over sixty students feature in the book, and as more than forty of these have been educated at Winstanley College between 1986 and 1988, when this book was written, it is up-to-date and as topical as possible in this respect. These numbers also indicate that a wide spectrum of student abilities and attitudes are represented: this is not a book about the talented few for the talented few. Indeed, some of the outstanding achievements recorded are by students whose potential had not previously been recognised by themselves or by others. Equally, some had not studied the subject at all in the preceding years or had taken it up as a last resort on dropping other subjects.

In keeping with national trends, female art and design students outnumbered their male counterparts during the period in question. Nevertheless, care has been taken to ensure that the viewpoints and perspectives of both are adequately represented whilst trying to avoid a contrived balance purely on gender grounds. The fact that Wigan's population only includes one per cent from Afro-Caribbean and Asian backgrounds is another constraint, but the need for all students' courses to be broadened beyond their present predominant Eurocentric frameworks is addressed. The Winstanley course is being broadened to take account of this need, but an obvious limitation is that the students still have to be prepared for examinations which, as yet, barely reflect these changes. Nevertheless, A–level examinations are being modified at the time of writing and Wigan's pioneering work in the critical studies field, etc., should ensure that *Approaching Art and Design* stands the test of time as well as being of immediate relevance.

Finally, though the obvious focus of this book is on A–level needs, it should prove to be of wider relevance. How students might record their achievements, approach objective study, use a sketchbook, approach gallery visiting and combine all these activities are issues which are equally relevant to the needs of the fifteen and sixteen-year-old GCSE pupil with a questioning approach. The students' opinions and attitudes have ensured that the book is demanding in its content, but may also make it relevant to other than A–level students in the sixth-form sector. Many unit of accreditation courses, for example, are boringly prescriptive and deny the students any of the involvement that, in a subject like art and design, can prove so motivating. Adults practising art privately or at evening classes frequently express frustration at the lack of any appropriate reading material. General Art and Design (GAD) and Foundation students at the higher education level often similarly complain about the lack of any discernible structure and principles which might underly their course. Equally, the insights which it provides into students' minds and feelings should make it relevant to all PGCE Art and Design students and to teachers, whether they are

in the 11 to 16, 11 to 18 or 16 to 19 sectors. *Approaching Art and Design* therefore has a clear, specific focus but wider implications.

INTRODUCTION

What should a book on art and design for sixteen to nineteen-year-old A–level students deal with and how? Over the years, many students have told us that, on being accepted onto their course, they went out to purchase an appropriate book in support of their studies. However, disillusionment rapidly set in. Once they had dismissed the vast range of 'How to do it' books as being inadequate for their needs, there was virtually nothing left. Even the more expensive and glossy 'Art School' type course books were, on closer inspection, similarly biased towards sets of tips about skills, techniques and processes. This widespread model of the 'expert' telling the beginner in step-by-step sequence what to do in order, in turn, to aspire to becoming a pale imitation of that expert is a traditional but out-of-date model which invariably fails the reader. It is a model which totally leaves out of account the students themselves.

The eighty-year-old artist Michael Rothenstein, still making fresh advances in his work, puts his finger on the problem when he compares his own career with that of his father, William, who was also an artist:

> When my father was young he studied at the Slade. All the work he did subsequently was a development of the foundations he laid down as a student. So the curve of his achievement was continuous in that it had a beginning, a middle and an end. European art at the time had a certain cohesiveness; certain things were admired like good figurative drawing, respect for perspective, respect for tonal recession. This series of values acted like a glue that stuck the whole together.

He goes on to suggest, though, that 'since 1930, maybe 1940, 1950' this pattern has completely broken down. With the proliferation of

reproduction in books and films we are constantly being subjected to what is happening in West Berlin, the West Coast of America, on the other side of the world. We are much more aware of the achievements and values of diverse cultures and, in a different sense, of ancient things like archaic art. He goes on to say that:

> Artists now have the capability of shifting viewpoints because they have been under a series of extremely powerful pressures, which certainly, for me, could not be disregarded. My life, unlike my father's career, is segmented.

Through all these influences, he felt able 'to reject the idea of perspective in a traditional sense', and to use colour in a boldly expressive rather than purely descriptive way. Equally, over the years his work has ranged from the purely abstract arrangement of

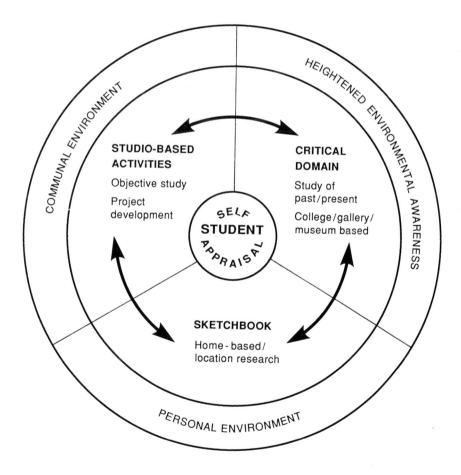

The Winstanley College Art and Design course attempts to deal with students' needs and personal responses in an individual way, but within the framework of three main areas: studio-based activities; home-based and location work; and contextual and critical studies.

forms and utilisation of texture to the figurative and symbolic, with these two extremes sometimes combining within a single work. All of these options, and many more, are available to artists today and are necessary to enable them to make positive use of the variety of stimuli to which they are now subjected. The problem with all those 'How to do it' books is that they take no account of these individual needs; they prescribe the same diet for everybody, pretending that nothing has changed since 1930.

But how can the art educator take account of this flood of stimuli, as its nature and impact is bound to vary from one student to another? It seems to us that the only constructive way forward is to tap into the ideas and aspirations of the students themselves, and this means enabling them to talk and discuss with us more and our listening to them more carefully. The pages of this book are fully illuminated, therefore, by the attitudes and responses of students, sometimes drawn from their written testimonies, at other times through the spoken word. These clearly indicate the limitation of the traditional teaching approach, whether that of the teacher working directly with students or through a distance learning system, of judging solely according to that teacher's criteria. For example, where a student's written testimony reveals that she wishes to make the silhouette of a tree branch seen against bright sky two-dimensional so as to emphasise its decorative and rhythmic qualities, the teacher consistently gives advice as to how to make it look more three-dimensional without having an inkling as to what the student is attempting. Instructions to 'make that area more grey to give depth', 'add some shading here to give form' and the like, are at best, of limited worth unless they are also based on an understanding of the student's intentions. Their testimonies reveal that they are just as capable as the so-called experts of having worthwhile ideas, attitudes and intentions about their art and design courses. This kind of negotiated learning and evaluation is much more complex but worthwhile than that conventional model of the student pain-stakingly attempting to climb the same ladder on top of which the expert already comfortably sits.

The layout and content of this book have been determined by these and similar considerations. There is a strong emphasis placed upon objective, or observational work, but set out in such a way as to, hopefully, open up in the reader's mind a whole range of

Plates 1 to 4 *Four sketchbook studies by John illustrate just how much progress can be made by students who have little or no previous experience of sketching. The first three drawings span the first half-term of the A-level course and the boat study was done at the Liverpool Maritime Museum during one of his many Saturday sketching visits during the Upper Sixth year.*

1

2

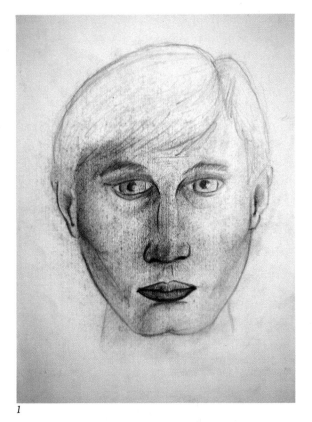

3

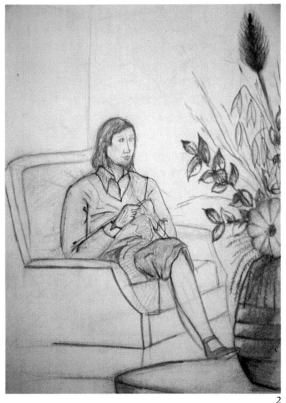

4

possibilities and ways forward rather than simply following the usual linear step-by-step approach. The opening sections on figure drawing, still life and the study of natural form are given importance because no student has ever complained to us about having acquired genuine drawing skills, rigorous though the process has to be. Conversely, those coming to their A–level course from one built around copying and the use of secondhand stimulus often become angry at what they have been denied for so long once they have been given the opportunity to experience all the benefits which accrue from a course rooted in first-hand experience and observation.

Another special attribute of art and design education is its capacity for involving students in problems which are intensely real to them in a sense which much of education most certainly is not. This is because it can provide so many genuine opportunities for personal and active participation, and consequent internalisation of experiences. There is no finer aid to this process than through the systematic use of the sketchbook with all its potential for the exploration of subjects, themes and environments of special concern and interest to the student. A section is, therefore, devoted to the use of the sketchbook, both as a fundamental aspect of the course and in preparation for examination purposes.

The widespread development of critical studies at all levels of art and design education is having an inevitable effect at the A–level stage. It is becoming increasingly apparent that it is unacceptable for students of this age to simply engage in practical work yet remain ignorant about the work of others, past and present. The whole of this book is, therefore, rich in critical studies implications, with many parallels drawn between the students' work, that of their peers and that of established and famous artists. In addition, a whole section is devoted to the importance of studying and responding to the work of mature artists as something of worth in its own right and for its own sake. Engaging with works in the original is seen as being of prime importance, so long as it is supported by background research and study. The model of Content, Form, Process and Mood which is proposed is also a worthwhile one for use by students with regard to their own work.

Finally, the section called 'Developments' draws all these strands together and illustrates how the student can make use of experiences from one or more of these areas to produce work in a wide variety of media and processes. Rather than being just conventional-looking A–level examination-type pieces, though, this work can be wide-ranging and broadly based, because the student is working in an informed and knowledgeable manner, combining his or her own ideas with a set of clearly worthwhile course objectives. As such,

this book attempts to set out a beneficial art and design framework within which student readers can begin to operate, aided by the testimonies and example of their peers.

Approaching Art and Design is, therefore, a handbook of ideas and utilisable working models to be constantly turned to as relevant throughout the duration of the course, rather than each section forming a disposable unit as the student progresses through it in a step-by-step manner. Particular passages, wherever they occur within the book, might become significant where at first they did not appear to be so because of the developments within the student. Another important feature of the book is that is has been written with the acceptance that it is both impossible and undesirable for any one book of this nature to be self-contained. The more aware the student becomes, the more that student will wish to draw upon material from an ever-widening variety of sources; rather than providing an alternative to this natural process, *Approaching Art and Design* will, hopefully, contribute to this important form of further development and background research.

OBJECTIVE WORK: figure drawing

All our judgements of architecture, of form and everything else are based on the fact that we're human beings of the shape we are and that we have a height, average between five foot six and six feet, that we walk on two legs, that we have bones inside us and that we can move in certain ways and not in other ways. That we understand from ourselves, and from our mothers to begin with, softness and hardness. All this: if you don't learn from your own body, you'll learn from nothing . . . We learn what is upright because we are ourselves. If we were like horses who could go to sleep on all fours all our architecture, all our art, would be different. Of course it would!

Henry Moore

Landscape, town and cityscape, still life and the study of natural forms, 'abstraction', the drawing of manufactured objects—all are subject areas which receive considerable attention in most art and design departments. Yet the human body is often neglected, usually because figure drawing is considered to be 'too difficult'. There are some students who begin their sixth-form studies with little or no previous experience of handling the figure in an organised art-room context. All too often this means that students have to overcome natural inhibitions; previous neglect beeds apprehension and fears of the unknown! 'This was the first time I'd attempted the figure-drawing and so I was a bit nervous', observed Rachel.

My first-ever figure sketching lesson and I found it very hard to get started and to find the *exact* proportions by using the pencil in front of the arm with one eye shut, i.e. measuring problems . . . where to put parts of the body in the right place; getting the right outlines in order to start filling in

Gary is starting from scratch, whereas Louise can make use of some previous experience:

> I have previously done a small amount of figure drawing in my last school but on a much smaller scale and they were only of 15 −30 minute poses so incorporated little detail. However these had helped me to look for the overall shape of the pose and the relaxed/upright structure.

In spite of lack of previous experience, confidence soon develops with practice to the point where Victoria can say, after a few months,

> ... I have attempted many figure drawings both at home and during lessons. I still find the figure the most difficult subject to draw, yet I feel I have improved since September. I now find the most difficult part of the figure to be the face, whereas the proportions used to be my main problem. I find it difficult to get the facial features reading logically especially from a 3/4 angle. I overcame the bodily proportions problem by carefully measuring and plotting onto the paper the exact position before I began to draw in the details.

Victoria is making many drawings and is now well on the way. She reflects the early experience of many students; having begun to come to terms with proportion and how to get the figure down on the paper in generally satisfactory terms, another set of problems, such as how to render the more precise details of hands and features, surfaces.

These problems are worth grappling with. Moore suggest that the way we perceive landscape, architecture and everything else is determined by the fact that we are human, and our size and form affect how we judge and measure other things. Such commonplace expressions as a 'bird's-eye-view' or a 'worm's-eye-view' emphasise that we see things differently, and therefore afresh once we are viewing them from other than our normal sitting or standing positions which we take so much for granted in everyday life.

It is equally because we are human that we are more critically inclined towards studies of the figure than we are to other things. We are much more sensitive towards discrepancies in the proportion of one part of the body to another than we are to, say, those of trunk to branches to twigs of a tree. This is why the figure is seen as being difficult, but conversely it is why it should be central to any healthy art and design course. Challenging the figure certainly is central, but all sixth-form students − irrespective of assumed aptitude and ability − can be systematically helped to look, respond, analyse and record. They can be taught how to measure, how to cope with

foreshortening and proportion, how to summarise and capture the essential characteristics of each particular pose and how to make constructive use of all the other elements which contribute to the rigorous study of the figure – movement, surface and texture, and so on. In other words, all students can be taught to draw the figure at an objective level and can then begin to utilise the resulting skills in other areas of their art practice.

Where to begin? What is meant by the essential characteristics of a pose? Every pose should be carefully set up and 'designed' with clear intentions in mind, and these should be known to student and teacher alike. There is far more to the setting up of a pose than just sitting the model in a chair and that being it. The pose might be set up with surrounding draperies to emphasise flowing rhythmic relationships; the patterns and textures of clothing might be affirmed through other fabrics and plants to develop an essentially decorative effect; a combination of spotlights and natural lighting might be exploited to create a dramatic feeling of three-dimensional monumentality; in one pose the model might be reclining, emphasising recession and foreshortening, yet in another be elevated to stress a different aspect of perspective and scale. Additionally, the pose might deliberately contain an echo from the world of art history with all the potential for wider study which such a strategy can open to us, as well as contributing to the intrinsic worth of the pose as stimulus in its own right.

As well as a pose having these general characteristics which all can enjoy and share, each student should also be able to react and respond to it at a personal, even emotional, level. Most subjects require that the student walks into the room and sits right down in the usual place, but a figure drawing position should only be selected after having spent some time walking round the model. This involves studying the pose from a variety of angles and positions so that a particular viewpoint conducive to personal interests can be chosen, or a viewpoint offering a new challenge, as it does in this case for Kathryn:

> The first figure was high up and I chose to do a back view with
> just the side of the face showing because I wanted to try
> something new and usually I sit facing the figure or with a close
> side profile.

As well as the more conventional standing and sitting positions, the choice of viewpoint could involve a student being elevated on a table so as to be able to look down on the model, or to look up from a deliberately low eye-level by sitting on the floor, consciously exploiting those unusual bird's- and worm's-eye viewpoints. Once caught up in such ideas, a student can consciously draw from, say,

low sharp perspectives for a considerable period with the work developing, in effect, thematically.

Walking round the model also provides opportunity to study the particular nature and characteristics of the pose. Is the pose or any part of it tilted backwards or forwards and to what degree? Or is it

Plate 5 *Ann working from a model posed in an unusually elevated position designed to provide distinctive and challenging viewpoints.*

simply upright? Is it straight or twisted? While walking round the model, the student can come to understand the actual physical distribution of the pose, whereas from the single drawing viewpoint a pose can only be read from that particular angle. This can be deceiving, as it is obviously extremely difficult to determine whether the head is slightly tilted or not until it is seen from the side in profile.

While walking round, the student should also be constantly gauging the respective merits of the numerous compositional ideas which will occur. Has the pose been set up in isolation deliberately divorced from the surroundings or has it been carefully conceived within the environment? How much of the surroundings needs to be incorporated into the drawing and how will this affect the scale and placement of the figure on the page? Might foreground objects, like easels, other students or a plant, help to form an interesting composition by adding scale and depth or by creating framing devices to focus the figure? By making a rectangular viewer out of card, the student can isolate and clarify specific compositional arrangements.

There are therefore three major activities involved in walking round the pose:

1. The student is making a considered decision as to which viewpoint is most conducive to personal concerns and interests.

2. The student is learning about the nature and distribution of the pose so that (s)he knows how it is arranged spatially.

3. The student is relating the pose to the environment in order to take account of various compositional possibilities.

Having selected a position, the decision whether to stand or sit is an important one. How is the figure going to be arranged on the sheet of paper? Is the whole figure to be portrayed or a selected part such as a portrait from the waist upwards? These kinds of factors will determine how near or far from the model one works. For example, measurement is much simpler if the size the model appears corresponds to the size it is being drawn. Michael gives evidence of these considerations with regard to three separate studies:

> I have drawn three figures during the course of the term, in pencil; the first of which was a full head and shoulders on A2. I sat on the floor looking up at the subject's face to get a more angular perspective, therefore creating different tones and sizes than the more usual proportions The second was again in pencil, B6, but here I decided to put more of the figure in. I put him on an A2 and put him on from his waist up covering a lot of

the paper. The pose of the subject was very difficult as his head was tilted forward and consequently the face was very compact The third was a pencil drawing, B4, on A2 paper but this time I was more interested in the face alone so I drew it larger than the first. I concentrated greatly on the skin tonality and the smallest details around the eyes It looked very real and it is a very strong drawing

The relationships between what he chooses to draw and the area of the paper are obviously important to him. Most students who lack experience tend to draw small with little or no regard for the considered placement of the figure to utilise the full sheet of paper. This often arises out of a fear of the actual activity, but some simple devices can help the student through this tentative stage. What is the overall shape of the pose? It is better to start by attending to broad issues of this nature rather than unthinkingly putting the head down first, as is so often the case. Does the pose, for example, approximate to a geometric shape? Is it essentially triangular or pyramidal in nature? Do its rhythms form an 'S' shape, or whatever? Might it help to make a small scale diagram of the overall shape within a rectangle in the margin or on the reverse side?

Ann, for example, feels that she improved her 'compositional technique' once she began to see the overall shape formed by the figure:

> ... I copied an idea I saw in Art History where we studied a Gauguin, where he paints Van Gogh painting sunflowers and the picture is a V-shape. Here I created the same shape

All these preliminary activities can help the student to then distribute the figure over the whole picture surface with confidence. It is sensible to draw the initial marks lightly, drawing more firmly and decisively as the scale, relationships and proportions of the pose become more clearly established. Robert discovered that he had to work in this manner:

> The figure drawing at first was quite hard since I hadn't done any before but I am beginning to overcome my difficulties and enjoy it. My difficulty at first was that I didn't get an accurate outline of the figure but I have learnt not to make my first lines too dark but to make them quite light and keep trying until I finally get an accurate outline. Before, when I started, I used to make my first lines very dark and thought that every line I made counted.

Two artists worthy of study in this respect are Daumier and Degas. Both used line to express form and produced numerous drawings in

which the form of an arm or a leg is fully realised, and yet the 'outline' can consist of as many as six lines as each artist sought to refine his drawing down to the exact contour. Another useful way of establishing the pose is to pinpoint the various parts of the body on the paper by initially 'mapping it out' through the use of dots, dashes and small marks to indicate the interesecting parts of the body–shoulder, elbow, knee, ankle – but in order to do this successfully the student has to be able to carry the main contours in the mind for an important initial stage in the drawing.

Building the drawing from initial light to subsequent firmer marks also reduces dependence on the rubber. The process of constantly re-evaluating and adjusting lines and marks, as the pose is rendered with increasing precision, can lead to a way of thinking and an approach to drawing in which there are no longer any 'wrong' lines as such. Many students at sixth-form level are not at this stage of maturity, however, and it is better that they use a rubber rather than be put off by what they see as a too incorrect statement or by marks which they are not happy with.

The inexperienced student also tends to use the pencil for security, but it is worth experimenting with a variety of media in order to discover which are the most relevant to individual needs and to particular situations. Charcoal, wash, ink, conté, watercolour, pastels, cray-pas and Caran D'Ache are all media worthy of attention. Nicola observes, for example, that:

> This pastel drawing was done because I wanted to get used to drawing with pastel. I found it very strange but I liked the effects that mixing pastels could create. I encountered a problem when I realised that certain colours were lost – but this seemed to make me use a more unusual colour scheme, e.g. purple for shadowy areas. I liked the way it was very easy to create a spherical shape with quite simple shading. I found that pastels were good to work with but probably not suitable for more intricate and detailed drawings.

Of course pencil, too, is an extremely versatile medium if its potential is exploited. With experience the student will learn which softness of pencil is appropriate to which need. In one drawing a student might use a range of pencils from 2 to 6B. Ian illustrates this point well:

> The subject was Rachel from our class, and a low viewpoint was adopted. In this piece of work a definite improvement could be seen in my work with a more confident approach. The tone is much stronger, and the subject observed to greater detail. I used 2B and 3B pencils for the face and up to 6B for the girl's

clothing. 4B and 2B were used for the hair bringing pleasing results for a change. I usually have trouble with the hair, but this time I treated it as blocks of tone rather than individual strands.

The pencil can also be the ideal medium for drawing of a linear nature. Many artists, such as Ingres, Picasso and Hockney, have submitted themselves to the rigorous discipline of expressing three-dimensional forms purely through line without recourse to the use of tone and shading. In order to render the contours effectively, the artist has to take full account of the nature of the forms and volumes which create them. Carole found this to be a worthwhile discipline:

> . . . the aim was just to base the picture on the main contour lines. I found this extremely difficult because I am used to working with tone and not totally depicting just outlines. The completed figure held together perfectly, without any shading.

Plate 6 *A ballet dancer pose lit by blue and pink spotlights made a 'really effective display' for Carole. 'Because of the challenge and wide variety of colours' her 'attention did not slip'.*

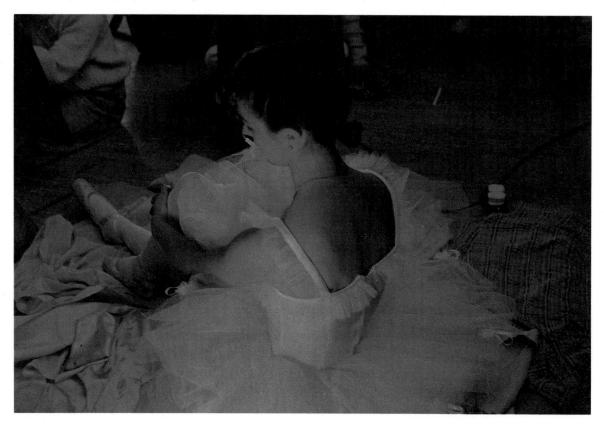

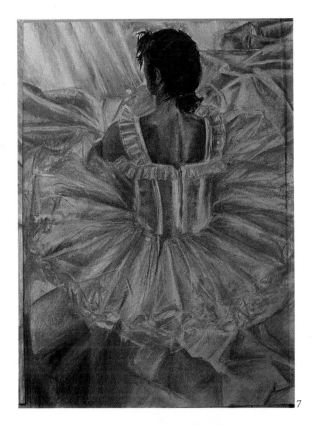

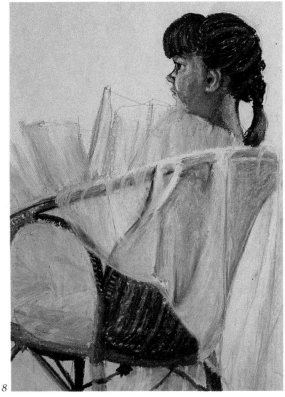

7 8

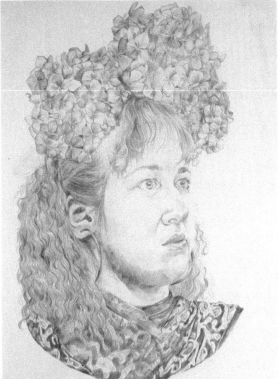

9

Plate 7 *Kate's study of the ballet pose. Her use of pastel enabled her to exploit the colour values which were such an intrinsic feature of this pose.*

Plate 8 *Another ballet pose in which Viv has beautifully 'seen' the profile head against the material of the tutu. By selecting a side view and a low angle, she has been able to give expression to her interest in Lautrec's treatment of facial features within more elaborate compositions.*

Plate 9 *A head-and-shoulders study of the 'Pre-Raphaelite set up' executed by Vicky in Caran D'Ache pencils. The student model was chosen because of her natural resemblance to many of those preferred by the Pre-Raphaelites with their pale skin and long auburn hair.*

The rubber, too, can be an excellent drawing implement which can be used to make clean lines or marks within dark tonal areas. Mark describes experimenting by 'applying dark tone and adjusting it with a putty rubber'. By making a sequence of ten-minute drawings, using a different medium or combination of materials each time, the relevance of media to particular situations can be explored beneficially.

Drawings need not be monochromatic either. Some poses obviously cry out for colour and Carole has experimented quite a lot on this front to good effect:

> I especially like to work in pastels, and I have begun to take more interest in using colour rather than purely black and white drawings I like to pick out the variety of colours that is contained within a particular subject matter. The range of colours that can be seen within the 'Pre-Raphaelite set-up' is really remarkable. Because the girl has red hair, the flowers in her hair and the bright colours of the scarf around her neck really stand out and emphasise the pale colour of her skin. The variety of tones and colours are quite difficult to capture, but by using pastel instead of black and white the tones are much easier to depict. I found quite a lot of difficulty in showing all the different tones because I tended to use colour as a broad medium. I used to just look for all the colours and put them down just as a particular colour and not as a colour that was tonally part of the overall effect.

Whether working in colour or monochrome, the type of paper used is also an important consideration. Grey might allow both light and dark tones to be established from the outset, or black cause the colour to glow, or a paper with a 'tooth' allow white flecks to show through, giving a feeling of shimmering atmosphere and light as in Seurat's conté drawings. Thinking about the type, as well as the size, of paper can be an aid to clarifying thoughts and aims and important to the outcome.

Another evening-session pose was also one which demanded colour:

> We also had a session set up with a young girl in her ballet clothing. Artificial lighting was used, i.e. a blue spot light and a pink spot light. These two delicate colours combined with the natural light, which steadily got darker, and proved to show a really effective display. It was because the natural light got progressively darker that the piece of work had to keep being modified. This was particularly difficult because I had not used pastels too much and I was finding it difficult to capture the

various tones . . . because of the challenge and wide variety of colours my attention did not slip.

Though not absolutely sure why she began with the region of the neck, Carole thinks that it was probably so that she could then expand outwards in any direction, revealing another experimental aspect of her approach.

This is in contrast to the student who reaches the sixth-form level having already settled on a set technique to be applied to any and every situation whether appropriate or not. When this happens the student can sometimes spend twenty, even thirty, seconds at a time without even looking at the model whereas the student who is really observing will not let more than a couple of seconds elapse without referring back to the model. In this case, the nature of the marks arises out of, and is determined by, the looking and thinking processes rather than being for effect. Drawings will gain in assurance through constant application and will take on a personalised quality in the process, whereas the predetermined technique soon looks predictable as it is grafted on to each situation irrespective of relevance. Michael raises some of these issues in a very clear manner:

> My approach to the figure has changed dramatically. Gone is the apprehensive approach. Gone is the 'tickling' of the figure and gone are the proportional difficulties encountered previously. My confidence has taken a giant leap forwards and the result is unbelievable to me. Never did I think that the figure could be drawn by me properly. But after searching through different techniques I have found my own. The main hypothesis of the technique is not to be afraid of the figure but 'attack' it with my pencil.

His use of the word 'technique' has very much to do with an overall approach rather than with a specific method of making the marks; he then moves on to the nature of the pose and the particular problems which it presented:

> It is a seated figure on an A1 paper. The size of the paper really brought out the best of the figure for me. I drew the whole figure with a 3B and drew the tonality of the face with it. The face: I encountered some difficulty with the lower jaw of the figure because he had his hands on his cheeks and consequently the proportion fell a little, but after some close consultation and adjustment of the figure's hands it began to take form. I tried to create a very solid sense about it by using very bold lines. The solidity arrived when I began to use tonality around the eyes and nose. Increasing the tone around the socket of the eye gave

it real depth and the light of the nose contrasted against the darker eye area gives a three-dimensional effect I have never experienced before in a drawing.

The excitement he felt at resolving these structural problems was dampened to some extent by his inability to handle the hair in the same way, and to deal with this problem he needed teacher support.

> The hair I found really difficult to draw, and still do, I can't seem to get the fine textural effect I need. It is a difficult problem I never seem to conquer. However despite my aspirations the end result is again very pleasing. It increased dramatically as a real drawing when it was pointed out to me that the overall tone of the hair was very much the same. So after darkening the hair in the appropriate places it began to take some form.

A crucial feature of the pose, particularly from Michael's position, was the significance of the hand and he felt that he had to pause and take stock before proceeding further:

> Moving to the hands I stopped and thought about it. Only one hand is visible so I concentrated a lot on it. I became interested in the actual structure of it because previously I had just thought 'hand' and drawn it. But this time I drew it sectionally with each part of the phalanges segregated. On the actual toning of the hand I never took my eyes off the subject hardly. The speed in which I did it was very fast to my standards because I usually do a very individual stroke of the pencil. But this time I attacked the hand and the result was again a great step forward in my drawing. All the knuckles, nails and joints were drawn in as I saw it, not as pieces of rubber but solid rigid parts of the hand.

Next he changed pencils in order to get more strength than could be achieved with the 3B used so far, but there were still problems to overcome:

> When I moved onto the shirt I switched pencils and moved to a 5B. This was to get a richer tone and the pencil enabled me to get a more varied tone. I found some difficulty at first because the shape of the upper arm and shoulder were present but I achieved this by doing circular strokes of the pencil. The actual proportion of the figure seems right but I am worried about the back leg, it seems wrong but it will probably become more visible to me when I move to that area of the figure. I am confident that when I finish the figure it will be quite a reasonable piece.

This extensive statement is of particular interest because it provides a vivid insight into the stages and progress of a drawing, with the sequences through which it moves made apparent. The problems encountered and the moments of achievement, the need to think through problems, even in advance of making a mark, and the intense levels of scrutiny involved are all made clear. The transition from just drawing a rubbery hand to conveying one with solid rigid parts also means that Michael has begun to master problems of foreshortening. The whole statement also communicates the tenacity and perseverance which is required to fully realise such a figure drawing; it obviously represents an important stage in Michael's own development.

If foreshortening is an important aspect of Michael's drawing, it is an absolutely essential feature of Viv's study of a reclining male model. Her drawing position meant that the head was closest to her, the rest of the body moving dramatically away from her in sharp perspective. She recalls that:

> The drawing of Roger was done on several of the nightly figure drawing sessions at College, and took probably between six and eight hours to complete. The pose was based on one of the figures from Géricault's *Raft of the Medusa*.

Her resulting drawing is a fine example of a student who has derived great motivation from a pose which is interesting in its own right, but which also has its origins in a particularly dramatic and expressive painting of a drowned figure famous in art history and well known to the student. The feelings with which Viv attempts to imbue her drawing relate to her whole knowledge of the plight of those shipwrecked people adrift on the raft. This has, in turn, influenced her in her choice of charcoal as her medium; it is one which she already favours and uses with assurance:

> I chose charcoal as the medium for the drawing as I have felt comfortable using charcoal since I did a triptych [see Pages 136-41]. I find it much quicker and more immediate than drawing with pencil. I am able to bring more feeling, aggression and movement into my drawings using charcoal, and I feel more confident now that I am more experienced, relatively speaking, in its use and limitations.

Though there is no evidence of pencil apparent in the finished study she did, however, use that medium to map out her initial lines:

> When drawing I prefer to draw out the lines of the figure lightly in pencil first to avoid messy mistakes, afterwards 're-drawing' using a charcoal pencil, and then using sticks of

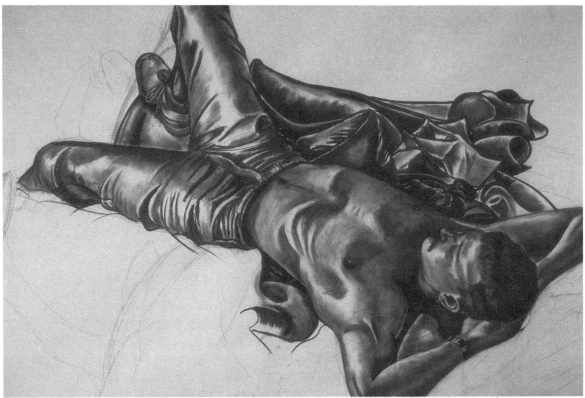

10

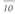

11

charcoal to describe the tonal variations throughout the pose, exaggerating the tones for a more dramatic effect. With this particular pose I tried to create a feeling of movement with the material on either side of the figure, again exaggerating the tones, but to emphasise the folds of the cloth.

From the initial faint pencil line through to the final bold, tonal charcoal mark it is clear that, with practice and experience, Viv has evolved an effective manner of drawing appropriate to her concerns and needs.

Like Michael she, too, experienced some difficulty in drawing one of the legs:

> I encountered one particular problem with the model's right leg, which was at quite an awkward angle to draw, but I feel that I have resolved this problem to a great extent in the final drawing.

Viv does not actually use the word 'foreshortening', but it is because of her understanding of it that she is able to deal with the problems posed by this leg. Foreshortening is when the length of an arm, leg, torso, etc., appears to diminish because the object is projecting towards or away from the viewer. In proportion to the angle, the cross-section – the 'roundness' of the object – becomes increasingly apparent. The student therefore has to learn how to render an object through a consideration of its length combined with an understanding of its cross-section. To focus sharply on this issue, get a rounded object like a tin can. Look at it absolutely side on and then gradually tilt it until only one circular end is apparent, noting the varying degrees of roundness in relation to the apparent changing length in the process. Foreshortening can be built up into a complex and daunting problem. In essence, though, it is quite simple but does necessitate an ability to think and see in three-dimensional terms.

In contrast to the arduous nature of these drawings which have to be sustained over a number of two-hour sessions, there are also many benefits to be gained from studying poses of short duration. Rodin used to have models walking round the studio and moving in and out of various positions as they did so. He would make one

Plate 10 *Viv favours charcoal because it enables her 'to bring more feeling, aggression and movement' into her drawing, illustrated in this study of a pose based on the drowned figure in the lower right-hand corner of Géricault's* Raft of the Medusa.

Plate 11 *The figure in question was added to the* Raft *painting at the last moment.*

Plate 12 *The scale and detail of the hands in this foreshortened study by Richard contribute to the dramatic perspectival view which he has carefully selected.*

'freeze' when a particularly interesting set of relationships formed and he would rapidly set down the movements, contours and form of a pose which could only be sustained for a short time. The need to work rapidly meant that he could not linger over details but had to capture the broader relationships and essence of the pose. Louise derived similar benefits from an exercise of this nature:

> This was a series of 10–15 minute sketches of the figure, also done in pencil after college. The poses were very varied and challenging since they involved foreshortening and had an emphasis on the weight being balanced on a particular part of the body, so that it was the pose itself and not the figure which was of importance. I enjoyed this, since it was a new approach for me, because I usually like concentrating on a head and shoulders view of the figure. It is the form and not the movement which I usually find of interest. However I was quite pleased with my efforts at foreshortening, etc., considering my experience.

Louise is clear that she is gaining new experiences by working on a different wavelength to the more normal time scales involved.

All the examples cited above involve the study of the clothed figure, and at sixth-form level the majority of drawing sessions are likely to involve the clothed model. These sessions always provide something specific to grapple with; folds in the material offer clues as to how the forms and volumes beneath might be rendered and clothing can add to character while providing textural and decorative interest. Ideally, though, every sixth-form student should have at least some opportunity to draw from the nude model with its elusive subtlety of form and surface. The exacting discipline of identifying muscular patterns and tracing the insertions and origins of muscles can be both demanding and rewarding and can help the student to better understand what leads to the externally visible shapes of the clothed model as Suzanne vividly illustrates.

> The second figure drawing is one which is in the process of being drawn at the present time. It is of a semi-nude figure who is portrayed in a reclining position. The conception of the drawing (which is A1 in size) is to discover the shapes, tones, texture of the muscles within the skin and to investigate how they all inter-relate to form the whole body. Proportion being my major hurdle in this observation, complicating the whole study in terms of form and tone. This problem has eventually been corrected during the course of the drawing by the aid of stepping back off the picture and analysing it critically . . . it has become a vital lesson in understanding the basic mechanics of the figure.

Many students by this stage have at least a smattering of anatomical knowledge, particularly if they have studied biology to any level. Invariably, though, this is just textbook or lesson knowledge which has never been applied to anything in a real life situation, but exists only at a factual and diagrammatic level. Names of major muscles and their location in diagrams might be known but when, for example, the student can actually see and has to record the sterno-mastoid muscle in a twisting neck, the way in which it runs across the line of the neck has to be considered. In this situation, the student is dealing with real 'action' knowledge which has more lasting effect than any textbook information.

All forms of figure drawing differ from every other kind of objective study in another respect: the object being drawn is human, it is alive and moves. Even if the model is able to remain very still, that 'life' factor can still be sensed and there is a potential for movement and change, all of which can be disturbing to some students. However, these psychological factors also contribute to the challenging nature of figure drawing and make it an activity imbued with urgency. Some students also find it fascinating that they have

to relate to character and personality traits. When scrutinising the face, for example, they can become obsessed by the life and vitality within the eyes; they blink, they glisten and they are mirrors of character and individuality. These are qualities to which we are all sensitive and with which we can identify because we, too, are endowed with similar qualities. These factors play their part in making figure drawing both a very rewarding and a frustrating activity; there is the potential for failure all the time but the feelings of achievement are tremendous when these problems are successfully dealt with. Kathleen beautifully summarises these ambivalent aspects of the activity:

> At the beginning of the term this was also an alien subject to me. I found that it is the most stimulating form of Art study that I've ever attempted; the slow, difficult mathematical process, looking and looking again, thinking and reasoning what goes where and why. Here also I found I reflected on the Art History. Remembering methods and approaches of the artists covered you begin to use the techniques they used, look in the way that they looked. Another good and worthwhile apsect of a figure drawing class is the other students around you. Looking at and observing each other's work is helpful and useful in the way in which you tackle your own. You pick up on, become aware of, small points and detail that otherwise slip away unnoticed. I enjoy this, have absolutely no confidence in myself as a figure drawer, and I feel as though I want to continue, to plod through the difficulties and to observe accurately.

Kathryn, too, enjoys these evening sessions because, 'It is a good atmosphere to draw in and I find it is better with other people around because this motivates me, although sometimes I prefer to work alone', which she regularly does when drawing at home. Figure drawing is quite possible in a home environment: family members often make willing models and, to Louise, an added bonus is the informality which this brings:

> ... in this particular study, the figure was more relaxed, more natural and in a home environment. This made it easier since the body formed more curves and was not as rigid and unnatural looking. The relaxed feeling was easily emphasised by adding to the composition everyday objects. In deciding on the composition I tried to place the figure a third of the way in from the paper's edge so that the focal point could be used to best advantage as with Constable's and David's work. After seeing a portrait on a slide in the art department, I decided to

use strange lighting to emphasise shadows on the face of the figure and also in the folds of the material.

Not only is the model more natural in this environment, but Louise's statement also makes it clear that in this context she, the student, is in complete control of the pose, the lighting and the addition of any supporting props, meaning that she can think compositionally in the fullest sense.

Julie takes this process a stage further by using her home-based figures as the basis for further developmental work, making use of her art history interests in the process.

Sister in Bed Asleep
All done at home in an A1 sketchbook. Like working big now. Done in pencil, 3B. Have really enjoyed doing this picture as I am interested in this subject and would like to develop it as I have seen various Degas and Lautrec pictures which I have got various ideas from for my next sketchbook pictures for homework. The picture seems to have developed more as it has got more strong and incisive in tone, etc. The difficulty was getting my sister to pose for me at the certain times that I wanted to draw in. I have always liked to draw my sister and would like to develop this idea further, which I am as I am doing a watercolour and pastel picture A1 size and a charcoal development of it in twice A1 size. The pencil picture seemed to look better as I added in more parts, e.g. the foreground as things seemed to relate to each other more as the picture developed. I now know that a good idea for the pastel picture is to use a colour scheme of Degas or another of my favourite artists.

And again, with regard to another home-based pastel project:

The problems I found with it were the faces which I solved by looking at the *Portrait of Duranty* by Degas and also another problem was the use of too much black which I omitted by using complementary colours instead, like blue and green in the shadows to complement the other colours (from the Impressionists).

Having obtained her A–levels, Julie's higher education course proved to be unsuitable and so she returned to College, working full-time in the art department whilst applying for alternative courses for the following year. The interest she already had in working large led to her spending her first week in making a pencil drawing in which the figure was about three times life size; when displayed it extended from floor to ceiling on the main art room wall:

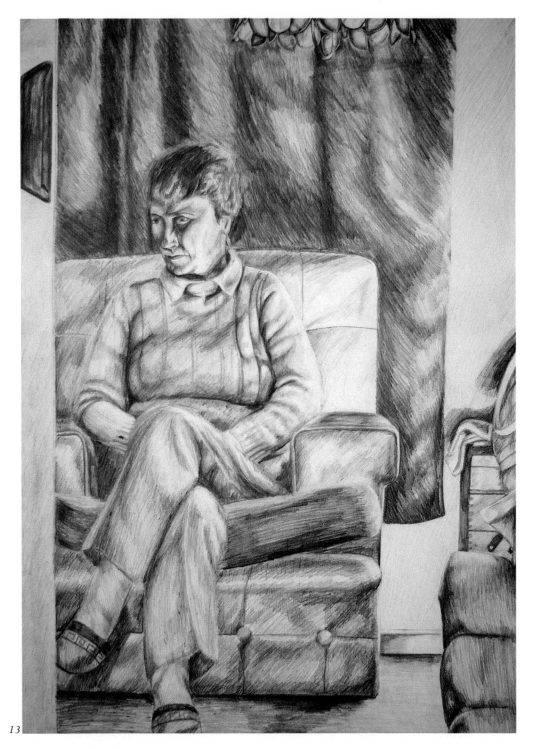

13

Plates 13 & 14 *Jane's drawings of her mother (approx. A1 size) and her father (A2) illustrate how students often begin to work in related ways at home, using friends and members of the family once sufficient confidence and assurance has been acquired through the figure drawing sessions.*

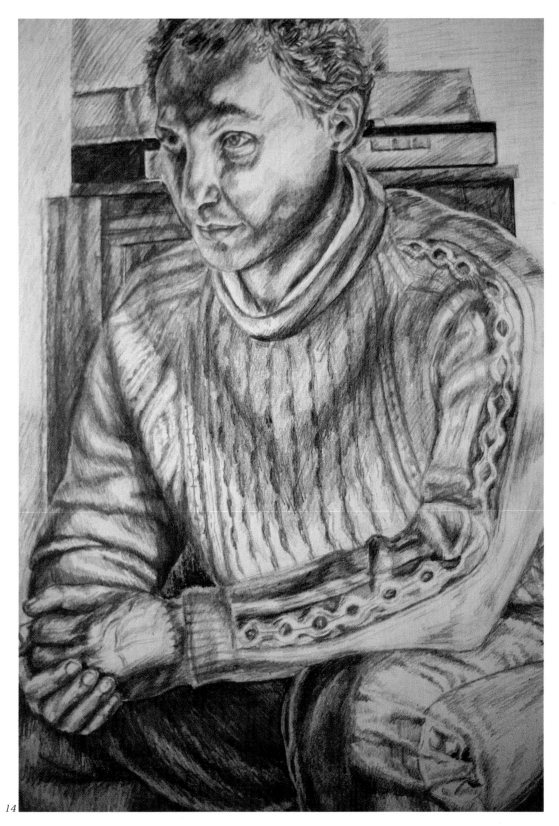

14

> I just felt, for a change, I wanted to do something completely
> different because previous to that I had done figure drawings
> that were not really small in scale, but, since starting off A—
> level I progressed getting bigger and bigger from really small
> sketches to A1 and double A1 size. I just thought I'd try
> something even bigger because my friend, who was
> unemployed at the time, had said she would come in and model
> for me for a week. If I'd done it small it wouldn't have taken me
> a full week, so I thought I'd do something really big and spend
> the whole time on it and get a big project out of it. So I started
> off with the head and shoulders on one A1 size sheet and just
> kept adding the pieces of paper together downwards as the
> week went on.

To enable her to relate each sheet to the preceding ones, she would
make two or three marks at the top or side of the paper to act as
guides as to where folds in the drapery, or whatever, continued. She
also 'kept putting them on the wall to check that they were looking
O.K.' and were consistent in terms of tonality, proportion and unity
of pose. 'That made me really eager to do other things on a large scale
and since then most of my work has been on a really large scale.' A
notable example was a painting of two people on a settee. Whereas
previously she had solved technical problems through reference to
works like the Degas *Portrait of Duranty*, she was not conscious of
any direct indebtedness to anybody in this painting, except that
favourite artists like Mary Cassatt and Degas were always at the back
of her mind because she had studied their works so avidly for so
long now:

> Actually I really enjoyed it because I didn't have to be so
> finicky with different things. Because it was on such a large
> scale I felt that I wanted to be a lot freer with the paint and it
> has made me a lot more flexible with the way I use the paint . . .
> when I did the eyes on the figures I used the paint in quite a
> restrictive way with the strokes quite smooth. Then when I got
> to the settee in the background I wanted the strokes and the
> colour to be really quite vibrant, and I sort of slapped it on. So
> the paint was in really big strokes then and I was sort of
> swaying my arm about as I slapped it on. So I used the paint in
> different ways throughout the painting, really.

Finally, then, figure drawing is a marvellous means to other artistic
ends. The skills and understandings which it develops arising out of
the looking, analysing, responding, designing and recording
processes all have relevance to other areas of artistic endeavour.

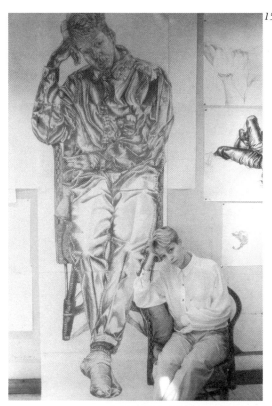

15

Plate 15 *Julie's friend recreating the pose she had maintained for a full week to enable Julie to make an eight foot drawing by constantly adding A1 sheets so that it could continue to grow and develop.*

Plate 16 *A detail of the above study illustrating the firm and decisive quality of the drawing.*

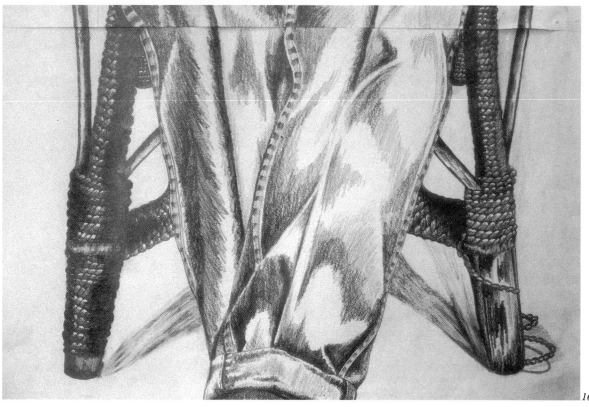

16

I feel that my present subject matter, the figure, is developing within the course. This is due to the fact that if you have got the patience and the analytical powers to draw the figure then any other subject matter can be mastered with less difficulty.

Carole

The figure drawing is definitely the most demanding type of drawing and because of this it does improve all aspects of your drawing.

Robert

Similar sentiments have been expressed by many mature artists. Van Gogh was a great admirer of the woodcuts made by Japanese artists like Hiroshige and he admired the directness of their drawing.
He wrote,

Their work is as simple as breathing, and they do a figure in a few sure strokes with the same ease as if it were as simple as buttoning your coat.

Oh! I must manage some day to do a figure in a few strokes. That will keep me busy all the winter. Once I can do that, I shall be able to do people walking in the boulevards, the street, and heaps of new subjects.

The artist Michael Rothenstein recounts an anecdote which vividly illustrates how seriously Van Gogh addressed this issue. A teacher of his at the Central School, A.S. Hartrick, while a student in Paris, had known Van Gogh and had given him use of his room, free of rent, while he was away from Paris for a time. On his return Hartrick was astonished to find the walls covered with drawings, in bright blue and red chalk:

The window of the room overlooked the street. When Van Gogh had seen something exciting there, the figures of children or old men, horses pulling carts loaded with wood or vegetables, he started drawing without waiting to fetch paper. These sketches had evidently begun round the window and as the space filled up, Van Gogh had worked progressively away towards the corners, filling the walls with a compendious visual diary of the street.

Lowry was an artist who populated many an industrial townscape with figures walking in the street. He is still considered by some to be a naive artist, but he planned, prepared and studied assiduously:

I did not draw the life very well. I was competent. But I did find it valuable, and I still believe that long years of drawing the figure is the only thing that matters . . . I did the life drawing for

twelve solid years as well as I could and that, I think, is the foundation of painting.

Similarly, on being asked why he produced so many paintings of roses, Renoir replied, 'I am researching into various flesh tints for my nudes'. Still-life, then, is another area which has many implications for expression in other fields of activity.

POINTS REGARDING THE DEVELOPMENTS SECTION

1 Its basic principles are teachable and can be understood and satisfactorily applied by the vast majority of students.

2 Being human oursleves, we are more critical in our responses to studies of the figure than to other subject matter. This is one of the main factors as to why figure drawing is such an exacting discipline.

3 Its multi-layered nature means that you are likely to encounter new sets of problems just as you feel you have come to terms with others; for example, the way to handle facial features becomes more of a problem as you master proportion.

4 The model should always be posed with clear intentions in mind; these can be further exploited through control of lighting, environmental context, and so on.

5 Always choose your viewpoint with care, having first taken account of numerous views and having studied the pose 'in the round'.

6 While moving around the pose, take note of its overall nature – how it is distributed in space, the angles of limbs from particular views, etc.

7 A rectangular viewer can assist you to 'see' the pose better in the form of a composition relating to the rectangle of the drawing paper.

8 You might find it helpful to indicate the main contours faintly at first, gradually strengthening the drawing's tone as your confidence grows as to the exact placement, angle and proportion of forms.

9 The nature of the pose should influence the choice of media, type of paper, etc. Experiment with a variety of these in order to discover their possibilities and limitations, remembering that pencil is also versatile encompassing a wide range of tone from, say, B to 6B softness.

10 The process of looking, analysing, responding and recording is so important that no more than four or five seconds should elapse between each glance or longer look at the model.

11 | Figure drawing translates academic textbook-type anatomical knowledge into real-life 'action' knowledge.

12 | Artists, both past and present, have also dealt with problems similar to those which you are encountering, making their work worthy of study for your needs as well as in its own right.

13 | Besides being an exacting discipline worthy of study for its own sake, figure drawing can also benefit many other aspects of your art and design studies.

SECTION 2

OBJECTIVE WORK:
still-life painting

T he cloth was very slightly draped upon the table, with innate taste. Then Cézanne arranged the fruits, contrasting the tones one against the other, making the complementaries vibrate, the greens against the reds, the yellows against the blues, tipping, turning, balancing the fruits as he wanted them to be, using coins of one or two sous for the purpose. He brought to this task the greatest care and many precautions; one guessed that it was a feast for the eye to him.

Louis le Bail's description of being in Cézanne's studio one rainy day and watching the artist composing a still-life arrangement of a napkin, a glass containing a little red wine, and some peaches emphasises how the same care and attention is required to set up a still-life grouping as to adequately pose a life model. It, too, should reflect a clear sense of purpose with the underlying reasoning being shared by teacher and students. Every still-life should make a considered compositional arrangement and pose, for example, specific tonal problems. It might be composed of essentially white objects set, in turn, against white so as to enable the student to explore the wide range of tones — and colours — which can be discovered even within 'white'. Vibrating complementaries juxtaposed one against the other might be the focus, as in the Cézanne example, or the colour might consist of a carefully modulated range of harmonies, whether warm or cool. The composition might be structured around vertical forms set against horizontals, or comprise a series of rounded forms balanced against straight ones. Nikki indicates that the actual process of creating a still-life grouping can be as important to the student as to a Cézanne. What she was attempting to do was to:

Create a flowing movement with the leaves, for a start, and then link that to the scarf that comes down, and (in turn) make that fit in with the flowing movement of the leaves.

She sought to unify the whole compositional arrangement through a sequence of inter-relationships.

Students will frequently use still-life as a vehicle to develop their drawing skills, building up form and structure through the use of line and monochromatic use of tone to render the play of light and shade on forms, as is the case with Adele when, as a Lower Sixth student, she writes:

The piece of work which I assigned myself, before the Easter Holidays (and during) was a pencil study I decided to include certain 'glass' items within my drawing as a sort of challenge, in the sense that glass is a fairly difficult medium to draw. Naturally, I encountered a few problems in trying to accomplish this aim – namely, showing the shadows on the glass which are formed by objects placed behind, and also drawing the water within the glass.

In drawing the water I had to be extremely careful that my pencil work was not too dark, for this would have given the effect of there being a 'darker' liquid than water in the glass. Also, the glass that I chose to draw was not a particularly easy one. It was more complicated than a standard drinking glass for the top of it was designed so that the glass gave a 'bumpy' effect, and the stem had a weaved pattern, which made things quite difficult The pencil drawing has also directed my attention and interest to reflected images.

Adele intends to develop these ideas further, introducing colour by using coloured pencils. Still-life also has great potential, though, for developing the student's use of paint in relationship to observation and the recording of analysis and sensation. The importance, yet neglect, of this process was underlined by the introduction of the Endorsed Painting and Drawing paper in the first G.C.S.E. examinations. Initial submissions revealed the degree to which fourteen to sixteen-year-old pupils had undertaken courses in which drawing took precedence over activites aimed at developing painting skills. The student who, on the commencement of an A–level course, declared, 'I love drawing but I can't paint. I don't know what colour to put where; I haven't a clue basically!' was echoing the sentiments of many. Still-life painting is one ideal means for the student who wants to acquire these painting skills and art history, again, provides numerous examples worthy of study, ranging from seventeenth-century Dutch works right through to the present day.

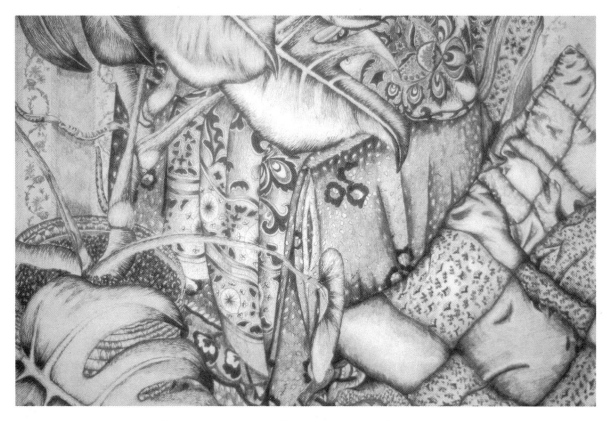

Plate 17 *Nikki's attempts to create flowing movement in her arrangement of scarf and leaves and her love of decorative qualities of pattern and texture can be clearly seen in this detail of her Flowing Forms drawing.*

Anne-Marie was a perfect example of the student with drawing skills, but who was insecure when it came to painting. A still-life was crucial to her development and so her statements run right through this section, interspersed with other student testimonies. Her first attempt at still-life was unsuccessful:

> At the end of the Lower Sixth year I did a painting of some onions. I wasn't really enjoying painting very much. I could draw, I really enjoyed the figure drawing. And I remember doing these onions and thinking I didn't know what to do with the paint. I'd been to London and we were looking at Art History, the Impressionists and everything, but I don't remember clearly making the connection between my work, what I was doing, and paintings I was looking at in the galleries. ... I remember doing these onions and feeling really, really miserable. The paint was very watery and it was mucky and dull, and I remember the teacher kept on making me scrape it off. I just hated it and I think I just threw it away in the end.

In many art departments, physical constraints influence the extent to which still-life is practised. Lack of space can limit the students' opportunities to set up their own groupings, though many rooms have cupboard tops and quiet corners which lend themselves ideally to this activity. The group set up for larger numbers to work around can present a problem because a background, however plain or simple, is an integral part of any still-life, the relationships extending beyond the objects themselves to the group within its location. This is difficult to contrive, as Ann discovered:

> I then developed into an A1 colour piece of work to which I then added a background, which did not look very real. The colours were very literal and unrealistic. I had problems in thinking of a background and of choosing the right colours and tones. In this piece of work I hadn't related the objects to the background and I didn't develop a colour scheme throughout the piece This was less of an achievement, more of a learning process where again I learned something about tonal values and colour relationships.

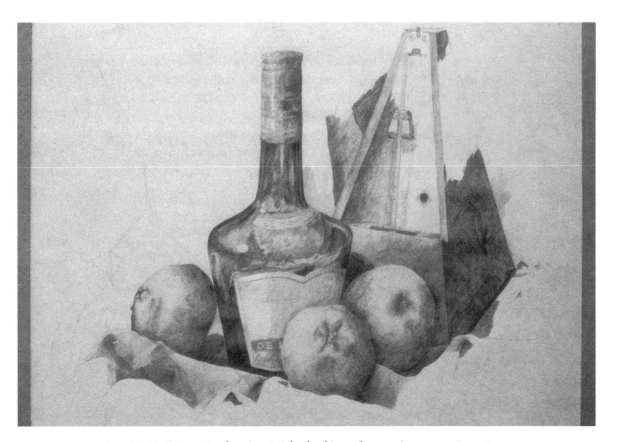

Plate 18 *In this precise drawing, Michael achieves form and structure through purely monochromatic means.*

Some of the most important learning experiences can be gained from the less successful pieces of work, if the student can clearly identify the nature of the problem as Ann has done. She will inevitably give consideration to the background as an essential element in the setting-up of her next grouping.

Simple, everyday objects can be effectively used for still-life purposes. Cézanne made constant use of a narrow range of 'props' to be seen to this day in his Aix-en-Provence studio: 'the plaster cupid, the blue ginger jar, the plain Provencal stoneware, the scroll-sawed kitchen table, the floral rug, the skulls, onions and peaches'. Musical instruments, a meal table, fish and pot plants, meat and reflective or distorting surfaces, natural and manufactured objects have all provided stimulus for the painter of still-life at various times. Include flowers and the possibilities become even more extensive. Van Gogh attempted to paint his sunflowers within a single day because they died so rapidly, whereas the painstaking Cézanne could sometimes even resort to artifical flowers so that they would be unchanging over the many weeks he required. Redon commented that we threw flowers away too soon: they were often at their most interesting when they were dying, their petals falling. In her attempts to come to terms with oil paint, Joanne

> . . . found it was helpful looking at paintings of flowers by
> famous artists to see how they tackled the problems of applying
> the paint to give the right texture and the colours they used.
> When I first began to paint the flowers I painted them with pale
> subdued colours. The actual colours were in fact quite rich . . . I
> kept adding more colours to the flowers so that they would
> stand out from the rest of the painting.

It was only 'after hours of painting' and the study of, in particular, Manet and Monet examples, that she achieved the necessary richness.

Following her disaster with the onions, Anne-Marie returned to College after the summer and began another still-life painting, set up within the department and made up of such everyday objects as a loaf, teapot, bottle and lemons. 'The starting point was the knowledge that I'd gained from looking at other artists, particularly Cézanne and the Impressionists.' She made many important decisions before she even began painting:

> I remember it all just making sense. Just the way it was
> suggested that we compose, before we even started to paint. The
> way we actually looked at the still-life even before we began to
> paint I think the starting point was making all sorts of
> relationships in your head first of all, to do with the

composition of it. The starting point was also your piece of paper and where you were. It was to do with looking and selecting and also dismissing parts of it as well. I remember being selective to the point where I didn't feel that I had to get all of it in. There was an orange plastic bag behind the bread and the curve of it linked with something on the other side. I was composing mentally before I started so I didn't feel swamped by having to get lots of elements in that I didn't feel made any sense to the composition.

Having studied the group and composition in this way, how do you actually start? Cézanne, again, offers an exemplary model because of his deliberate approach, made even more clear because of the numerous unfinished paintings which have survived to provide further evidence of his working methods. He insisted that 'drawing and colour are not separate and distinct' and so, not surprisingly, he drew out in paint advising that one 'begin lightly and with almost neutral tones'. The early marks established the architecture of the composition with the relationships between the horizontals and main vertical objects emphasised. His 'almost neutral tones' tended towards blue, it being the most recessive colour. The initial lines could therefore remain visible throughout without becoming obtrusive; they are frequently apparent in his completed works. Another significance of blue is that when used as the outline of an object it also represents the furthermost, and therefore most recessive, point from our vision. Another advantage of drawing in paint is that it discourages unnecessary detail, the main purpose being to establish the relative position of one object to another on the canvas. The student is then able to apply blocks and areas of colour from an early stage without having to overcome any artificial separation of 'painting' from 'drawing'. Anne-Marie recalls that:

> I don't think I drew with a pencil at all, it was straight on with the paint—very watery burnt umber In the past I'd always hatched in my light and dark areas, whereas on this occasion I didn't do that at all. It was tone to do with colour rather than just thinking in terms of light and dark, with it going muddy ignoring the colour. The paint was then so much easier to handle because it was simply a matter of building up the tones and the colours in relation to one another, whereas in my previous paintings the colour all became on the same level. I'm sure that was because the underpainting was just muddy and I wasn't clear about my aims.

Her previous notions about paintings were that they were 'up in the sky' and about artistic inspiration. Here, though, she was looking at

something which was very ordinary and real, and it all became so simple:

> I was looking at something in relation to something else, unlike the onions. There was a teapot in it, very rounded, and it made a similar kind of shape to the loaf of bread, but it was a completely different colour. And how to relate these two completely different colours, and learning that colours are reflective and that there are subtle ways of making it read, making them relate to one another. Learning that through just observing – looking, mixing and applying without fiddling around and muddying up the colour The fact that there was something to work from: the loaf, for example, that was a whole range of different colours and I'd never used so many colours together as in that loaf It was quite a structured exercise in the first instance, though it did become much more emotional, obviously. It was making all those colours make sense, because when we first looked at it there was this huge thing on the floor – it was quite mind blowing.

Another important discovery which she made was that there is a subtle interplay between attempting to accurately mix the colour which you are observing in an object and 'orchestrating' a colour scheme:

> I was conscious of colour relationships and that orange plastic bag was so important because it brought lots of colours together, it played a really important compositional role. It was like the link with everything revolving around it. The way I reconciled the different colours was, I think, to be not so true to what I was looking at. That sounds like a contradiction, but looking at the work of Cézanne and the way he relates lots of different colours, well, he's not, really. He is using quite a rigid colour scheme of his own.

What Anne-Marie says is, of course, far from being contradictory. Two students painting the same still-life group using the same medium and sharing the same conditions will inevitably arrive at different solutions. This is not simply a matter of differing temperaments, but is equally because both can only make paint approximate to their observations of nature. Each student has to decide on a tonal range. How light is the lightest tone going to be and how dark the darkest? Where is there a middle tone in the group and how frequently and in what different colours does it occur? It does not matter that each might use a different tonal scheme with one student producing a painting that looks darker than the other.

What does matter is that each is consistent in their use of tone once a tonal range has been decided upon.

It is similar with colour. The colours on the palette will normally be restricted to, for example, two blues, two reds, two yellows, a black, a brown and white. Colour in nature is not restricted in any such manner, though the choice of one red as opposed to another might be made because the student perceives the whole group as being bathed in a particular kind of unifying light to make it more appropriate. As with tone, therefore, it is the consistent realisation of a colour scheme which convinces us of the integrity of the painting. Whereas a seventeenth-century Dutch still-life painter or Chardin in the next century produced paintings dark in tone and colour compared with those of Van Gogh and Cézanne, neither is wrong. Each is consistent within their chosen framework. As a matter of interest, Cézanne eventually graduated to working in a range of eighteen colours plus white. But, however wide the range, the artist is still producing equivalents to what the eye sees in nature.

Ann is taking account of these same principles in an Al painting, but using pastel as her chosen medium:

> ... I am tackling the tone and three-dimensional effect of the composition much more positively and effectively too. I started to use Impressionistic colour as it was a basis from which to start from and this way I could use my Art History knowledge to build an image in my mind of how it would look and so I had an idea of the effect I wanted to achieve. So instead of starting off very slowly not knowing exactly what I was going to do, I was more confident The Degas pastels and other pastel work I saw in the London galleries inspired my use of colour and interpretation of the still-life. I need to build up more rich colour and richer shadows, as at first I just used grey but I can see that it needs to be richer and darker to create a more representational and 3-D effect.

Her knowledge of other artists' work has enabled Ann to build her painting up as a unity from the outset, rather than paint it object by object. That unity exists as an image in her mind's eye in the form of a tonal and colour scheme as well as simply relating to what she sees in front of her. Organising what we see before us in this way is an important aspect of all objective work. So, to this end, it can be helpful to set the brushstrokes down in pairs, side by side, to encourage constant comparisons to be made; how do the colour and tone of the plate rim relate to the adjacent drapery in shadow? What is the colour of the orange in shadow against the reflective glow of the wine bottle? Having mixed a particular colour, does it occur elsewhere in the composition and might it not therefore make sense

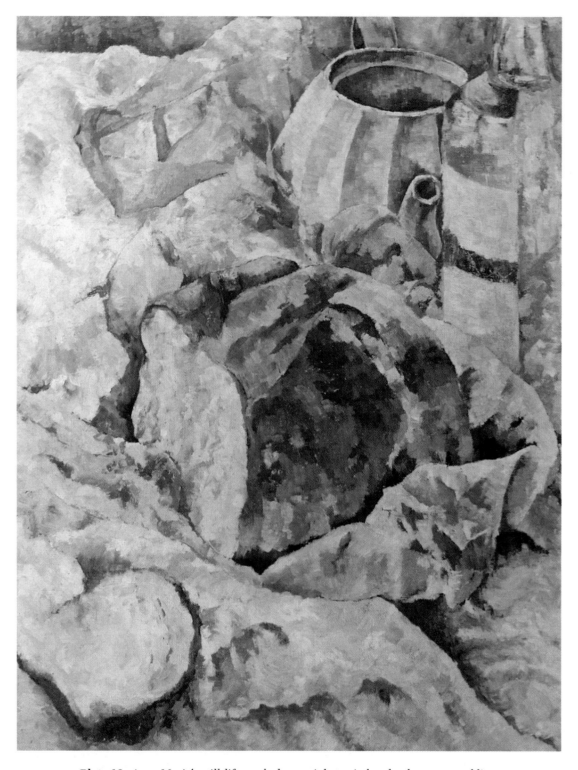

Plate 19 *Anne-Marie's still-life marked a crucial step in her development, enabling her to combine her love of drawing with new-found painting skills, and to make a whole range of judgements and decisions with important design implications.*

20

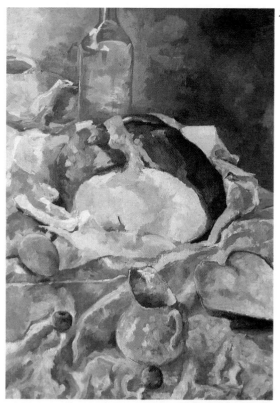

Plates 20 & 21 *Two more paintings of the same group by Ann and Adrian which also show clear evidence of the rigorous process of looking, and then mixing and applying each patch of colour with a decisively applied brushstroke.*

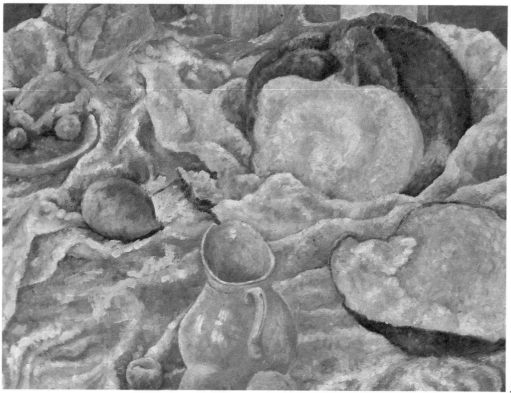

21

to make further use of it? By these means it becomes possible to build up the painting as a total entity through a whole field of brushstrokes, reconciling in the process what we see in front of us with the unified colour and tonal schemes which we form in our mind's eye through observation and response to the group.

An alternative means of achieving this goal, preferred by some, is to select a key area of the composition containing a representative range of colour and tone. Concentrating on this one area until it becomes fully realised, the student can then use it as the focus and criterion for determining the rest of the painting. Ian selected this approach as being the most appropriate for him. Having seen the works of Seurat in London and having studied them in theory lessons,

> ... I decided to adopt a similar approach to my own work I have begun a still-life study using the technique of pointillism. The work is on size A1 paper. I have worked in pastels, as it gives the soft, subtle effect I wanted. The technique of pointillism has made the curves and folds of the material more apparent and subtle, and it has also helped to create a sense of depth in the work I am also pleased with the vivid range of colours and tone. After the first few weeks I began to enjoy doing the painting and towards the end, as I saw all the different objects fitting together I enjoyed it even more

> At first work was slow, I didn't have much motivation as I did not seem to be progressing very far, after hours of work. Eventually, I decided to take a certain area of the picture and concentrate on the colour and tone relationships between the objects. This led to the work progressing much quicker. As soon as I saw the relationships and the work seemed to come together, I had the motivation to carry on at a faster rate.

Julie adopted a similar approach when painting some fruits set against blue material. Though normally well prepared for her art lessons, having been away on an interview she came into the art room intending to do something, but unsure as to what on this particular occasion:

> I came walking through the door and I saw this still-life set up with all this material and I just thought, 'Oh, that would be lovely to paint!' So I just got the paints and started off—that was just it, I just started painting. I started with the fruits and all I did was draw a very faint outline, a sort of big swirly circle, and I started going from there and I didn't draw out or anything. I did the tomato first and then the grapefruit in the background and then I started with the material and the two oranges,

whereas with figure drawing I tend to start from the top with the head and work downwards.

She found her approach natural, 'and it just progressed'. Nevertheless she knew exactly what had attracted her to the group in the first place and she carried a clear picture in her mind's eye as to what she wanted to achieve:

> The thing that attracted me to it was that I love really foldy things and creases in things like material. With the figure I prefer to have somebody with a really baggy sweater on that makes loads of creases, rather than a pose with decorative qualities. The other thing that attracted me to it was the bright colour. I love the primary colours, and there was the red of the tomato, the yellow of the grapefruit and the blue of the material; I love really zingy colours.

As the painting developed, therefore, Julie utilised her knowledge gained from art history relating to complementary colours, using the blue of the material to surround and intensify the reds, yellows and oranges of the fruit so as to give the painting that 'zingy' richness which she wanted.

Whichever approach is chosen, the wider knowledge of art obviously aids the process. Ann's move from grey in the shadows was made possible by her awareness of the practical use which the Impressionists made of the scientific theories and knowledge of their time: they learned that shadows were complementary in colour to the light source; a warm yellowish-orange light will cause there to be bluish-purple colour in the shadows. This can assist the student in the use of positive colours, based on a logical scheme, over the whole picture surface without need to resort to safe but dully muddy neutrals. When allied to a Cézannesque approach in which each brushstroke derives from precise and rigorous observation, it becomes doubly possible to maintain clarity and freshness throughout the painting.

Another of Cézanne's maxims was that when colour is at its richest, form is at its fullest. It was the truth of this statement that came home to Anne-Marie through the still-life painting with the loaf as opposed to her earlier struggles with the onions:

> With the onions you were trying to make them look round, or to get depth in the painting, whereas with the still-life that became less important. I think the priorities changed; it all worked because of looking at the colour first and the tonality. What was most prominent in my mind was just the relationships between the colours on the flat surface.

Plate 22 *A home-based grouping similarly enabled David to combine still-life and figure. This detail demonstrates how skilfully he used pastel on black sugar paper to convey the surface qualities and textures of the objects rendered.*

Plate 23 *A studio-based pose within a carefully arranged environment also provided Anthony with the opportunity to paint a complex still-life arrangement, as this unfinished gouache detail illustrates.*

Plate 24 *The pointillist dots and crisply applied dabs of oil paint in this area from a larger painting enabled Nikki to produce a sparkling still-life detail within the canvas.*

Cézanne similarly observed that, 'While one paints, one draws; the more the colour harmonizes, the more precise becomes the drawing', and Anne-Marie recalls with regard to her still-life,

> It was a really good discipline because you had to sit there and look at it and translate it. I'd never done that before, I'd never been forced to do it with paint. It was like linking drawing and painting and I feel that was a really important marker I was drawing with paint. I'd always found painting a problem. I'd always been told I was good at drawing and I loved drawing, but when it came to painting I always felt that I failed. So to actually draw with paint, that made quite a lot of sense The onions only served to confuse me, but doing that served to make everything more clear.

Cézanne did a great deal to make still life into an art form considered worthy of practice for its own sake. Anne-Marie's main pre-occupation is with the figure though, and much as she enjoyed producing this painting, still-life did not become important to her as something in its own right. Nevertheless, that particular painting with all its learning experiences has provided a basis for much of her work in other areas:

> I felt somehow freed. I felt really liberated that I could use paint and I felt that I'd really achieved something properly. I knew why it had worked, I understood why; it wasn't a fluke After that I didn't go on and paint in the same way, but in terms of composing, working out colour schemes, making decisions, accumulating information, it was really important . . . It was like a means to an end and a way of breaking down all the things that were being thrown at us. Nobody was doing it for me but the advice to look, mix and apply was helpful to me. I started to enjoy applying the paint, and that helped me when I was painting the figure or fabrics or whatever. After that I really enjoyed just putting the paint on, leaving it and not rubbing it in.

POINTS REGARDING STILL-LIFE PAINTING

1 Suitable areas for setting up still-life groups can be found even in the busiest studio. Take care over the grouping and its background, so as to be able to achieve unity in the resulting work.

2 There should be clear intentions behind every arrangement, with specific problems posed, or qualities established, in relation to colour, tone and composition.

3 A wide range of objects, including ordinary everyday ones, can be used in groups. Study Chardin and Cézanne, whose works offer exemplary models, in this respect.

4 Still-life can enable you to reconcile drawing with painting and to develop painting skills through the process of mixing, and applying, colour and tone in relation to what you can directly observe.

5 Because still-life groups can remain reasonably the same, you can constantly refer back and modify your work acordingly. This makes it an ideal process for developing confidence and overcoming hesitancy.

6 Choose your viewpoint carefully and try to visualise it as a composition on your paper or canvas before actually starting. Draw out in a neutral or recessive colour and then attempt to build up the painting in pairs of comparative brushstrokes based on observation.

7 Colour and tone in a painting are only equivalents of those in nature. It is the consistency with which you use them that determines how successful or otherwise the painting will be.

8 You might build up your painting by distributing each colour and tone over the whole work wherever they occur or, conversely, you may prefer to build one area up more fully and then use it as the key to the whole painting.

9 Still-life's potential for developing compositional skills, ordering colour and tone, rendering form, making considered decisions, and accumulating information will prove of value in virtually every other area of your art and design studies.

SECTION 3

OBJECTIVE WORK: the study of natural form

The human figure is what interests me most deeply, but I have found principles of form and rhythm from the study of natural objects such as pebbles, rocks, bones, trees, plants, etc. Pebbles and rocks show nature's way of working stone. Smooth sea-worn pebbles show the wearing away, rubbed treatment of stones and principles of asymmetry Bones have marvellous structural strength and hard tenseness of form, subtle transition of one shape into the next and great variety in section Shells show nature's hard but hollow form (metal structure) and have a wonderful completeness of single shape.

Henry Moore

The importance which Moore attaches to the study of the human form has already been highlighted. In addition, though, his studio always contained a range of natural objects which had the advantage of being readily available at all times. Individual students can similarly acquire their own personal collections for constant use in their homes. Contrary to the popular notion that artists mess around doing nothing whilst waiting for inspiration to arrive, art is in reality a demanding and exacting discipline and Moore made regular use of his natural objects as a means of inducing ideas and work,

> . . . by starting in the far little studio with looking at a box of pebbles. Sometimes I may scribble some doodles . . . in a notebook; within my mind they may be a reclining figure, or perhaps a particular subject. Then with those pebbles, or the sketches in the notebook, I sit down and something begins

He did more than just sit and observe these objects, though, he held them in the palm of his hand in order to fully experience their

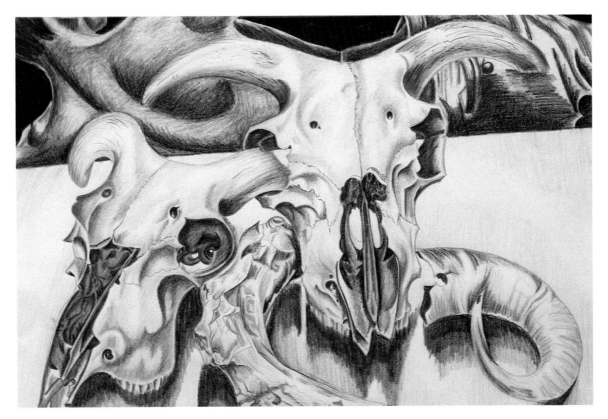

Plate 25 *Through her skull studies, Viv discovered something of the truth of Moore's assertions about the qualities of bones such as structural strength, tenseness of form, variety in section and subtle transition of one shape into the next. (Graphite and pastel pencils on white cartridge.)*

qualities of form, structure and texture; the sense of touch can play as important a part in understanding these qualities as can that of sight. If it is important to sit at a distance from the figure one of the special characteristics of natural forms is that they encourage this close contact and exacting scrutiny and examination. Kathleen's bark studies reveal the importance of this close exploration of surface qualities relating to both their appearance and their feel:

> A study from the bark but this time using tissue paper and watercolour. Layering it on with watery paint, screwing the tissue, tearing, rolling and pushing bumps and holes into it. Finding all the crannies and craters, the lumps and jagged edges and the formation of the bark, I tried to capture the feel of the bark with this mush of tissue painted over and over. When dried it actually has the same feel as my actual piece of bark.

One study of bark led, in turn, to a whole series, each piece having its own characteristics but all related by similar recurrent concerns.

. . . The emphasis, I suppose, is on colour and texture, and on capturing whatever you see in the object in front of you. The different ways of doing this, colour schemes and the different results are endless, and each seems unique in its appearance.

Kathleen is studying the object with scrutiny and care, but is also using the nature and properties of her chosen media to recreate, rather than simply represent in a conventional manner, the bark in front of her. Another student, Kathryn, similarly uses paint in an expressive way so as to find equivalents to textures she is discovering in the bark:

> I have done painting previously but not something like this, (drawing part of the sketch and enlarging it and emphasising the colour depending on the light and dark regions of the wood). The subject matter is also new to me (rough textures). The work done in art history influenced me (Impressionism). The painting of the wood was slightly simplified and the colours were emphasised. The paint was applied very thickly to try and add to the texture of the wood, to try and show the bark was rough. The painting seemed to improve as more of it was done. It was difficult at first to try and blend the colours but I soon overcame this problem.

In her attempts to find textural equivalents through the potential of media, Debbie goes even further along these lines, utilising a whole range of materials and processes in her attempts to recreate those qualities which she discerns in her subject matter.

> The work on Bark (TREE BARK) was going on at the same time as the weaving at home. I worked out a type of system whereby I did a pencil drawing of a piece of the bark, did the same again working in direct colour, then extended the texture, shape, colour and design into wool, inks, threads, lace, material and crochet. It became apparent that from one or two tonal drawings so much work can result . . . the effects of the texture in the drawing would be great in machine embroidery so I used silk and threads on the dyed silk material and embroidered around the shapes and designs – the effects were quite impressive. I think the pieces needed to be made small in order to capture the many effects.

The scale of the work is important. In analysing and responding to the natural form, the size of the study to be made is one of the major considerations: some ideas need to be small and intimate, others large and broad in their treatment. Just as Debbie senses the need to work small, so Vicki's idea requires scale:

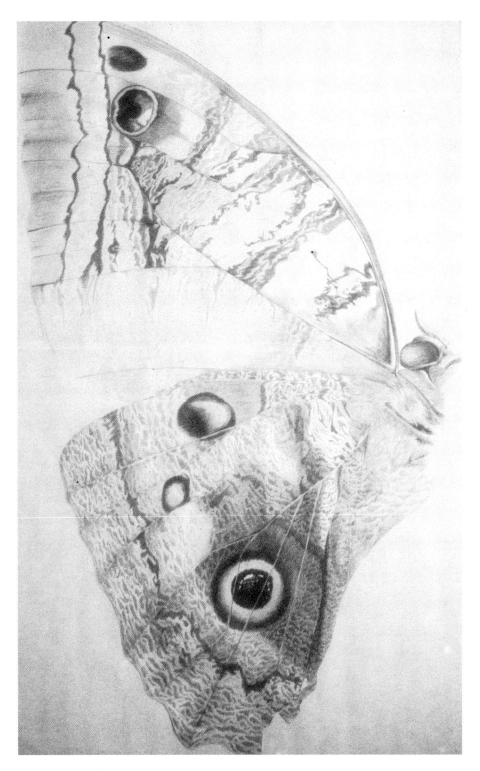

Plate 26 *Alison's use of the hand-lens enabled her to explore and record the most minute surface patterns and markings on a butterfly's wings. (Caran D'Ache pencils on white cartridge.)*

This piece was produced on A1-size paper. It shows a section of wood on a large scale. Each part of the wood had to be carefully studied in order to achieve the right texture. A magnifying glass had to be used in some areas.

Nicola made similar use of the hand lens in order to explore the nuances of texture, form and shape more fully. The beauty of the hand lens is that it can reveal another world within the normal world to which we are accustomed:

> ... the idea was to work on a small intricate drawing of wood so that it did not resemble the original subject at all. This involved very careful observation and a 'Blow-up' of a very small area. It was quite difficult to see the area in which you were working and magnifying glasses and hand lenses had to be used to increase visibility.

It 'did not resemble the original subject at all' because the subject was taken from 'within' the object, rather than the more conventional approach of drawing the outline first being adopted; as Caroline writes, ' ... but this is a little different as this was a close observation starting from the middle outwards, normally we would draw the whole object. I think I have improved in my looking and observation.'

Kathleen takes this process a stage further by producing a whole series of drawings made by studying plant cells on slides through the microscope, which has opened up a whole fascinating new world to artists, minute in scale on the one hand but suggesting forms and structures which also exist in nature on a vast scale. Robert Hughes evocatively captures this duality in writing about Paul Klee:

> At one end, the moon and mountains, the stand of jagged dark pines, the flat mirroring seas laid bare in a mosaic of washes; at the other, a swarm of little graphic inventions, crystalline or squirming, that could only have been made in the age of high-resolution microscopy and close-up photography. There was a clear link between some of Klee's plant motifs and the image of plankton, diatoms, seeds, and micro-organisms.

Plate 27 *Kathleen's bark study is top right in the art-room display of student work with the colour, patterns and textures picked up in the plates of the magazines, which are also a feature of the display.*

Plate 28 *A detail of the bark study, indicating its qualities of textural relief which led to Kathleen observing how, once dry, it had a similar feel to that of the actual bark. (Mixed-media: P.V.A., dyes, pastel, hand-made paper and pulp, paint.)*

27

28

It is sometimes suggested that an emphasis on objective work can stultify the imagination, but approached in the right frame of mind and spirit it can clearly act as a trigger for the imagination. The student drawing from the inside outwards can discover the same kinds of ambiguities which characterise these works by Klee. Jayne, for example, focuses on an area of her wood study which 'looks rather similar to a human eye which hopefully can be developed ... bringing further interest to the painting'. In order to fully exploit the potential of the initial drawing:

> I decided to do a photocopy of the piece and transfer that onto a clear sheet in order to use it with an overhead projector and therefore enlarge the drawing to whatever size I required. Once the overhead was set up and I'd chosen a particular part of the drawing to study at close range, I furthered the idea by faintly going over the reflection on the A2 sized paper. Various watercolours were tried until a series of colours were chosen which I felt were appropriate for the source from which my painting is taken.

In addition to the 'Warm and glowing' colour range chosen, Jayne further elaborates her study through the use of Caran D'Ache pencils. The metamorphosis of one object into another is also the motivation behind Robert's wood study:

> The drawing is of a piece of wood with many plant root nobbles protruding from it. The subject matter was chosen because of the way the wood grain patterns resembled flowing water when drawn which is my goal The approach to drawing the subject matter is new because I used a magnifying glass to draw the intricate detail of the grains of wood.

These parallels in characteristics of one object and another are time honoured in that Leonardo explored those qualities which related, for example, flowing water to hair. He advised that we:

> ... Look at walls splashed with a number of stains, or stones of various mixed colours. If you have to invent some scene, you can see there resemblances to a number of landscapes, adorned with mountains, rivers, rocks, trees, great plains, valleys and hills, in various ways Do not despise my opinion, when I remind you that it should not be hard for you to stop sometimes and look into the stains of walls, or ashes of a fire, or clouds, or mud or like places, in which, if you consider them well, you may find really marvellous ideas.

Max Ernst, having initially set out to 'interrogate' the floorboards of his hotel room one rainy day by making a rubbing of them, extended

29

Plate 29 *Two separate bark studies in pencil gave rise to this oil painting by Michael, one as the basis for the root and bark structure and the other to convey the feeling of flowing water. (Oil paint on buff-stained canvas.)*

Plate 30 *The notches and nobbles on a small piece of wood began to suggest to Eddie a Surrealist-type profile head which, in turn, led to an interest in Arcimboldi, the painter of fantastic heads. (Gouache on cartridge.) To the left is Eddie's composite etching combining straightforward and reverse printing methods with added hand-illumination.*

30

this 'frottage', or rubbing, technique to frayed cloth, leaves, cotton threads, and,

> . . . before his eyes these produced 'human heads, animals, battles that finish with a kiss'. 'I insist on the fact', he affirms, 'that the drawings obtained in this way lose more and more, through a series of suggestions and transmutations . . . the character of the original material and acquire the aspect of images of an unbelievable precision'

To Ernst, 'ideas and inventions in technique were cross stimulants', and the student, too, can experiment in this way supported by the firm base of objective study. Sam is one who imaginatively fuses the two:

> I took a piece of wood and on the back of it there were some lines where woodworm had gone through. I liked this pattern so I took a rubbing of it. Next I then made a sketch from it from which I was going to make an embroidery. I then did a colour study from this which led to a small embroidery. In the embroidery I used a new idea by putting some silver under the material then sewing the pattern and cutting away the top material. I thought I could use this idea later on.
>
> I bought a punnet of cress because I thought the pattern they made was interesting, for a textile study. I made a quick sketch from this, drawing the separate strands closely. I then took a piece of paper I had made and placed it on top of some silver (idea from embroidery). I drew on the pattern of the cress and cut away the excess. Then worked on top of it with pastel.
>
> From this I thought that maybe it would work if I used silk instead of the paper. It did, so I decided that this would look great on a coat. I designed the coat and thought that the cress pattern could be used on the two pockets and on a collar . . .
> This coat took me a very long time but it was quite satisfying in the end when it was displayed on the hanger.

In the light of Ernst's statement, it is worth recording this working sequence of Sam's; it leads her by an extremely complex route from a frottage study made from a piece of wood to a beautifully conceived and executed coat. There are too many occasions when art-room experimentation becomes an end in itself with no possible outcome, but this is an excellent example of experimentation with a purpose.

Though the student does not see the plant or related types of natural forms actually move in the sense that the posed figure will move, these too can nevertheless embody profound feelings of life; they are, indeed, alive and the student can give expression to this

through attention to surface detail and texture, and through a concern for the underlying structure. Growth patterns and intervals in many natural objects conform closely to the Golden Section,

> that ideal proportion which is obtained by dividing a line in such a way that the shorter part is to the larger part as the larger part is to the whole.

'Ideal' in that human beings have consistently found the Golden Section to be the most pleasing and satisfying of proportions. It is to be found as a fundamental element in the design of many great works of art and architecture throughout the centuries in many countries and cultures. By devoting time to drawing plants and other natural objects, the student can study such principles of form and structure allied to surface detail, pattern and texture. A student drawing a variegated leaf plant, for example, can become absorbed in the surface pattern of the leaf with its relationships to the veins. These, in turn, lead back to the leaf springing from the stem and then to the intervals which relate one leaf to another and to the overall pattern and shapes of the plant as a whole, inevitably involving a consideration of the negative shapes—the shapes formed by the spaces between 'objects' such as leaves and stems. This involvement in the detailed in relation to the whole is reflected in Mark's approach to his drawing:

> Cabbage – quite an alluring vegetable to draw. I drew it A2 size, and although it is not quite finished I am pleased with the way it is going. I have observed it as honestly as I can even though it has had to develop from several fresh cabbages. I drew mainly with HB/B pencils and made an effort to tonally sculpt it recording the actual shades and nuances within my perception of the growth. The shadow is drawn with a 6B pencil to enhance the feeling of depth. The shadow I cut abruptly making a stark contrast to the subtle shading of the wooden table top. I plan on drawing quite a few more cabbages each as drawings in their own right viewed from different angles and undertaken in various media: It shall be my 'tribute to the cabbage' incorporating all its essential intricacies.

Michael, too, created a fine balance between detail and whole in an extraordinary study which he made of an irregularly shaped lump of wood:

> Because my artistic instincts have usually led me to the detailed drawing of natural forms, it is perhaps amusing that at first sight the picture appears abstract. In fact it depicts a magnified lump of dead wood

31

32

33

34

Plates 31, 32 & 33 *Starting with a series of microscope studies of plant cells, Kathleen developed them into a series of machine-embroidered panels, each designed as a decorative section of a nightdress. All the stages involved in the process are made apparent in the design sheets which she produced.*

Plate 34 *In this development from a small fossil study, Sam produced a rich effect by working in mixed-media on textiles, the bold use of colour and shape also reflecting her interest in the work of Kandinsky. (Batik, inks, hand and machine embroidery on fabric.)*

Plate 35 *Sam wearing the coat she designed and made, the patterned silver pockets and collar derived from the studies she made of a punnet of cress. The design skills she developed meant that she was able to make most of her own clothes and she is now studying Fashion and Textiles in higher education. (Procion dye, machine embroidery on silver lamé and cotton.)*

Plate 36 *A small but richly textured colourful machine-embroidered cross-section of a sprout by Debbie. (Sequins, padded cotton, dyes, silks, hand and machine embroidery.)*

35

36

He feels that 'it is fair to say that, at the time, I myself would not have seen the wood as interesting'. As he became involved in the drawing, however, his attitude changed completely:

> Having commenced recording the detail of the subject I was motivated to complete the picture by obsession. Completion did however take some weeks' time. I was never really aware of any need to maintain a particular standard of drawing. In retrospect it seems that the obsession produced a discipline.

Though the drawing seemed abstract in appearance to Michael and though it was, in reality, based on an intensive scrutiny of the wood's surface textures seen through the hand lens he nevertheless managed to incorporate his name into the textural fabric of the study. Imposing something of his own invention onto this seemingly objective study makes a final interesting variation on all those drawings where the students have 'seen' something within the pattern of the object.

> It may be of interest that I have signed the picture in the manner of some old Dutch and Flemish masters. My signature is contained in the minutiae and thus forms a tiny part of the whole work.

As with the figure and still-life, the study of natural form has its particular rigours and benefits, and, just as the student can use the figure and still-life as the main mode of expression, so natural form provides students like Michael with a fully involving area of study in its own right. The sensitivities and awarenesses which it develops can make it, too, a marvellous basis for use in other fields of artistic and visual enquiry, as the architect Corbusier amply illustrates:

> I'm an architect. I work with planes, sections and cross-sections. A sawn-off bone . . . gives you two cross-sections; when it's like this you get the front, the elevation or the volume. And a bone is a wonderful thing, made to resist jumps, punches, kicks – anything you like – and to support dynamic exertions. Each particle of bone is delicate, extremely delicate, and a cross-section shows you all that. And if you look at your piece of bone and you think about it, you realise that there is still a lot more you can learn from it. When you are building with concrete, a sawn-off bone is an eye-opener.
>
> I have a soft spot for shells, because the shell is a wonderful form that has impressed me ever since being a child. There is nothing more beautiful than a shell; it is pure harmony, it is the law of harmony. The concept is simple, singular. Its development is either the sunburst or the spiral, inside and outside – it is quite amazing.

Plate 37 *Michael's pencil drasing of a lump of wood which motivated him to the point where he completed it 'by obsession', even though this involved several weeks of intense application.*

These objects are the things you find everywhere. The most important thing is to notice them, to observe them, to recognise them and see that they are wonderful, because for the most part they express and contain the laws of nature, and it is a fine education. It's the real education that I've always sought. The only education that I've had is looking at nature, studying it – and accepting what it teaches.

At the present time there is a danger at all levels of education of a damaging split separating Fine Art from Design. The time-honoured activities of studying the figure, still-life and natural form are an aid to understanding the underlying forms, structures, proportions and growth-systems of nature. They thus provide the student with an opportunity to grapple with issues fundamental to design principles as well as to personal expression.

Another activity more often associated with fine art is that of sketching, but this again should be an essential aspect of any prospective designer's training. Artists and designers as diverse in their work as Moore and Corbusier have made extensive use of the sketchbook. For the A–level student it is a means of researching and investigating, of recording a more private and personal world and of gathering data for other purposes. Many of the skills it requires emanate from having studied the figure, still-life and natural form.

POINTS REGARDING THE STUDY OF NATURAL FORM

1 Many of the issues dealt with in the previous two sections are also appropriate to the study of natural forms.

2 Natural forms provide the most readily available source of objective study material. It is possible, both at an individual and group level, to build up an ever-increasing supply of objects worthy of study.

3 Natural forms can provide a constant means of triggering ideas. In addition to their potential for close scrutiny, they can be handled freely enabling them to be fully experienced.

4 Their surface qualities and textures can encourage experimental work in a variety of media leading to transpositions of scale, the building up of surfaces, etc.

5 The use of hand lens and microscope can reveal a world within a world and new ways of working which are in contrast to the convention of starting with an outline and then filling in, with the object always being recognisable as such. In the process, connections can be made between the observed and imagined.

6 Natural forms, and in particular plants, possess qualities and feelings of life which can both fascinate and make great demands on the student.

7 Many natural forms enable the student to begin with the study of surface patterns and textures, but then to work through many layers of experiences to underlying structures and principles of nature.

8 There are important design principles in the study of natural form which result from relationships between, for example, shell and bone forms and structures in relation to building and sculptural needs.

SECTION 4

PERSONALISED USE OF THE SKETCHBOOK

T he sound of water escaping from mill dams, willows, old rotten planks, slimy posts and brick-work – I love such things. These things made me a painter, and I am grateful.

John Constable.

Constable was born in 1776 in that area of East Anglia where the meandering River Stour determines the borders between Suffolk and Essex. Even after he had moved to London to officially establish himself as an artist he returned to the Stour Valley whenever he could, producing countless sketches and studies of the area where he had grown up and which he loved with an intimate knowledge. During the years 1813 and 1814 he carried two minute sketchbooks around with him which contain the seeds of most of his mature paintings, sometimes with the whole idea there to be barely altered in the paintings of ten and twenty years later. A small area of East Anglia, now known as 'Constable Country', was to provide the artist with a lifetime's subject matter and inspiration.

The previous section has demonstrated that many aspects of drawing can, in fact, be taught contrary to the deeply ingrained belief that drawing is a gift of birth bestowed on the precious few. In the final analysis, though, it is the way in which these skills are harnessed and used which is the issue. The theme of this section is therefore the use of the sketchbook. Even with the advent of G.C.S.E. it is still possible for some students to reach the sixth form without ever having kept a sketchbook and in these circumstances the requirement to sketch on a regular basis can come as a shock. Nevertheless, the sketchbook is of the utmost importance, providing a potent means of identifying and exploring subjects and themes which are of personal significance to the student. It can have the liberating effect of enabling the student to become acutely conscious

of aspects of the world previously ignored and considered unworthy of study.

The extraordinary use which Constable made of his immediate locality is in marked contrast to the idea that sketchbooks are primarily for holiday use to record attractive harbours with pleasure craft, awe-inspiring mountain landscapes and spectacular sunsets reflected in gently rippling water. It is all too easy to fall into this trap, as Constable did himself when, as a young man, he made an expedition to the Lake District because of the association of picturesque beauty with mountains. He felt uneasy there and his work, in the main, lacked conviction. Though unspectacularly flat and ordinary – even mundane – by comparison, his own Stour Valley, known to him in intimate detail, was what enabled Constable to make such a significant mark on British painting. It is doubtful whether this would have been the case had he spent his life producing art to conform with other people's notions as to what was appropriate. In the event he opened our eyes to the inherent qualities of his locality which many now see as 'beautiful'.

Those two sketchbooks of 1813–14 are as small as 11½ x 8½ cm yet when opened at some double pages they contain as many as six fully resolved drawings. A sketchbook of this size can obviously fit into pocket or bag to be available at all times, making it possible for the owner to record any unexpected but visually worthwhile moment. It can be an aid to training the powers of observation and the visual memory in such a way that no day should pass without some observation having become part of the student's storehouse of visual material for future use as appropriate. Some students keep a number of sketchbooks on the go at any one time, ranging from the pocket sized to larger ones for more planned and considered usage.

Like Constable, Degas felt the need to make constant pictorial use of the place he knew best, in his case, Paris. His love of Italy and in particular Assisi was so great that he was tempted to settle there, but in an 1858 notebook he wrote, 'I am thinking of France which is not so beautiful, but the love of my own place and of work in a little corner triumphs over the desire to enjoy all that is beautiful in nature.' He had a well-developed, almost photographic, visual memory but a jotted note made in 1879 gives a glimpse into his attempts to organise some of his Parisian interests. He was intending to utilise these ideas in a journal to be called *Le Jour et la Nuit*.

> For the journal. Cut much. Of a dancer, do either the arms or the legs or the loins. Do the shoes, the hands of a hairdresser, piled up headdress, bare feet in the act of dancing, etc. etc.
> Do all kinds of objects in use, placed, associated in such a way that they take on the life of the man or woman, corsets that

Plate 38 *Two pages from Constable's sketchbooks; one (left) from 1814, the other from 1813*

have just been taken off, for example, and which still retain as it were, the shape of the body, etc. etc.

Series on instruments and instrumentalists, their shapes, the twisting of a violinist's hands and arms and neck, for example. The swelling and hollowing cheeks of a basoonist, an oboist, etc.

Do in aquatint a series on mourning (different blacks), black veils of heavy mourning floating over the face, black gloves, carriages in mourning, equipment of the Company of Funeral Undertakers, carriages like Venetian gondolas.

On smoke. Smoke of people smoking pipes, cigarettes, cigars, the smoke of trains, of high chimneys, of factories, of steamboats, etc. The crushing of smoke under bridges. Steam.

On evening. Infinite subjects. In the cafes, the different values of lamps reflected in the mirrors.

On bakeries. Bread. Series on loaves, seen in the cellar even, or through the air-shafts of the street. Colour of pink flour – beautiful curves of pies. Still life of different loaves,

long, oval, fluted, round, etc. Essays in colour on the yellows, pinks, greys, whites of loaves. Perspective of piles of loaves, delightful distributions of bakeries. Cakes, wheat, mills, flour, sacks, strong men in the market.

The projects were never realised but some of the ideas surfaced, at least in part, in other aspects of Degas' output with evening effects in cafe and concert scenes. Ten years earlier he had already combined two themes: in *The Orchestra of the Opera*, there is his basoonist friend Dihau in the foreground with 'hollowing cheeks' and the top of the canvas cuts off the upper half of the on-stage dancers focussing attention on ballet skirts and legs. No mourning figures, though, or treatments of smoke or steam apart from the occasional distant factory chimney in a racecourse scene, and no bakeries with bread still-lifes. Knowing, though, how he approached themes like the ballet, the milliners and laundresses, it is possible to envisage how he might have approached that of the bakery. Look first at his treatment of his major themes and then consider how he might have approached the still-lifes of 'different loaves, long, oval, fluted, round etc.', and how he might have related these foreground groupings to the shop environment with its assistants and customers.

Degas was always aware of the taut relationships between component elements and the picture edge. How might he have exploited this in a series on bakeries? Choose a local baker's shop or bakery market stall and select a number of key compositional views by looking through a rectangular viewer cut out of card. Having chosen two or three interesting viewpoints take each in turn and observe how the relationships between the various elements change as a result of the slightest movement of the head in any direction. Identify which of these adjustments provides you with the most taut composition and in which you begin to sense unifying rhythmic relationships, repetitions of shape and so on, linking the component elements together.

As a sixth-form student, Mark had a part-time job in a bakery and he made numerous sketchbook drawings in which he exploited the effects of the perspectives of shelves and trays of loaves of varying shapes and sizes, the predominant feature of his sketches being their unusual still-life quality.

In studying the work of artists like Constable and Degas, we can begin to see the world around us more acutely and clearly. By studying how Degas approached his chosen themes from so many different standpoints we can begin to envisage the potential in those themes which he had obviously considered but not tackled. In turn we can begin to identify the subjects and themes which most appeal to and challenge us and which are familiar to us in our daily lives.

Most of us are surrounded by material which passes unnoticed but which, once recognised, can be as liberating to us as those mill dams, willows, old rotten planks, slimy posts and brick-work were to Constable. Over a period of two or three weeks, therefore, jot down – as did Degas – half a dozen themes of your own from your immediate world and surroundings. Identify the essential pictorial qualities which could enable you to explore each in turn from various standpoints without fear of repetition.

But why so much emphasis on the sketchbook in this age of easy-to-use cameras? Don't many established artists make use of photographic material anyway? Some have, and do, make extensive use of the camera. As early as 1872 Degas was experimenting with the camera and many of his compositional devices derive from qualities revealed by photographic images. Nowadays many students own or have ready access to a camera and make use of it, but there is a world of difference between becoming dependent upon the camera and using photographic material in support of the sketchbook and as an adjunct to it.

The painter Brendan Neiland uses the camera as the basis for his acrylic paintings of the architectural reflective glass facades of the modern cityscape. However as a lecturer who in his own work 'uses photographs all the time nowadays', he discourages his B.A. Honours-level students from using the camera.

> I don't like to encourage people to work from photographs
> I drew and observed for years and years and I think it's so
> important to just have a look My own feeling is that as
> much drawing and colour observation work should be done as
> possible In the case of the students it's so important for
> them to be able to walk round a model, for instance, or in a
> landscape to walk. They might be drawing from one point, but
> actually go round a gate, the hedge, the tree, the model, the
> building and see what it looks like – and to smell, to touch! I
> mean I wear my eyes out looking and experiencing.

Neiland here makes reference to the use of three senses: SIGHT, SMELL and TOUCH. Constable recognised that a fourth contributed to making him a painter; it was the SOUND of water escaping from mill dams which he recalled. A fundamental aspect of sketching, then, is that of actually being there and experiencing all the senses over a period of time. Even though sight is obviously of paramount importance, sketching is an activity which involves total sensory experience. When referring back to a sketch, therefore, the artist does not simply recall what was seen, but also the loneliness or bustle, the cold or warmth, the stillness or noise of the experience.

The nature of the sketched marks will, at least in part, have been determined by these factors.

In recalling the work she undertook during her Christmas holidays, Karen reveals the levels of discomfort which she was prepared to endure in order to fully experience what she was recording.

> The thing is that I like to be warm and work in a studio, but all the things I respond to best are always outside in the wildest spots! It's true that. I do dislike being freezing cold as my hands go all numb and I can't hold a pencil even, and yet I can't respond to things inside where it is warm. I have to be freezing cold and uncomfortable to sketch properly and draw. I don't know why, but that is the way it is. You see, I have to be uncomfortable before I really pull out all the stops and do something decent, whereas if I am warm and comfy I do something but it has got nothing behind it.

In this respect Karen is following in the footsteps of the artist who first affected her deeply and who recorded nature in all its moods and extremes, Claude Monet. A local journalist described him painting in deep snow at Honfleur during the winter of 1886–67:

> It was in the winter, during several days of snow, when communications were virtually at a standstill. It was cold enough to split stones. We noticed a foot-warmer, then an easel, then a man, swathed in the coats, his hands in gloves, his face half frozen. It was M. Monet, studying a snow effect.

Karen and Monet illustrate the lengths to which some artists will go once they are clear about their sense of purpose. Karen's favourite subject-matter was a disused pit close to where she lived. The tenacity with which she explored this motif was formed partly in response to those Constable 1813–1814 sketchbooks, which she has carefully studied. She feels that she had made the mine her own; it is more than just an interesting subject to her.

> My mine has always been a good place for me to go whether it's just to sketch or just for a walk, or whatever. I always go up there. It's my personal source of inspiration. When I get stuck for an idea I just walk up there. It doesn't need to be anything to do with the mine, it's just the fact that that is where I find my inspiration from. If ever it goes I think I'd be lost. If anyone pulls it down, I don't know what I'd do without it.

It is because of her many drawings of it in the first place, though, that she feels that it has become 'my mine'. She disciplined herself to

the point where she dated every sketch, determining to do one drawing every day during the summer holidays.

> I had been to the mine a few times before that and just done the odd sketching, but I decided that I would go every single day from then on, sketching every day. I've got quite a lot of self-willpower, so I would get up at about 8 o'clock in the morning and go out sketching for a couple of hours, come back and then go out again in the afternoon for another couple of hours and each day I had one drawing. It usually took about four hours to do.

Through the discipline of a drawing a day, Karen was able to make a visual diary which built up into a detailed exploration of the mine from many viewpoints. Rose-bay willow-herb flowers, weeds, crumbling doorways and disused machinery as foreground objects established a sense of scale and were used to dramatic effect as compositional framing devices. Sometimes the colliery railway lines would provide depth as they moved into the picture in perspective. Karen sometimes used watercolour and wash but the majority are executed in pencil. Sometimes subtle nuances of tone are recorded through a variety of marks as the pithead is rendered in detail, but at other times it stands in simple silhouette. Foreground rubble is often drawn in detail as bricks, wooden planks, weeds come into sharp focus but sometimes it is treated in a generalised manner. This variety is in marked contrast to the mechanical use of the pencil with its predictable quality of tone which is the hallmark of all those art-room drawings which are laboriously copied from photographs.

Karen's mine is certainly no 'beautiful' subject in the conventional sense, but in it she found a whole range of pictorial possibilities which led to her art developing in a genuinely personal way. Each painting, print and drawing was of value in its own right, but in total they added up to a powerful and convincing composite picture of the location in the round.

Karen sketched in order to gather information for her paintings and prints, but she equally drew for the sake of drawing, knowing that because of pressures of time only a percentage of her studies could possibly be developed. Nevertheless, in the light of the problems encountered in painting or print, the artist modifies and sharpens the approach to sketching to ensure that the relevant information is contained for possible future developments. Like Karen, Mark also lived near the pits. Of the two collieries near to his home, one was still operational and the other closed – 'gate locked, closed down, sadness, end of an era'. Even while sketching he was already considering how he might develop his ideas in other media.

41

42

Plates 39, 40, 41 & 42 *Because both were thinking compositionally at the sketching stage, the two on-the-spot sketches by Richard and Karen translated naturally into oil paintings. Each was working close to home with subject-matter with which they closely identified.*

The sketches I did over the summer at these two pits were not so much drawings in themselves but a sort of derivation for more suitable media. The pits had always fascinated me from a distance but to get close to one is quite an experience. They are awesome structures, brimming with history, great interlaced monuments reaching into the sky which they pollute. . . . I stated at Bickershaw with very intricate cartridge pen and ink drawings trying to capture the life of the wheel at the very top of the pithead. This is why I have started etching these ideas . . . Astley however seems more suitable to monoprint, less detail and more atmosphere.

Richard, too, was affected by those two small Constable sketchbooks. Inspired by their example, he discovered that similar subject matter existed in abundance within a short walking distance of his home. His sketches are also small in scale, but he manages to encapsulate

Plates 43 & 44 *Mark's intricate cartridge pen drawings of the still operational Bickershaw Pit naturally led to etchings, whereas the atmosphere of Astley—'gates locked, closed down' and marking the sad end of an era—suggested the broad medium of monoprint.*

within them the feeling of the vast expanse of the Lancashire plain, north of Wigan. Their atmospheric quality is determined by his sensitivity to the sky and its light effects for he has absorbed Constable's message that 'the sky is the keynote, the standard of scale and the chief organ of sentiment' in a picture. In some of Richard's studies, slanting shafts of light angle down from behind the clouds to contribute to both atmosphere and the dramatic feeling of scale.

In these drawings, details dissolve in the light and atmosphere but, as he develops his ideas further, the debt to Constable becomes much less apparent. In a series dealing with artificial light, the shafts of light are cast by street lights seen from his window at night. This development is a logical one, and both subject and treatment are now entirely his own. Kathleen's subject matter was gardens, plants and vegetation but in a half-termly appraisal she indicates that she, too, is aware of sky qualities and that Constable has contributed to her understanding. She also gives us insight into ideas which, as yet,

Plate 45 *After seeing the Constable 1813-14 sketchbooks, Richard proceeded to make a whole series of small-scale studies of his own locality, full of atmosphere and passing effects of light, as these four examples illustrate.*

exist only in her mind but which have obvious implications for her future practical work.

This is soon going to be filled with drawings and sketches. At the moment I have a short series of shallow landscape studies. Fields, gardens, sheds, trees, bushes and plant life. I like to look at the landscape around me, but I do find it hard to capture the feel of the skies behind the trees, through the broken wood of a shed wall, between gate posts and fences, with just a lead pencil. When I do sit outside and sketch though I find myself thinking about the Art History, the techniques and approaches of mature artists. With my drawing I intend to begin a small watercolour sketchbook of sky studies. I know Constable did this and that he had a great feel for the sky. I want to do this also. I want to be able to capture the pinky rose glow of evening, the tangerine sort of marmalade streaky effect when the sun sets, the swirling shapely clouds on the watery blues

during the day. It probably sounds unconstructive and poetic but that's what I like to see best in a landscape – how the sky is. So maybe I could begin another theme using skies and build the landscape around that.

Some artists seek to 'match' the colour in the sketchbook with what is observed, others are happy to recall it later believing that in this way they can recapture its essence. A common practice is to jot down colours on the sketch while drawing, but words like 'red', 'blue' or 'purple' are too generalised to be of much use in the studio later. The artist's knowledge of paint names can be of obvious value. Carmine, scarlet, vermilion, crimson, rose madder, magenta and cerise enable the painter to recall nuances of red. Foods can be of equal value for beetroot, radish, tomato, shrimp, lobster, strawberry and cherry equally represent nuances of red.

Kathleen envisages actually sketching with colour, though, and there are many appropriate media available today, such as gouache, poster and acrylic paint, watercolour, Caran D'Ache pencils, oil and water-based pastels and crayons, fibre pens, etc. Some facilitate work of a precise nature, others are appropriate to bolder and more gestural processes, but the students can soon acquire a range relevant to particular aptitudes and needs. During a full day's sketching, with all its unexpected eventualities, the student is likely to produce a combination of monochromatic and colour studies.

'Constable Country' is now seen as representing everything that is typical of the English countryside, but Karen's and Mark's pitheads and Kathleen's gardens are part of the urban environment. Just as Constable changed perceptions as to what was acceptable landscape subject matter, so numerous other artists have opened our eyes to the qualities of the town and cityscape, none more so than L.S. Lowry. Yet he confesses to having lived in Pendlebury, Salford, for seven years and completely ignored it. It was only because he missed a train one day that, on leaving the station, he noted the Acme Spinning Company's Mill:

> The huge black framework of rows of yellow-lit windows stood up against the sad, damp-charged afternoon sky. The mill was turning out hundreds of little pinched black figures, heads bent down, as though to offer the smallest surface to the whirling particles of sodden grit, [who] were hurrying across the asphalt, along the mean streets with the inexplicable derelict gaps in the rows of houses, past the telegraph poles homeward to high tea or pubwards, away from the mill and without a backward glance. I watched this scene – which I'd looked at many times without seeing – with rapture.

Having once seen the place 'with rapture', Lowry was able to produce work after work which epitomised both the place and the period. Most of us look without seeing. List six or seven themes, topics or places which you pass on a regular basis and explore these from a variety of viewpoints to find out whether you have been looking at material full of artistic potential without actually seeing it. Though many of Lowry's paintings incorporate figures, we think of him first and foremost as being a painter of the townscape.

'Landscape', 'townscape', 'cityscape'; the words represent vast areas but individual students can discover a whole fascinating world relevant to personal needs within any of these general categories. Viv, for example, became interested in trees through a photographic project. She then studied the works of Sutherland, Inchbold (a Pre-Raphaelite artist) and Ken Cottam (a local Wigan painter). The project culminated in a huge pastel drawn triptych, each panel being of one tree derived from a powerful sketchbook study. The first such drawing was of a dead tree and Viv records the multi-layered nature of her thoughts which led to her choice of that particular tree:

> At first I chose to draw a dead tree near to where I live. This tree interested me partly due to the relative positions of, and shapes formed by, its branches. I chose a dead tree as the hard edges and sharp angles of the branches would not be softened or interrupted by masses of leaves. My photography influenced me in that I began to represent the smaller branches as fairly flat forms, rendered black by the bright white of the sky. I chose a fairly low eye-level from which to draw the trees throughout the project, in the hope that the immense size of the trees would be obvious from my drawings. The bushes around the tree contrasted quite effectively with the tree itself. The random, curved, rapid movements of the leaves counteract the sharp hard angles and shapes formed by the branches. The huge tree evokes a feeling of security and permanence – despite the fact that it seems to be dead and lifeless, it remains standing and refuses to be defeated by the elements. This contrast also evokes the idea of life versus death.

As the tree dies, it gives way to the bushes below, a higher form of life being replaced by a more primitive one. 'Is this picture optimistic or pessimistic?', she asks.

In this passage Viv reveals that even at the sketching stage she is fully conscious of the formal properties of the tree and the formal problems which it presents her with. She is aware of the technical issues with which she has to deal, and the feelings which she has to encapsulate in her drawing; feelings about life and death, the cycles of nature and of permanence and change. Her tree has to be rendered

Plate 46 *Viv's sketchbook study of a dead tree involved her in a wide range of concerns, from formal ones such as the silhouetting of branches and twigs against the light sky and the rhythms and patterns they form, to thoughts about life versus death.*

with technical assurance in a formally satisfying manner and with all its symbolical significance apparent.

The human figure represents another vast subject area. Henry Moore suggests that it determines 'all our judgements of architecture, of form and everything else'. Surely, if this is true, it should also represent a fundamental area of sketchbook study. For some students the figure is their main motivation and yet many have only restricted opportunities, if any, of studying the figure prior to the sixth-form stage. This was the case with Anne-Marie who, once there, began attending the figure drawing sessions, but it was only on being set a sketching topic of figures in interiors that she discovered that the figure was of special interest to her:

> That was the first time I had even drawn people, you know – apart from drawing the figure in a drawing class. I'd get my mum to pose for me and I always liked Degas and Sickert . . . and when I began to realise that I could draw figures, that I could get women in a similar sort of situation to what Degas painted, then I could make something more about what I wanted to paint.

She had always displayed a natural talent in her work, but it was only now that her work took on a genuine personal meaning that took it beyond mere technical virtuosity. She made particular use of Degas in her study of other artists. She feels that, 'his actions are really tense, I don't think mine are. It was really just opening up what I wanted to paint, sort of "woman in an interior".'

Degas is a constant source of inspiration for students who are attracted to figures in interiors as their major subject matter. The variety of devices he employs to establish a sense of scale and to place the figure successfully within the composition are endless, but Adrian's interest in the sculpture of Henry Moore and his wartime drawings of sleeping figures in the London Underground led him to produce a whole series of monumental studies in a wide variety of media – pencil, conté, pastel and paint – of his sister asleep in bed. The sharply observed and recorded face is usually in marked contrast to the broad sweeping rhythms of the folds in the bedding which Adrian skilfully utilises to give compositional unity and in order to emphasise the sculptural form of the recumbent body beneath the clothes.

As A–level examinations move into line with GCSE and National Criteria, the emphasis should shift towards a greater valuing of coursework and the way in which ideas and concepts are formed and handled. In the recent past, preparatory examination studies were not always taken account of for assessment purposes, even though many students used the two or three-week preparatory period to

Plate 47 *In this pencil and wash sketch, Anthony's choice of the foreground angel on the tombstone set against tree and church came about, in part, because of his study of Spencer's painting,* The Angel, Cookham Churchyard, *in which the composition is built around these same motifs.*

Plate 48 *Ian's love of figure drawing gave him the skill and confidence to attempt elaborate sketchbook compositions using family, friends and himself as models, some appearing more than once within the same study. (Detail.)*

great advantage. Their sketches, researches and investigations were often conducted with great intensity, providing a model worthy of emulation as a fundamental coursework feature in the new contexts which are emerging.

To conclude this section, therefore, we are going to examine in depth how two students went about accumulating this preparatory information and how they were able to successfully relate examination demands to their existing concerns. Both are close friends and they are interested in the pictorial problems involved in depicting the figure in domestic settings. They are Sheila and Nikki, but reference is also made to Anne, a third member of this group.

By A–level time, Sheila's art history knowledge had become extensive and she was fully aware of the compositional means employed by artists who used the figure in interior settings. Degas, Cassatt, Bonnard, Lautrec, Vuillard and Matisse were all particular favourites, but the kinship she felt for the work and ideas of

like-thinking colleagues was equally as significant. Sheila, Anne and Nikki all became close friends through their art and regularly compared and discussed ideas, each taking pleasure from what the others were doing. Sheila liked

> . . . the pattern of Nikki's drawings of the Indian scarves. I think in a way I was influenced by that in my own drawings and by Anne's compositions I was interested in pattern and I'd gone round Carnaby Street on the London visit and I'd seen all these Japanese shops and I bought the umbrella and some material, a diaphanous material. On the next trip to London I bought some Indian scarves, so I had all these materials round me.

Utilising all these 'props', Sheila transformed her bedroom into a studio and total drawing environment where, whatever her original intentions, she invariably finished up by including herself as the model, often cut off by the picture edge à la Degas. In relation to one study she says,

> At first I was going to do just a still-life with a mirror, but there was something missing! So I thought, 'right, I'll put a figure in'. But my sister was too busy, so I thought, 'well, I'll put myself in'. I was going to do it clothed, totally, then it was, 'I need something to contrast against the material', so I put some bare flesh in.

Sheila invariably finished up depicting herself semi-nude, so much so that for a joke her young brother put up a notice outside her door which read, 'Do not come in – Streakers Anonymous'!

The drawing referred to was a preliminary study for the examination topic 'Flowing Forms'. Sheila simply adapted the set topic to enable her to continue working on the interests which she already had, the studies being developed as much for their own sake as for examination purposes. Consequently she willingly devoted considerable time to them:

> I started drawing on a Saturday at 9 o'clock in the morning, and if I got cramp I'd take a break, and I'd be drawing until 10 o'clock at night. After the Easter holidays I had to continue drawing in the evening time. For the two weeks before we had to start painting, I was drawing all night. I would draw after my tea from about six until half-nine or ten – well, one night it went to about twelve. My little brother called me a little hermit because he didn't see me much and my dad he used to leave a drink and a sandwich outside my door. Everybody knew not to disturb me when I was drawing.

Plate 49 *One of an extensive series by Adrian of his sister asleep in bed, reflecting his interest in Moore's work, in particular the London Underground wartime Shelter studies. Adrian employs a wide variety of media according to his concerns, this study being in oil pastel on coloured paper.*

She sat two A–level examinations in Art and Design, devoting the same time and effort to the second one, and her chosen topic 'Dressmaking', which she again interpreted in such a way as to allow her to use it as a natural extension of the thematic work in which she was already involved:

> At first I chose that subject because it would involve bringing in patterned materials and shapes. Then I thought, 'I need a sewing machine' and I was wanting one of those mannequin dummies from tailors.

There was such a dummy at the local art achool, but 'that was out' because she would have had to go there to draw, but her mother had spoken to a neighbour on her behalf.

50

51

52

All students have an ever-present and readily available model in themselves. The self-portrait is also an invaluable means of enabling them to come to terms with their own appearance and unique personal identity through the searching scrutiny demanded by this task.

Plate 50 *Mark's interest in distortion led him to study his face partly seen through a drinking glass, the whole composition observed in the reflection in a bowl of water, rather than in a mirror.*

Plate 51 *In another self-portrait study, Mark's unusual choice of angle helps to imbue the drawing with a strange psychological atmosphere.*

Plate 52 *Kathryn achieved unusual multiple magnification and a feeling of intensity by looking at her face in exacting detail through a magnifying shaving mirror further magnified by being seen through the hand lens. (Detail.)*

53

55

54

Plate 53 *Kathryn (not the student mentioned in* **Plate 52***) was far too shy to look into the camera lens, yet she scrutinised herself with painstaking honesty in order to produce a self-portrait of extraordinary intensity.*

Plate 54 *Her painting retains the same intensity and, in addition to the use of watercolour, makes use of mixed-media such as dried flowers and hand-made paper, enabling her to build up selected areas in relief.*

Plate 55 *Studying herself by candlelight enabled Ruth to produce a self-portrait with a strong feeling of chiaroscuro. She also delighted in recording the various colours of her distinctive punk hairstyle by tinting the pencil drawing with additional coloured pencil highlights.*

I had been actually knocking on all the doors trying to find one of the old-type sewing machines that you operate by hand. This man said he saw his friend bringing one for his wife from the junk shop, so I asked him where he lived and I went down and they were obliging enough to give us one.

I was going to have the tailor's dummy in the background and have all the materials. Originally I wasn't thinking of a sewing machine; I was going to have my sister stood beside the tailor's dummy and arranging materials around it, and then I thought it was too much to ask my sister to stand for so long, because it takes me ages to do a drawing . . . and, as always, I ended up myself in the picture.

There's something which suggested action in the subject of dressmaking, so I just interpreted that as having to have the figure in some action. If I just put some materials in it would be like a dressmaking room, it wouldn't be actually dressmaking. So again I put the figure in and arranged all the still-life around What did take ages to do was the diaphanous material draping from the sewing machine onto my figure. The reflection I restricted to a silhouette, but the materials all hanging down and the carpet was a bit complicated.

Nikki also chose 'Dressmaking', and she provides an equally graphic account of how she produced her studies for this same topic. For the purpose of extra clarity, some of the questions from this recorded conversation have been included, marked 'Q'.

I didn't set out the composition as it was going to be. I didn't have a picture in my mind as to how it was going to be exactly. I started off – my friend's grandma gave her an old-fashioned sewing machine and I thought, 'right, I really want that in my picture', so I decided that I was going to have a sort of detailed view of the actual sewing part of the sewing machine. I wanted that in the foreground Then I just thought of having lots of material in the foreground. It just built up from there – and then the figure, I wanted half a figure in my picture with a richly patterned dress.

Plates 56, 57, 58 & 59 *The 'Dressmaking' drawings of Nikki (top left) and Sheila (top right) illustrate the exacting lengths both were prepared to go to in order to create personalised sketching environments in their own homes and how both were already thinking compositionally at the sketching stage. Sheila's sustained exploitation of her chosen theme, always using herself as the model, is further demonstrated by her 'Flowing Forms' study (bottom left), and yet another complex variation for use in her A–level drypoint etching (bottom right).*

56

57

58

59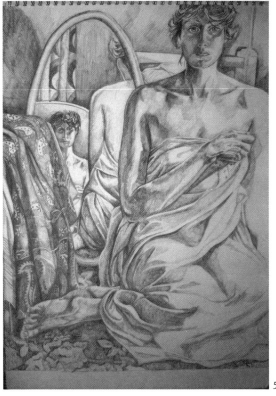

Plates 60 & 61 *With the aid of the photocopier, Anthony was able to produce a collage design, elaborating on his original sketch of his father, in preparation for a woodcut. His love of German Expressionist print-making, with its gestural block cutting qualities, had made the woodcut his favourite medium. (Two colour elimination woodcut.)*

Plate 62 *By comparison, Simon's block cutting technique is more restrained, but his autobiographical print containing the symbols of all his current interests, makes a telling image.*

Q. So you were clear that you wanted half a figure going out of the picture?

Yes, I was clear about the figure and I was clear about the sewing machine.

Q. So you were clear about some very important compositional ideas?

Yes, the shapes of the sewing machine making a pattern. I don't know how it happened, but the underneath curve picks up the upper part of the dress as well, so it's like a mirror image of the two When I looked at it afterwards I thought, 'oh, it fits in!'. I knew I wanted the window in. Originally I was going to have someone behind looking in a mirror and trying on a dress, but then I thought it would look really awkward and so I tried to simplify it. So I used an arched window because that fitted in with the figure, the shoulders and the arch of the sewing machine, and so I had to have that in. And then I wanted to do more material work, so I hung that diaphanous dress in the window to catch the light so I wanted to keep the background fairly simple.

Q. And the patterning on the sleeve?

Oh, I went to town on that!

She also produced two beautiful painted studies of the materials, analysing their colours, patterns and textures and, like Sheila, she also made an elaborate and carefully considered preparatory drawing for 'Flowing Forms'. She spent two days setting up her 'environment' in her bedroom, 'putting things in and pulling things out trying to arrange them'. She says of the study,

I was really proud of that drawing because it took me three weeks to do it and I spent every available minute of my time on it. I was really into that picture. I don't know in hours how long it took me to do it, and I don't want to know – I don't care. I loved every moment I spent on that drawing.

Sheila expresses similar sentiments:

I didn't think of it as an exam. I enjoyed it. It's not as if I'm doing my maths exam, or my theology exam. That is an exam and I'm revising for it. I actually enjoyed doing my drawings. I didn't think of it as an exam, I just got down and did them.

Both became engaged in something which was demanding, arduous and extremely time consuming, but found it so personally rewarding that they did not regret any of the time spent. As Sheila commented,

'I don't think I would have chosen anything else!' Both regarded their art and design examinations as opportunities to produce what would have been their next piece of work anyway, but with the added incentive that these pieces marked the culmination of their course and, it being an examination, were definitely 'for real'. Students with the confidence to approach examinations in this spirit do not appear to fare any worse than their peers who approach them as a task, with the set topics perceived as questions to be answered accurately; indeed they frequently fare a lot better.

One final important observation about these preparatory studies for examination purposes: as their comments make clear, they are thinking very consciously about compositional arrangements at this drawing stage. This is in marked contrast to a frequently encountered approach in which sketching is seen as being synonymous with 'sketchy' vagueness. This can lead students to produce isolated bits of drawing – a figure here, then a tree, a bit of architectural detail, and so on. At the painting stage, the student then attempts to artificially concoct a composition which invariably does not come to life and invariably looks contrived. Nikki, by comparison, is thinking in compositional terms during the two days she spends 'arranging' her environment and at every stage in the drawing. She is clear as to what her aims are during these stages, and there are obvious implications arising out of this for the painting stage. Her main interest is in:

> Inter-relationships of shapes – that's very important for me. Shapes flowing into one another so that you are confined to the picture area, and the way that you draw your shapes leads you into more important aspects of the picture that you want to concentrate on, so that your eye is not carried straight off the page, so that it revolves round the actual piece of paper.

Whether as part of their course work or for examination purposes, all the examples dealt with in this section have one important characteristic in common: they have been done willingly and voluntarily. The students are all prepared to make demands on themselves because they find what they are doing to be personally involving and rewarding, because they feel that their choice of subject matter and the manner in which they are able to interpret it is special to them. They are involved in approaches to art and design which enable them to feel that they are active participants whereas in many other subject areas they are merely passive recipients who are expected to soak up the facts and information which others deem to be important. The sketchbook is central to this process, both by supplying the students with an invaluable body of data for future use in terms of, say, painting or printmaking, and in its own right in

that the student who treats the sketchbook like a visual diary is building up a rich record of a highly personal nature. A section of this book is devoted to 'Individual Developments', and the sketchbook plays an important part in many of these, but so do the student's responses to other artists' works. First, therefore, it is important to look at the whole issue of Critical Studies.

POINTS REGARDING THE USE OF THE SKETCHBOOK

1 Carry a small sketchbook with you at all times to enable you to record the unexpected and interesting, whenever and wherever encountered.

2 Also keep one or two larger sketchbooks for use in more planned ways.

3 Date your sketches to monitor and guage your progress, and as an incentive to working regularly, every day if possible. Treat your sketchbook as a form of visual diary.

4 Sketching involves more than the purely visual. Be fully aware of sounds, smells, temperatures and all of your surroundings. Cultivate all the senses.

5 From time to time set down half a dozen or so themes or topics which interest you and to which you have access. Note down their particular characteristics, compositional potential, etc.

6 Do not be afraid to explore a favourite theme in depth over a period of time, for as long as you are finding new features within it without just repeating yourself.

7 Work on a variety of topics if no theme particularly interests you; challenging subjects are likely to prove more stimulating than 'easy' ones.

8 A rectangular viewer can help in the choice of viewpoint, but take account of angles and low or high levels. Formal ideas such as 'Near and far', 'Seeing through', 'Dark and light', can help you to see compositional possibilities.

9 Do not be afraid to brave the elements, but strike a balance between outdoor and indoor locations during the winter or in inclement weather.

10 Build up a range of sketching materials and media to meet various needs. Train yourself to match media with content and experiment so as to be able to use a wide vocabulary of marks in order to record your observations better.

11 Adapt your sketching approach to the available time, weather or circumstances of light. General compositional features and relationships between forms can be of more value than one or two objects drawn in isolation.

12 Examination topics are best adapted to ongoing interests and concerns rather than being treated as 'one-off' topics to be 'answered'.

13 Share ideas and interests with your friends. Two or three like-thinking colleagues, constantly comparing notes, will often develop their work more fruitfully than when each is working in isolation.

14 There are many avid sketchbook practitioners, past and present, who are worthy of study and who can teach you a great deal about approach, exploitation of subject-matter, media, and so on.

SECTION 5

CRITICAL STUDIES

P urple and blue, the lurid shallows of the hollow breakers are cast upon the mist of night,which gathers cold and low, advancing like the shadow of death upon the guilty ship as it labours amidst the lightning of the sea, its thin masts written upon the sky in lines of blood, girded with condemnation in that fearful hue which signs the sky with horror, and mixes its flaming flood with the sunlight, and, cast far along the desolate heave of the sepulchral waves, incardines the multitudinous sea. I believe, if I were to rest Turner's immortality upon any single work, I should choose this. Its daring conception, ideal in the highest sense of the word, is based on the purest truth . . . and the whole picture dedicated to the most sublime of subjects . . . the power, majesty, and deathfulness of the open, deep, illimitable sea!

John Ruskin.

Ruskin wrote this passage about Turner's *The Slave Ship*. He describes in marvellous prose the glorious sunset reflected on the sea which is the dominant feature of the painting, but his references to condemnation, 'lines of blood' and 'the shadow of death upon the guilty ship' reflect another significance of the painting; it depicts the throwing overboard of dead and dying slaves in order that the ship's owners might escape insurance liabilities. Critical studies is the aspect of art and design education which introduces students to such artists as Turner and to what art critics have to say about them, whether writing now or as contemporaries of the artists as Ruskin was of Turner, giving rise to the issues which their works raise.

Anthony 'discovered' Ruskin as a result of his background reading and researches on Turner, and his College art history and appreciation course. He made an intensive study of the artist because

Plate 63 Turner *Dido Building Carthage*

he wrote his A–level Personal Study about him. An essential aspect of critical studies is that students must study art and craft objects in the original, and must therefore visit galleries and museums on a regular basis. Anthony spent a long time studying Turner's painting, *Dido Building Carthage*, in the National Gallery in London. His Personal Study contained this evocative description of the *Dido* canvas, and it has clearly been inspired by the examples of Ruskin as well as by Anthony's observations made in front of the painting:

A cerulean blue sky encompasses the haze of the sun, its light, clean colour compares with the flickered clouds to which the sun's warmth clings. As the eye stirs towards the centre an array of glorious, warmer, more intense colour develops in the atmosphere. The sun, layered in bands of warm and cool is painted thinly, so much that the surface has now cracked, as if caused by the swirling radiance of the brilliant orb. The colour of this glaze is translucent white, underneath is an impasted yellow. Surrounding the sun are a group of approximately twelve brushstrokes, simply painted in unequal lengths of orange, which represent the rays. Already, the shimmering

effect of eager light is reaching the distant architecture, eroding away the solidity of the structure, reducing it to a gossamer of wafered marble.

Anthony wrote poetry at home as a private interest, but this passage did not come all that easily because initially he wrote it in a much more matter-of-fact way, reflecting that common tendency amongst students to 'play safe' and repeat what the 'experts' have to say when writing personal studies and written assignments. Many A–level students resort to regurgitating book information to the neglect of their own discoveries about, and reactions to, art objects.

Anthony's final description, though, communicates what he saw and felt whilst standing in front of the painting. To aid the looking process he made detailed notes in the gallery and these formed the basis of the passage, as a comparison between it and this extract from his notebook makes clear:

Cerulean blue sky, light, clean. Flickered clouds. Warmth of sun coming into clouds. Left to right moving towards warmer, stronger colour. Moves away again but to a more purply blue. Sun is layered in bands of warm and cool. Thin paint, cracking. Sun is white (flake white) on top of yellow. About 12 brushstrokes in orange represent sun's rays. White haze pours down from sun, colours appear to have been rubbed on over thick paint forming a glaze. Atmosphere in background in similar yellow to top – very light. As light colour is applied, more thick. Appearance of sky being painted right down to footbridge, permeates all other colours. Masts and buildings in distance are painted in thin glazes . . .

These notes were obviously far too important to ignore. He was also aware of Claude's influence on Turner and had chosen the painting because it was hung adjacent to *The Embarkation of the Queen of Sheba* by Claude in accordance with a stipulation in Turner's will. In the event, the *Dido* painting was the one which commanded his attention. He recalls that he'd scoured every inch picking little bits out. It had been so enjoyable that one and a half, perhaps two, hours flew past and seemed more like ten minutes:

I made stacks and stacks of notes. Very detailed descriptions, like I'd start off, 'In the top left-hand corner there is rich cerulean blue phasing into a more yellowing impasted cloud', and that would take the space of, say, one on two inches. I'd probably write about three or four paragraphs on that inch, and it went on for ages and ages, all these notes, until I could actually repaint the picture from the notes because they were so detailed; I won't say accurate, but detailed!

He believes that he 'got to the spirit of the painting through the notes'. Turner was searching for the actual source of light:

> From the distance you could actually see the sun, but when you looked close it was so true to life that he had actually found what he was searching for. You couldn't see the progression – a sun and burning-out light – it was just one glazed wash.

Turner had obviously come to mean something special to Anthony, yet he had not visited any galleries or done any art appreciation prior to his A–level course. He decided to approach this new aspect of art and design with an open mind and soon became really interested. He thought of doing the study on Constable but then decided on a comparison between Constable and Turner.

> And then I became so interested in Turner that that took priority. I was picking certain art books and finding that Turner was linked to Monet or such and such an artist in the twentieth century and I became interested, especially when we went to London, as well, to see the paintings themselves.

The colour had attracted him in reproductions, but in the original he was struck by the impact of the colour in relation to paint qualities and the actual application of paint. Through his researches, he built up a thorough picture of Turner, his relationship to his contemporaries, earlier influences on him and his effect on subsequent artists. For example, having compared Claude and Turner in the National Gallery he wrote that:

> Claude composes an 'ideal' of calm through the classical system of divisions, whereas Turner's painting is one of fluidity and activity in which the eye is invited to dance among the variety of abstracted shapes created by the dramatic chiaroscuro. The reason for this is the fact that Turner was more observant of the nuances of natural light. He had actually seen the phenomena occurring and had recorded it in numerous studies whereas Claude relegated the light effects in favour of the Classical foundation of his painting.

In relation to two of Turner's British contemporaries, he observed that:

> John Martin produced colossal works of apocalyptic disaster in a setting of cascading nature. Both he and Ward attempted to impress the spectator by the sheer size of canvas and the over-statement of colour effects. Turner was able to convey the vastness of nature even though working much smaller – such was the power of his understanding of natural phenomena and his formidable recall of observed images.

Having commenced his A–level course with no previous wider knowledge of art and design, it is obvious that Anthony has become critically aware of a period of art history and is able to understand Turner in the context of his time and with regard to his wider significance. He is able to gauge his own attitudes and responses to Turner's and other artists' works against the opinions of others. He knows about the relevant facts and dates, but has penetrated beneath the surface to an appreciation of the intrinsic qualities of the works themselves and he has found, and is developing, an appropriate language to enable him to communicate his understandings and insights to others. In fact, he does this so effectively that it comes as quite a shock to learn that he failed his A–level English examination.

Another student who had had problems with English was Jennifer, who had needed more than one attempt to obtain her 0–level. This was hardly surprising in that she had lived in South America and had only spoken Spanish until moving to England in her teens. Her ideas still come to her in Spanish, and then have to be translated into English. Nevertheless, she became intrigued by those 'colossal works' of John Martin's and was powerfully affected by them when she had opportunity to study them in the original. For example, with Spanish to English dictionary in her hand, she managed to conjure up this remarkable description of his *The Great Day of his Wrath* (painted 1851–53) in the Tate; and though she invents a word of her own, 'stratered', she does so in such a vividly evocative manner that the reader cannot fail to grasp what it is that Jennifer is attempting to convey:

> The mountains cave in yet appear suspended opposite the shattered mountain peak of natural architecture, a split second before crashing head on and filling up the ripe valley with destruction's splinters. 'Judgement' is the true subject of the painting. This is the moment of truth when the entire human race has wrath poured down upon it: all are affected alike.
>
> The people seem to pour in their thousands from either side at the front of the composition, trying to prevent themselves from falling into the chasm that Martin, being a religious man, would probably have called 'hell'. They struggle in vain as the mountains crash. Martin seems to like painting masses of people in trauma, judging their future as if he was a sort of God.
>
> For lack of any central focus for his attention, the onlooker finds himself swept, confused and disorientated, into the inner circle of the painting, towards some dislocated perspectival vanishing point, a black hole in space
>
> The centre of the work is painted in warm tones, a vivid coral red representing a powerful explosion. The veins and agitated

Plate 64 Martin *The Great Day of his Wrath*

rhythms of colour follow the aggressive movement up and off and into the upper regions of overhanging rock. The burning colour combines and represents the light defining the stratered structure, hanging precariously.

In the distance is the central heart of the storm, into which all creation, all matter, people and buildings, represented as they are in dots and dashes of cream, mauve and scarlet, will shower like dust and ashes to vanish into anti-matter, reverting to the state of things before time began. The valley walls on the edge of the canvas sides, bottom and top, are painted so forcibly, in globs of pigment laid on with a palette knife, so streaked, scrambled, furiously agitated, yet far from being a blur. The cascading rock looms overhead with almost stereoscopic effect.

Like Anthony, Jennifer's extensive background research is one of the means that have given her the clues to enable her to study the original with such purpose. Like Anthony, her on-the-spot observations and notes have helped her to get to the spirit of the painting. Like Anthony, her aroused interest and involvement have

enabled her to surpass all previous expectations about levels of writing ability and attainment, and, like Anthony, she had no previous experience of art appreciation prior to the commencement of her course.

And yet this is the aspect of A–level art and design which many prospective students assume is boring! 'I'd never done any Art History as such. I'd always regarded it as boring like any other academic subject', observed Joe, echoing the sentiments of so many. All A–level students should be able to benefit from regular lecture and discussion sessions which, if properly handled, can help them to focus on book material which will not otherwise become relevant to them, as Julie discovered. She became so interested in her course that she began reading in anticipation of the sessions, 'but once I go into a lesson it's like having a prior knowledge and then it's clarified for you'. Similarly, it is the lecture sessions and background reading which frequently provide the student with the necessary criteria to home in on works in the galleries. Nikki, for one, had:

> . . . walked round galleries before and not batted an eyelid, not
> knowing what's behind the paintings and what's gone into
> them – it doesn't click. I need to know what's gone into a
> painting, I really do, before I can appreciate it. I've gone round
> the Renaissance period and just not been interested at all. It's
> not appealed to me. But once I've read about it and everything
> that has gone into that painting, I look at it again and think,
> 'Yes'. It just means so much more to me. It all becomes more
> clear in your mind, everything slots together.

Anita, too, stated emphatically that, 'When I go to galleries I – at the moment – go up to the ones I've read about', and once in the gallery an extra layer of meaning, which book material cannot provide, becomes apparent. Nikki again:

> It's a weird experience to have studied a painting in a book for
> so long and to then go and actually see it in real life. You just
> understand it. When you stand in front of it you can
> understand it just like that, whereas before you had taken ages
> to read about it and everything. When you stand there in front
> of that painting it's fantastic, you really appreciate it, you
> appreciate it much more.

Getting to 'the spirit of the painting' also involves the student in the use of specific language. Jennifer describes nuances of colour — mauve, scarlet and vivid coral red conjure up a much clearer picture than just 'red'. In describing a Monet waterlily canvas, Rosemary

demonstrated further the effectiveness of this use of specific, rather than general, colour descriptions:

> The flowers are painted in deep dusky pinks, with a vibrant mauve in the centre. Monet paints a sensation of varied greens around the flowers, lime green catches our eye as it dashes across the canvas, giving the effect of light.

Another significance of original paintings is that, as Berger writes, they 'are silent and still in a sense that information never is. Even a reproduction hung on a wall is not comparable in this respect ...' Art objects have a special life and presence of their own so that, on confronting Monet's *Waterlilies* painting plus two others in the Cardiff National Museum of Wales, Rosemary found them to be:

> ... a wonderful sight, they relaxed the eye but most importantly the mind. They gave off a mysterious atmosphere; the stillness is almost disturbing. The peaceful tranquility which surrounds this painting is in keeping with a statement about nature shown at its most beautiful.

Studying art objects should be an active, not a passive, activity. Making notes and diagrams is an aspect of this, and so is the physical act of moving backwards and forwards to see the work as a whole, then in detail, and so on. Rosemary again reveals how, once involved in this activity, the canvas begins to occupy space in a special way which is obviously quite distinct from studying a postcard or reproduction. In the *Waterlilies*:

> Monet tries to convey not only light on the surface of the water but the light of the sky in reflection. We are aware of the feeling of light behind us, just as when we look into a pond He liked his water garden, it was 'His Magic Mirror'. A smooth, reflective surface can suggest space; in this case it is the space behind the viewer. I didn't feel claustrophobic when looking at the painting, as the sky suggests infinity. The spectator is surrounded by nature: Monet includes sky, water and flowers in his composition.

Anita became obsessed by this process of moving backwards and forwards in relation to the biology of how the eye works. She discovered that vision is most acute at the fovea, 'a tiny depression at the centre of the retina'. This gave her criteria which enabled her to analyse exactly what happened in relation to where she stood in front of Peter Sedgley's abstract stripe painting of 1965, *Yellow Attenuation*.

> The colours are bright and pure each in their own right, though I only appreciated their identity when close to the board itself.

Plate 65 Monet *Waterlilies*

At approximately 5 metres from the board I could evaluate the whole, or so I thought. We can come to terms with this need for distance when we consider the biology of the eye. Vision is most acute at the fovea: when close to the picture we can only focus on small areas at a time and surrounding areas are blurred because sections other than the fovea cannot cope substantially with the brightness of colour in the work. A greater distance from the picture widens the span accessible to the fovea, thus resulting in a more satisfactory focus.

She analyses how Sedgley plays around with this fact by using colours which progress and recede, intensified further by his organisation of complementary colours, so that this picture:

> . . . creates an illusion of projection of space, it appears to protrude leaving me unsure as to whether I am standing closer

to the canvas than I really am. So I see that juxtapositioning of colours and their interacting tonalities have disorientated my understanding of space.

In her attempt to understand what is happening here, Anita cannot do other than stand at different distances from the painting; a postcard reproduction of the same painting carries none of these implications. As with all the other previous examples cited, however, a background course and book research were also essential to Anita's studies. In fact, two books dealing with 'optical' works of Agam and Anuskiewicz contributed to arousing her interest in this field.

Similarly, a film on Lynne Moore and her card prints caught Anita's imagination because it showed 'how she did it, how she used the card and how she actually got the tone from dark to light. I was looking to see what colours she'd used and she said on the film that if the edges went over she scrapped them [the prints], and I was looking to see how neat she'd actually got the edges—it was amazing.' she also met Tadek Beutlich when she visited an exhibition of his weavings and 'he told us how he was doing things and we watched the way he used pipe cleaners and grasses, and as you got it explained it became exciting, you got excited.'

In developing critical understanding and insights, therefore, the student can make use of a variety of first and second-hand sources.

Plate 66 Sedgley *Yellow Attenuation*

Plate 67 Moore *Mimosa*

The study of first-hand material is of the utmost importance, but it is aided by the second-hand. These two areas can be summarised as follows:

1. THE USE OF PRIMARY SOURCES

(a) Original art work seen in museum, gallery, exhibition, studio, workshop, etc.

(b) Original art work on loan to a school or in a school's own collection.

(c) Visits and residencies by practising professional artists and craftspeople.

(d) Statements made by artists about their work (including comments made during workshop sessions), published or broadcast interviews, letters, manifestos, etc.

(e) The art work of other pupils.

(f) The art work of the teacher.

2. THE USE OF SECONDARY SOURCES

(a) Reproductions of art work in the form of photographs in books, postcards, prints, slides, etc.

(b) Monographs, critical or appreciative studies in books or on film or on video.

(c) General background documentary information which places an artist's work in a social or historical context, including reconstructions or fictionalised accounts of artists' lives, methods of working, etc. in books, film or video.

This provides students with a very useful checklist of all the areas of study which can enable them to develop their critical awareness by understanding contexts, making interconnections, forming an ever-broadening overall view and realising that there are often differing viewpoints about the same work or artist. All A–level students should also be able to benefit from a regular, ongoing course of study which makes use of all or most of these areas of material, and in an interesting and stimulating manner.

Joe feels that his course broadened his mind and Anthony says that it was from that basis that his interest in Classicism and Romanticism was born, leading to his making such comparisons as that between Claude and Turner. For Julie, her lectures 'have a significance, they were the beginning of my interest and they will always have a significance'. They kindled Anita's interest, also, because she likes 'to have it explained, go and see it, come back, read what was explained and then think about it'. Jayne feels that one of the great benefits of the course for her is that it has made her question what she reads, enabling her to accept that the chronology of European art, for example, is presented with misleading simplicity

Plate 68 *To be able to handle and study unframed original works can be an especially memorable experience, as Mark discovered in the Print Room of the Victoria and Albert Museum.*

in many of the books on the subject. For example, the waterlily painting which Rosemary writes about was painted in 1906 and Monet was to continue painting this subject for another twenty years. Yet he is labelled an Impressionist and most books are set out and written in such a manner as to convey the idea that Impressionism finishes at the point where Post-Impressionism commences. It can therefore come as a shock to the student to discover that the leading Post-Impressionists, Seurat, Van Gogh and Gauguin, were all dead before that work was painted with Cézanne dying in the same year. It is an even greater shock to realise that Cubism and Fauvism and many other of the 'isms' had passed while Monet was still working away on his waterlilies.

Though Rachel was not officially studying an art and design course, she knew through her friends that the theory sessions were interesting, and so attended whenever she could just for interest's sake. After a few sessions she realised why it was different:

I was expecting it to be like other lessons where you take notes and you deal with each topic as it comes. But rather than that, we'd talk about a Movement in general, then take an artist as an example and then look at the works and really progress from the works by looking at them and talking about them I'd seen the Pre-Raphaelites and the Impressionists and I knew that I liked them, but I didn't know about twentieth century art at all until I started coming to the lectures. When we started off looking at Picasso we looked at some of the earlier works where he was using facet Cubism, with all the sort of sides of the shapes to bring the figure out. I hadn't seen anything like that before. It helped to show how it was a progression. When you come across some 'Modern Art' that looks really weird and odd, you can't understand them, but if you see the beginnings of the 'Modern Movement' it helps, and it can then make sense. It was the things that influenced him, like the African masks, that you could see appearing in his paintings, and you could see how later artists had been influenced by Picasso. Whereas before I'd seen famous works but out of context, not knowing where they came from, it helped to understand the whole background to it.

She did not realise that there were so many strands to twentieth century art and 'so many different influences from different cultures like Japan and Primitivism that I hadn't known about at all'. Even an earlier artist like Van Gogh, and his use of Japanese prints, 'the delicate tree painting. I hadn't seen these before and they are so completely different from his more famous works.'

Traditionally, courses have only referred to other cultures as they influence Western European art and written examination papers at A–level still conform to this pattern – meaning, in turn, that this bias is inevitably reflected in this section. Changes are taking place, though, with a shift of emphasis from the Eurocentric approach which has predominated for so long to others relating more to a 'World View'. Through these approaches students should have more opportunity for coming to terms with and valuing the works of non-European cultures in their own right, rather than these only having value because European artists have chosen to make use of them. In the process, traditional ideas as to what constitutes 'Art' are likely to be challenged and broadened. Helen's project on the art of the North American Indians, for example, led her to the realisation that, for some peoples, Art was inseparable from other areas of their lives and had 'always had a tendency to be abstract and decorative' with use of the imagination

... to interpret a subject in a way in which its whole truth was represented instead of just what can be seen They believed that there was much more to nature than we can visually understand; they had more of a spiritual understanding.

This was an inevitably generalised beginning, but a basis for more in-depth study in museums. The Victoria and Albert Museum's Oriental displays particularly interested Carole and, 'when it came to the practical session',

> ... I chose to make studies of a Chinese Throne Cushion. The amount of detail and the decorativeness of the cushion really drew me to this embroidery. I spent a very long time just studying an area that was only about one inch square.

She 'was so impressed and taken with Japanese and Chinese art' that she chose 'to do something on a similar line'. In the event, the experience affected her own practice throughout the rest of the course. Richard chose to do a project on the Japanese Print, and, amongst others, found the Hokusai print of *The Kirifuri Falls* in

Plate 69 *Chinese Throne Cushion (detail)* **Plate 70** Hokusai *Kirifuri Falls*

Manchester City Art Gallery to be absorbing and worthy of detailed study in its own right:

> ... an unusually striking piece showing the strength of Japanese colour woodcuts characterised by flat contrasting colour and networks of coloured lines. The waterfall central to the piece has a dagger-like quality, viewed from a distance it looks like a shaft of lightning cutting the composition in two The waterfall is flanked by the beautiful vegetation of the Japanese countryside, the branches of the trees creating a striking vertical which contrasts with the smooth lines of the tumbling vortex. Leaves and bush are represented by blobs of pure colour creating an unusual impression. The flow of the waterfall can be seen inhibited by razor-edged rocks placing an emphasis on the eternal battle between the elements of earth and water, which were a strong influence in the ancient Japanese religious mythology of Shinto. The sweeping curve of the hillside below creates a counter-curve to the falling water, strengthening the infrastructure of the piece's composition....

However thorough and wide-ranging the course, Art is such an infinite subject that one can continue learning and making new discoveries throughout a whole lifetime of study. Art galleries and museums therefore always retain their capacity to surprise and even shock. Julie loved seeing the Constables and Turners on her first London visit but was totally unprepared for the Abstract Expressionists in the Tate Gallery.

> ... I was full of disbelief. That is one thing I do remember, being disbelieving at why that was any good You know, that a canvas that was painted all red with one purple stripe was any good Even though I like the Barnett Newman for its colour – I mean bright red, it really attacks, it really hits you – but I wanted to know why he'd done it bright red and why he could get away with it being just a bright red canvas with a purple stripe.

Next she went into the Rothko Room with its dark maroon and black canvasses on all sides. These made her feel 'so melancholic, so depressed', and the mood affected her for the whole of that day. It was 'a complete eye-opener' that art could affect her so strongly in that way. The shock and emotional impact were new experiences to her and proved to be an invaluable learning experience.

It is also possible to adopt very clear strategies to ensure that the time spent in the art gallery is utilised to the maximum, whether in relation to previously studied or unfamilar works. It is many years

now since the art critic Eric Newton wrote that an artist when painting a Madonna and Child had four sets of conflicting demands which had to be reconciled as satisfactorily as possible, and these can still have relevance to the student today. The artist has to:

(1) Invent a set of shapes and colours which will express his [or her] feelings about the Madonna and Child theme.
(2) Invent a set of shapes and colours which will (however vaguely) remind the spectator of a woman holding a baby.
(3) Invent a set of shapes and colours which will fill the required space pleasantly, and,
(4) Having reconciled the conflicting claims of these three sets of inventions, the artist has to translate them into pigment applied to a flat surface.

These four tasks can be summarised as relating, in order, to Mood, Content, Form and Process, and can be as valuable to the student engaging with other artists' work as they are essential to the painter, printmaker or sculptor. They represent four clearly separate and identifiable standpoints from which it is possible to approach any art object. To put it another way, they enable the same art object to be studied in four different ways, from four different slants, in order to understand and enjoy it more fully. Even without any prior knowledge of a work, it is still perfectly possible to use them as a basis to frame a range of appropriate questions when standing in front of a work. It is a temptation to say 'any work,' but in 1959 Clement Greenberg, talking about the aims of the New York Abstract Expressionists, wrote that 'Content is to be dissolved so completely into form that the work of art cannot be reduced in whole or in part to anything not itself'. With the passing of time it is a matter of debate as to whether or not this was, in fact, achieved. To many people, to cite one example, Mark Rothko's late paintings are now seen as representing one of the last great statements of the Turneresque Romantic tradition, containing landscape implications, but many would accept Greenberg's point with reference to some aspects of twentieth century art. These are relative rarities, however. In any case, the categories are not meant to be straitjackets and can, in fact, give students clear criteria to help them make sense of the exceptions when they do occur, with Form being seen as the Content.

How might the student address these four areas? In relation to Mood (or Feeling, or Atmosphere) these kinds of questions might be appropriate and fruitful:

Does the work affect me, the viewer, in any way? Does it capture or convey a mood, atmosphere or emotion which I have previously experienced? Does it capture and/or convey feelings about life and nature? Can I imagine what the artist's feelings

71

72

School or college displays can contribute significantly to students' critical understanding and awareness. Displays should be both attractive in their own right and informative.

Plate 71 *The Winstanley College foyer area is a meeting place, social area and natural focal point. Regularly changing exhibitions bring the visual arts to the notice of the whole college community, making the captioning and use of supporting information of vital importance. The* Cable Street Mural, *owned by the College, is at top left (see page 116) and Anne-Marie Quinn's pregnant nude pastels (see page 109), from the Wigan Schools Loan Collection, generated animated discussion amongst art and non-art students alike.*

73

74

Plate 72 *The Art and Design Department entrance area provides an invaluable critical studies focal point, the displays often combining the work of artists and students. Reproductions of a Botticelli 'pietà' (a detail) and the Mantegna* Dead Christ, *for example, relate naturally to Michael's interpretation of the examination topic 'Modern Pietà' in the form of a mother holding a drowned boy.*

Plates 73 & 74 *The Wigan Schools Loan Collection can be used as a means of bringing a wide variety of original works to the attention of students. Striking displays of Indian textiles and Balinese masks top and of Japanese woodcuts bottom are invaluable stimuli for practical work and for beginning the process of gaining knowledge and forming judgements about the works and values of non-European cultures.*

were, or might have been, when producing this work? Is the work quiet or noisy, soothing or disturbing, happy or sad, relaxing or jarring in its mood? What are the qualities inherent to the work which cause it to so affect me?

An example of a student being responsive to the Mood of a work is that of Stephen writing evocatively about Turner's painting *Norham Castle – Sunrise*:

> A mood is conveyed which makes the landscape pictured seem like an idea that Turner dreamed up rather than the actual reality of it. At that particular moment in time it must have been quite awesome to see the mists and colour swirling to and fro. And slowly, very slowly, the thin vapours joining together, becoming bonded and knotted, as they congealed into solid shapes. Like a gas condensing and forming a solid, they must have seemed as if some wizard had conjured them, to literally transform into solid matter. And the sun, constantly present, shining meekly through this unearthly apparition. Steadily becoming bright and real as its furnaces are stoked and fed. Condensing, with heat, the fine vapour into *Norham Castle*.

The types of questions which might be posed in relation to Content could include the following:

> What is the subject matter of this work, what is it about? Is the subject matter incidental or of importance? Is it a vehicle for the communication of social, religious, moral, economic or political concerns of either the artist or the client? Was the subject matter based on direct observation, or was it remembered, invented or imagined? Was it the intention to treat it representationally or has there been deliberate exaggeration, distortion or abstraction and if so, why? Is the content immediately apparent or are there hidden aspects alluded to through, for example, the use of symbol, metaphor or analogy?

In a study on War Artists, Sandra's description of Nevinson's *Paths of Glory* is a vivid example of writing about Content:

> The collapsed soldiers lie involuntarily on the sodden earth, transmuted into this hellish graveyard. These men, once courageous soldiers, are now pitiful bodies which are confined to oblivion These bodies begin to decay, the effect composed by Nevinson's fluent paintwork which flows from land to man uninterrupted. Man's identity is lost, as their faces become engulfed in the mud, and the land on which they lie

becomes a paragon of war. It is unable to sustain life, only the symbols of conflict such as the clawing barbed wire, the muddy trenches and death, which dominate. Man and nature become one as death takes over, as if the earth is being fed by the destruction of war.

The following kinds of questions might be posed in relation to Form:

How has the work been arranged? Is this in keeping with its content? What kind of colour scheme has been employed? Is it harmonious or does it make use of contrasts? Is it subtle or vivid? Does one colour predominate or do two or more have equal significance? Is there a main overall shape or is there an interrelating sequence of shapes? Is the design of the work determined by use of recurring shapes, lines, rhythms, tones or forms? Does the work have variety or unity of texture? Does the work hold together as an overall entity or is it pleasing in parts but not as a whole?

In his description of Gerd Winner's *St Katharine's Way* screenprints, Joe focuses clearly on their formal qualities; five individual images when placed edge to edge build up to form a whole architectural facade:

Studying *St Katharine's Way*, we are aware of a feature of picture organisation which is recurrent in Winner's work. Over and over again he shows us the frontal plane of a building. This is the case here where he insists on the structural qualities of verticals and horizontals. Like in Seurat, these aspects give his work not only structural cohesion but create a mood through the rhythm of interval. The notion held by Seurat that verticals represent stability and horizontals calm, is surely borne out in this work. In a frieze which is depopulated the appearance of the subtle diagonals could represent, as they did for Seurat, the element of life. Using a highlight or a totally lighter version of colour he persuades the eye to follow them, occasionally placing his diagonals and curves to upset the expected tempo

Winner's brilliance shows in this series as we become aware of the difficult task he has overcome in producing individual prints which function as complete ideas in isolation, yet combine to form a continuous interrelated picture when printed touching. These subtle relationships are applicable to ongoing forms and textures but especially to a travelling wave of carefully adjusted colour from left to right.

Questions relating to Process might be along the lines of the following:

75

Plate 75 *Newman Eve*

Plate 76 *Turner Norham Castle – Sunrise*

Plate 77 *Nevinson Paths of Glory*

Plate 78 *Quinn Pregnant Nude*

76

77

78

How was the work made and what was it made with? What materials, tools, processes and techniques did the artist use? How might the artist have commenced the work and through what stages did it proceed to completion? Might the artist have made, and made use of, supporting studies, such as sketches, photographs, maquettes, collages and companion works? Do you think the work was executed rapidly or did it evolve slowly over a long period? What range and variety of skills must the artist have required in order to produce this work?

Anne-Marie Quinn had been resident in Julie's school, so she knew her working methods well. Julie is well placed, therefore, to bring this knowledge to bear when studying two large pastel paintings of a recumbent pregnant nude which Quinn has subsequently produced. The extracts are from her notes made while standing in front of the works.

> Soft pastels on paper . . . the pastel is blended in with the fingers and therefore looks soft and tender giving the perfect impression of skin. This softness also conveys the peaceful mood The strokes of pastel in general are long, graceful and flowing going with the forms of the body. Only occasional cross-hatching is used but this is very subtle and almost unnoticeable. White diagonal strokes can be visibly seen on the cover over the blended soft pastel
>
> . . . Certain colours are overlaid onto each other – giving a richness and glow to the colours – but are carefully blended in. Although the colours are rubbed in Anne-Marie has gone back over the top in places to put her last visible strokes of white pastel on the flesh and cover The paintings look as if they have taken a long time because of the scale and because one can see how much work has gone into them. But maybe they didn't take as long as one would imagine because when Anne-Marie was in (my high School) she worked very quickly – I was amazed at her output in her time spent there. However, one has to consider the fact that a comparative lifetime has been spent on the study of the figure and lots of hard work and sketching to get to the stage she is at now.

Gallery visitors often devote as little as five or six seconds to each work, but students studying in the gallery, who are conscious of the four areas, have criteria that can enable them to spend considerable amounts of time in front of a work without losing interest or concentration, provided that they have the confidence to make conjectures and trust their own reactions and judgements. Inevitably, of course, there are areas of overlap with regard to the

four areas. Joe makes reference to Winner's control of mood through his uses of formal devices, Julie similarly emphasises how Quinn's techniques are in keeping with the quiet, intimate mood of her works and Sandra refers to process – Nevinson's fluent paintwork – in describing the content of Paths of Glory.

The four student passages are personal and authentic and share three significant characteristics:

> (1) All arise out of direct first-hand experience, each of the works in question having been seen and studied in the original.
> (2) The students have had sufficient confidence and trust in their own responses and judgements to make use of their own observations, personal responses and reactions, and their powers of analysis.
> (3) These responses are all substantial and set in a wider context through extensive reading and research, regular gallery visiting and, of course, because of a systematically taught background course of generous scope.

The four paintings used are also interesting because only one is by an acknowledged great artist – Turner. He has a place in all the histories and surveys of Art, certainly of Painting. By comparison, Nevinson is a British artist of significance, but not 'great' in the same accepted sense. Winner, being a printmaker, is often treated differently; indeed, Joe had difficulty in getting Winner as a topic accepted by the examination board because he was not a painter. Finally, Quinn is, as yet, unknown outside her region and is also a female artist. Women artists have had a much greater struggle in gaining recognition until recent times. The statements illustrate, though, that artists do not have to be 'great', male, or dead to be deemed worthy of study and relevant to student needs.

Content, Form, Process and Mood are also criteria which can be used to relate different works and artists, one to another. Joe's interest in Winner's use of frontality in his compositions leads him to a comparison with Boyle and Neiland, two other contemporary artists. 'Mark Boyle looks down, Winner looks straight on, Neiland looks up.'

> . . . in the Tate Gallery I was confronted by Boyle's *Pavement*. This is a painting in relief (an idea which in itself breaks down the barriers between painting and sculpture). Boyle looks down on a section of pavement and road which looks as if it has been transported from the actual street. He notes man's existence by the imprint of a tyre, fallen matches and coins on cracked flags. Man has crossed that way but moved on Neiland's

'Mark Boyle looks down, Winner looks straight on, Neiland looks up'

79

Plate 79 Boyle *Pavement*

Plate 80 Winner *St Katharine's Way*

Plate 81 Neiland *Clouds*

81

80

paintings and prints are taken from man's eye level thus impressing upon the viewer man's insignificance in relation to the scale of modern architecture. To enforce this feeling he allows the perspective lines to converge in and uses the glass facades to gain a multiplicity of reflected images Neiland also excludes figures which would disturb his stark grid system inherited from his subject matter.

Winner and Neiland both use representational subject matter and impose on them similar abstract forms, but whereas Neiland makes use of the converging perspective caused by 'parallax', Winner 'takes great pains to adjust this' and 'creates total verticality'.

Sandra's interest in war artists grew out of an initial concern for the work of the Nash brothers, John and Paul. This then led her to Nevinson and to making a round trip of more than three hundred miles to see Stanley Spencer's First World War paintings in the Burghclere Chapel near Newbury and, in particular, *Map Reading*. A study on war artists is, almost by definition, going to contain a strong emphasis on Content, but it is interesting to note how subtly she also intermingles elements to do with Form and Mood:

> While browsing through the pages of a book, I was drawn to a black and white reproduction of *Map Reading*. The absence of colour produced a response contrary to the one I experienced after observing the original at Burghclere. Instantaneously I was directed to thoughts of death, and since death and war seem to be interconnected, it was the ideal painting to discuss, disclosing the real effects of war on man to its extreme. Spencer's achromatic image manifests that concept of death because the soldiers lie in positions corresponding to wounded men as they have fallen to the ground and remain as yet more forgotten victims of war. It was impossible to discard my first impression of this painting even when I was privileged to see the original, as behind the cascade of vivid colours the image still remains. *Map Reading*, with its magnificent colouration, is in complete contrast to the other themes in the chapel, where khaki predominates and dull earth tones are recorded.
>
> Lush greens expel into a well nourished landscape, precise and integral in detail. The scene conforms with the natural setting because the rusty-brown colour of the soldiers' war regalia is complementary in colour to the green landscape. Because of the reddish tinge the colours which Spencer exhibits are unobtrusive to one's eye, but create a feeling of warmth and security in the painting.
>
> I love this scene for the obvious reason of resting and contemplating. Tranquillity radiates out, as the fatigued soldiers

rest in the arms of Morpheus on the flourishing green grass, and eager men scramble up the bank in the background, extending into the relaxing task of picking bilberries.

This combination of phenomena guides your thoughts away from warfare, but an officer supervises this painting while sitting astride his chewing horse. (This is the only officer in the entire chapel themes.) Could Spencer be mocking the farce of war? As the officer issues orders ignored by the surrounding men, even the map is placed upside down, consequently becoming only an informative guide to the viewing public of places Spencer had visited in his past. Yet wouldn't it be difficult for the officer to read?

To me there appears to be some symbolic design managing the painting, influenced by Spencer's religious convictions. Well aware as Spencer is of the brutality of war on men, when fighting men are maimed and slaughtered, he still nevertheless directs his thoughts to peace. The peace one dreams about in the restful mind and when sleep takes over, as Spencer reveals in *Map Reading*. He indicates in the painting that the monumentality of war is too great for mere mortals to withstand, by making the men's uniforms, the ultimate symbol of war, huge; and dwarfing their heads, which is the container of all thoughts. In sleep the responsibilities and remembrance of war which are thrust upon them in consciousness slip away to reveal the soldiers as they really are, just normal, frightened people not warriors or super heroes. The men in this painting direct us towards peace: the path which forms an enormous cross. Then the path is crowned with thorny bushes; could this represent the crown Christ had to wear? – and – is this a portrayal of the crucifixion of Christ? And the men's arms lead skywards perhaps to heaven the place of ultimate tranquillity.

In this sustained passage, Sandra captures the mood of *Map Reading* in the most evocative manner. She has penetrated deep into the work in order to 'read' its hidden as well as its more obvious meanings, and she is not afraid to conjecture and to pose questions in her search for those significances. The theme of war is unfortunately a universal one but as such it offers the student a potential means of linking works across the centuries and across countries and cultures.

Linked to war is civil strife, disorder and unrest, a significant example of which is depicted in the *Cable Street Mural*. All art works exist within contexts as well as in their own right and the modern student is expected to be able to show evidence of 'knowledge and understanding of the differing contexts in which work may be produced e.g. historical, social, cultural, technological'. Like Sandra,

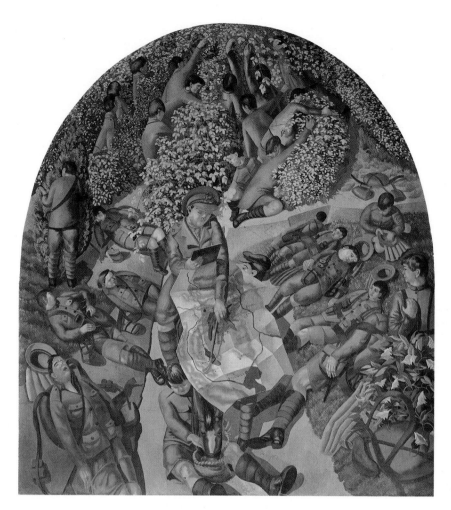

Plate 82 Spencer *Map Reading*

Alan went out of his way to see a work which had become significant to him – the *Cable Street Mural*. His College owns a superb pencil drawn preparatory study for this mural, executed by Paul Butler who made the main contribution to the mural which is in the East End of London on a gable wall, illustrating that important works can exist outside of gallery and museum. Indeed, the whole impact of its location contributes to the powerful statement which Alan produced, one which is imbued with social and political implications:

> As you approach the *Cable Street Mural* you notice the
> surrounding area. There is a feeling of nervous tension of the
> stranger in a strange new city noticing the split between rich
> and poor, coloureds and whites. I left the tube and set out to
> find the mural. The journey takes you past the Tower of

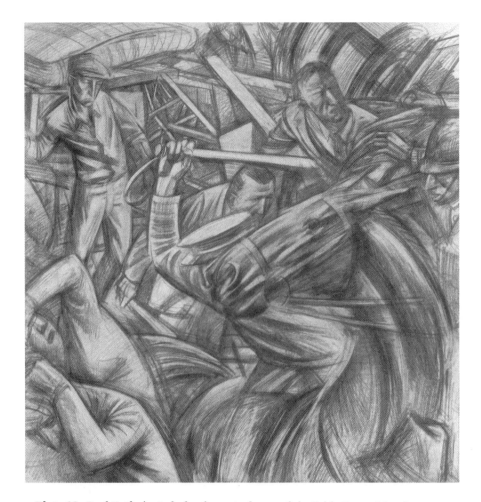

Plate 83 *Paul Butler's study for the central area of the* Cable Street Mural.

London; the Trade Centre, with new buildings being erected and completed. The upgrading of the city slowing down as you move further away from the Trade Centre, then you move into a district of garish concrete buildings, many stories high, on both sides of the road, with disused land near a railway bridge. Darkened roads lead you under the bridge, giving you an insecure and claustrophobic feeling.

It is within this alien environment that Alan confronts the mural, completed in 1982, commemorating the battle which occurred there in 1936 when police confronted the Jewish community as Mosley's fascist blackshirts attempted to march through the Jewish quarters. Measuring fifty-five feet by sixty feet, the 'painting is symbolic, both of the feeling which produced the riot in 1936 and the increase in tension in society today'.

The first thing you notice about the mural are the buildings in the painting, curving in and trapping the people giving them no other option but to riot. The painting uses social realism as a basis and offers cogent symbols throughout the complicated mesh of rioters, police, furniture, weapons and buildings. Each area of the work portrays either an emotion or dramatic gesture, part of the narrative of the riot. Such are the movements and reactions to the terror of this event.

The artists do not allow the viewer to see the eyes of police or soldiers in order to show 'the blind obedience of the two peace enforcing factions', whereas:

The people of London's East End are sympathised with, for they are given expressive poses. Each gesture or expression adds a further element to the tensions behind the present social unrest and that of 1936 As you move down the painting you see faces, their expressions questioning, accusing, observing, panicking and, as you reach the lower part of the painting, you see the pain of the innocent The most moving figure in the painting is the male in white at the bottom of the painting covering his head, seemingly wishing to escape but unable to do so. This may be the face of lost innocence fleeing from the riot.

The overall feeling of the painting is one of involvement not in what has passed but may still be to come . . . nothing is new and since Hogarth recorded the inequalities of the eighteenth century there have always been painters ready to make a forceful social comment; maybe one day governments will respond to these visual statements.

In addition to this inevitable emphasis on Content and Mood, Alan was also sensitive to the use of Form in this mural as an essential means of emphasising its message:

The final mural is painted with an almost sculptural form allowing every tension and movement in the picture to be made forceful. This is echoed by the colour of the painting, declaring its presence on the surrounding area The colour seems to be a mass of fox orange, pale orange and vibrant tomato reds, compared to the pale sky blue. The general colour is much more varied throughout but using a dark background and highlighting the action makes the images sing out and makes it impossible to ignore the painting and its political message.

'Almost sculptural form', wrote Alan. Jayne's response to Christine Merton's 1986 *Winged Messenger* takes full account of the tactile qualities which are fundamental to sculpture. Again, though she is

Plate 84 *The Cable Street Mural, 'declaring its presence on the surrounding area'.*

writing about an 'abstract' work, what she has to say is a blend of Content, Form and Mood:

> The work particularly appealed to me because of its vividness as an image. It consists of separate but connecting forms, and a relationship is gained and maintained through the integration of different colours, texture and media. The simplification of the form places more emphasis on the geometric – triangular, spherical and cylindrical – as does the absence of any superficial surface decoration. Thus it can be seen that the sculptor has been primarily concerned with the form in itself.
>
> As in many of Christine Merton's works, she is concerned with the representation of human emotion and movement, and in *Winged Messenger* it can be seen that the very title stresses movement – the wings and the messenger both evoke images of mobility. The wings themselves seem to sprout from the spherical shape. The title can be equated with the Roman God Mercury and one of the planets – thus the spherical shape.

Plate 85 Merton *Winged Messenger*

She conjectures about the inherent contradiction of a sculpture which communicates feelings of movement and flight being made out of 'earth-bound and solid materials' then continues:

> The work is of a constructional nature, and to some extent appears to have been left in its natural state, bringing it closer to nature.
>
> The mood of the piece is created by the balance and tension within it – between shape, line and texture. The sharply angular form with its smooth surface of the sphere evokes tactile responses thus stressing its three-dimensionality as a whole

This section amply illustrates that A–level students are well able to engage with art works in intelligent, often moving and sometimes profound ways, and to communicate their ideas and responses. Any art and design education is incomplete without this aspect being developed, though in the past its worth was diminished because of too much emphasis on facts and dates. These might be important, but only in so far as they enable the student to better come to terms with the ideas, thoughts and feelings which are at the heart of all worthwhile art. In their writings, the students handle social, moral, ethical, political issues, all in relation to artistic judgments. The next section illustrates how students can harness their critical studies knowledge to their practical skills to produce work of their own with meaning and depth.

POINTS REGARDING THE DEVELOPMENTS SECTION

1 Critical studies embraces all those aspects of the subject which can help further your knowledge, understanding and enjoyment of the visual arts than your art production alone will achieve.

2 The 'Critical Studies' section is devoted to the study of mature artists' work, but the book as a whole contains many examples of students' practice interacting with that of others.

3 There is no substitute for the study of art and craft works in the original. This means that you should, in particular, visit art galleries, museums and exhibitions whenever and wherever possible.

4 Making notes and diagrams, studying works from near and far, background reading and research both before and after visits, can all help you to study works in greater depth than so many gallery visitors at present.

5 Some works can arouse strong, even hostile, feelings. You are under no obligation to like works, but even unfavourable reactions can stimulate you to find out more, and possibly to modify your opinions as you test them against those of others.

6 Critical studies should develop your vocabulary and increase your ability to talk, write and read about matters to do with art and design, and to express your ideas more clearly and precisely.

7 As you become more involved, consider whether your inclinations lead you towards in-depth study of aspects of the visual arts or whether you are drawn towards studies of a more wide-ranging and general nature.

8 The Content, Form, Process, Mood and Context models can help you to approach a wide variety of art and craft objects from varying standpoints and to have confidence to make reasoned conjectures and judgements.

9 Traditional Eurocentric approaches are giving way to courses which can range across time, places and cultures, and there are a variety of approaches which can assist your studies in this respect.

10 A balance should be sought between thematic, process and formal approaches, and the chronological ones which have traditionally been favoured by examiners and art historians in relation to European Art.

11 New approaches also increase the opportunity for you to study a much wider variety of artists'; male, female, young and local as well as the more famous artists, past and present, who are written up in books.

12 Critical studies relates to every aspect of the whole field of art, craft and design, from the oldest to more recent forms, such as Computer Graphics, each of which has its own history – however short – and current exponents.

INDIVIDUAL DEVELOPMENTS: course studies as a springboard

I t was a grand sight, solemn and gloomy, an abyss from which a murmur came. One had the feeling that everything was about to evaporate, disappear in a colorless obscurity Hard as we looked, we still saw nothing but heavy gray space, somewhat indistinct, the bridges as though hanging in the air, the smoke soon disappearing, and close to the riverbank a few surging waves of the Thames. We tried to catch a better glimpse, to penetrate this mystery and in fact we finally saw some distant and mysterious glimmer which appeared to be trying to penetrate this motionless world.

Gustave Geffroy

How wonderfully and vividly the critic Geffroy captures the sheer impossibility of the nature of the tasks which some artists set themselves! He is recalling the experience of watching Monet at work painting his fog-laden Thames cityscapes in the early years of this century. We are at a far remove here from the popular notion that art comes easily to the talented few for whom it is intended. In reality, of course, all worthwhile artistic achievements involve challenge, struggle, discipline, and the enjoyment arising out of the effort and ultimate achievement. Monet set up his easel to work directly from nature whenever possible. The work of some grows out of experimentation with, manipulation and control of materials and processes. This section has been called 'Individual Developments', though, because in the main the students' paintings, sculpture, prints and textiles will arise to a greater or lesser extent out of their objective work, use of the sketchbook and from ideas born out of their critical studies interests.

The traditional picture which many people have of A–level Art is of a set of detailed and illustrative paintings, maximum size A2, done in response to set questions to be sent off to external examiners. Changes are taking place, though. These are aimed at relating A–level to G.C.S.E. criteria and principles in order to give coherence and continuity to students' courses. One outcome of this in the coming years is likely to be an increase in assessment of course work displays and the discontinuation of the set examination topic. However, some students produce their most outstanding work in response to such topics at the culmination of their course. This section therefore combines A–level examination work with course work examples, the emphasis being on the personalised nature of the responses in each case.

An example which combines the two is that of Samantha, for she was adept enough to produce an examination painting which naturally arose out of the concerns which motivated her course work. She had 'always fantasised about being a good artist', but knew that she was not one really. In fact, she had failed O–level Art at her first attempt and therefore could only commence A–level a year late. Even then, she found the first year of the course boring, spending most of it on an unsuccessful painting:

> The freshness goes out and you're plodding away. It becomes murky then and your ideas have disbanded and you don't really know why you're doing it any more . . . in the end we just used to sit round and do nothing.

At the beginning of the next year, however, it was the history of art that really helped her. 'I loved it, it was really good.' She had hardly used her sketchbook the year before but now she set out 'to see what I could actually do'. She decided to 'use what's handy, use myself!'

> So I started drawing my feet in the mirror and all of a sudden I realised that if I looked hard enough and I concentrated and really tried to understand and master it, I could draw. Not brilliantly, but I could give my best and what I did I was quite proud of. And then gradually the feet grew out – obviously, you know – and then you tried to master the lace on the petticoat and understand how a mirror distorts Then you realise that you could link things through and all of a sudden I had, to me, a lovely picture.

Her course introduced her to fifteenth-century Flemish painting. Her interest in these turned to love on a visit to the National Gallery. She was fascinated by their symbolism, pristine surfaces and jewel-like colour. 'I don't know, but there's a mystique, a quietness about

Plate 86 *Samantha's study for the examination topic 'Modern Morality' was the opportunity to create a present-day version of those qualities in Flemish Art which appealed to her most—but she had to include her 'signature' in the top right-hand corner!*

Plate 87 *She went to unusual lengths to produce a small but expressive supporting study of feet.*

88

89

Plate 88 *Samantha's first successful painting, in oil paint, of her feet. 'It was my treasure. . . .It amazed me that I was capable of it.'*

Plate 89 *She saw a connection between her studies of interrelated feet and the Flemish painters' depictions of the praying hands of donors. It became an ambition to see one day the Van Eyck Ghent Altarpiece, which incorporates her favourite donors. (Detail.)*

them. I feel I can relate to them.' She saw a connection between the praying hands of the donors and her drawing of her feet. With these Flemish paintings before her as a model worthy of emulation, she brought a new concentration and intensity to bear on the resulting painting.

> It was my treasure and I used to put it away, no smudges on it, and I tried to keep it clean and fresh. It amazed me that I was capable of it and then when you realise you are, you tend to love it. It becomes virtually part of you, part of your identity. You've put your feelings and thoughts into this painting, and mine was rather Surrealist, but it was my ideas and you weren't

Plate 90 *The symbolism in 'Modern Morality' was carried through into the colour, the young girl wearing the red of the Magdalene and the mother the blue of the Virgin Mary.*

embarrassed to say that this was your painting. In fact, you'd bring your friends in and say, 'Look, look what I've done!' It was a really lovely feeling.

Every painting she produced that year featured her feet. Everybody referred to her feet as being her 'signature'. 'It was a bit of humour really.' In response to the examination topic 'Modern Morality', though, Samantha made a preliminary drawing of two people, her mother and her sister's friend posing for her. Both were at prayer, one – the mother, unquestioning about her faith – conveyed in a conventional praying posture with hands together and eyes firmly shut. The younger model, however, was 'withstanding the pressures of the church', desiring to lead her life in her own way. Her hands were clenched, the rosary beads entwined between the fingers.

The rosary beads stood for the church and as it was intertwined it meant that she was tied to the church to a certain degree and

her look is one of frightened distance, really, with her mother sitting behind. Her expression is very clamped. The mouth is tight, the wrinkles are harsh and the hands are pressd together as if insisting, 'I do believe'. The young girl seems to be questioning – looking away – but she is tied by her mother's feelings and the church. She has respect and duty to the mother but also respect for herself.

Her interest in the symbolism of Flemish painting is here made manifest and her love of those Flemish donors had now surfaced in a clear and decisive manner. However, she had to include her 'signature'! She did this by including the feet of a crucifix in the top right hand corner of the drawing. In addition, she made a powerfully expressive drawing of just these feet. But how on earth had she achieved the effect of the nails penetrating the flesh – surely she could not have simply imagined this!

> Well, you see, we have this big deep freeze at home and I got my dad to get this big lump of pork and he hammered two bolts into it for me. I got my sister to stand on her toes until the veins stood out on her feet and then I painted the stigmata onto her feet with cochineal.

By using her imagination she 'just put the two together'. A previously disinterested student of little assumed ability had produced this extraordinary study for a small detail in her painting which she could so easily have fudged with the information she already had. In that painting the symbolism is further extended into the colour, with 'the red for the Mary Magdalene and the blue on her mum for the Virgin Mary'. This examination painting is the fitting culmination of all Samantha's efforts of that year. The bridging of fifteenth-century Flemish values with Samantha's contemporary concerns imbues her work with a historical dimension and feeling, and it is also overlaid with strong social, cultural, moral and religious values. Samantha demonstrates practical skill in this work, but her skill is used to convey the underlying concepts and ideas and it also clearly relates to qualities she has discovered in the Flemish art which she loves.

Nicola is another student who delved deep into symbols and their meanings in response to another examination topic, 'Pandora's Box'. On her preparatory study sheets which accompanied the resulting painting she included a statement which summarised her research into the actual 'Pandora's Box' myth. It inevitably aroused quite a lot of group discussion and amusement on 'sexist' grounds. She wrote:

Pandora was created by the Gods. Hephaestus fashioned her in clay, Athene breathed life into her, and taught her to cook and sew. Hermes taught her guile, deception and false charm. Aphrodite taught her to be desirable to all men. Other Goddesses robed her in silver and placed a garland of flowers on her hair. Zeus gave her a casket and told her never to open [it]. She married Epimethus. Out of curiosity she opened the box. There was a rustling sound of great wind. Out of the box blew all the evils which have troubled us ever since: hardship, poverty, old age, sickness, vice, jealousy, passion and distrust. She tried to close the box, but it was too late. The contents had scattered far and wide. Zeus had his revenge on mankind. They were no longer a threat to his power.

However Zeus had not triumphed altogether. When Pandora looked inside the casket she saw that one thing remained at the very bottom. She shut the lid and trapped it. It was Hope.

By saving this, Mankind had found a way of surviving in this new, hostile world. With Hope he had a reason for going on living.

But how might a student represent such a subject in pictorial terms? Nicola researched into the nature and usage of the relevant pictorial symbols and effectively incorporated these into her initial drawn design, collaging the abstract ones having first painted them. The eventual painting remained quite faithful to this study, and she described the process as follows:

In Pandora's Box I chose to represent individually each of the evils which came out of the box; Death represented by a Skull; lust represented by the lovers; fear, illness and vice represented by various other faces. I chose to represent Hope by a foetus-like baby in the bottom of the jar, although I would like to have worked into this area more, had I had more time.

I was influenced in my work by the drawings of both Edvard Munch and Richard Dadd; from Munch I especially learned that hairless heads show more expression than ones with hair. The symbols I used are actual symbols of evil used by the pre-Raphaelite painters, which I developed, with colour, in the style of illuminated manuscript initials.

In the painting Nicola has depicted Pandora starting back in horror, eyes literally popping out of her head, as the swirling mass of demoniac figures and abstract symbols rise upwards from the flask in her hand.

In her treatment of the same subject, Erica has incorporated an extraordinary trio of expressive snarling heads, each derived from

91

92

self-portrait drawings with flowing hair. A Sinbad film in which figures and objects are transformed into stone helped her to see possibilities for her work. In her painting she therefore depicted the foul contaminating air escaping from the flask as polluting everything it touched. The edges of flower petals, initially pristine in their perfection, turn neutral in colour or become an unnatural green as they are transmuted into something unpleasant by the vile air which eventually forms into the three heads, symbolic of evil, at the top of the painting. In order to effectively render these transitions in an appropriately subtle manner, Erica chooses watercolour as the medium best suited to this task.

For her painting, Erica made separate studies, some using Caran D'Ache pencils, but those of flowers were in watercolour. When she came to make the actual painting, the 'design' was so clear in her mind's eye that she was able to draw out her composition in a direct manner incorporating the various studies she had made as they became appropriate. Nicola, on the other hand, had also made numerous individual small studies but she then made an A2 drawing in which the design of the eventual painting was fully established. This is in keeping with many of the examples already set out in the

93

Plate 91 *Nicola used both figurative and abstract symbols in her 'Pandora's Box' pencil-drawn study, the abstract ones being painted in colour and then stuck onto the drawing.*

Plate 92 *Through extensive research she was able to identify and make use of the symbols of evil which the Pre-Raphaelites had used in their paintings.*

Plate 93 *Her painting was of the moment when the world's evils escaped from their container.*

'Personalised use of the sketchbook' section where the students' testimonies make it clear that they are consciously engaging in compositional ideas whilst actually sketching. Having already established these design principles, the student can accurately transfer them from sketch to canvas, printing block, or whatever, by a variety of means. If the work is to scale, one simple method is to trace the main contours of the design and to then draw over them onto the picture surface, having put something like chalk on the reverse side of the tracing paper. The commonest method is to square up the drawing and establish the same number of similarly proportioned squares or rectangles on the surface to be painted. This was the method which Nicola used to transfer her drawn design onto the painting.

Some students are resistant to such methods, though, as they prefer to draw out the painting more freely, perhaps in paint from the word go so as to avoid being inhibited by the more precise lines which tend to result from squaring up. Anita provides a good illustration. Her first oil painting 'was a disaster', she recalls. The colour had become dull and muddy as the brushstrokes merged together, but in

her art history she had looked at Cézanne and studied Seurat 'in quite great depth', and so in her next painting, she says,

> ... I did a very little bit of drawing up, it was hardly worth doing, and I based it on a sort of mixture of Cézanne's style and Seurat. I did it in blocks of colour and I used a square brush, and nearly everything is in blocks of colour. It's a sort of pointillistic approach but with blocks of colour the same as Cézanne used. So it's pointillistic but the blocks are square, if you follow me. I found out where I was going wrong with my oil painting, why the colours looked so muddy, and that if I applied the paint in separate blocks and kept the colour more pure without trying to mix it in with other things, it would come out fresher, sharper, and that was the effect that I was trying to achieve. I could connect the Art History with what I was trying to do in class more readily, and I found out that you can learn from other people – not just your classmates – but from other people; from the artists of the past, the Great Masters and all that.

Anthony developed an interest in Turner, particularly when he had opportunity to study his works in quantity in London (see p.88) and

Plates 94 & 95 *Erica studied her own face to provide the basis for an extraordinary series of snarling heads for use in her version of 'Pandora's Box'.*

94

he, too, found that the bond he felt for Turner's work was relevant to his own practical needs:

> I think it was the colour and the application of the paint. When you look at reproductions you can only see the colour, but the application of the paint stood out as well because the techniques were so varied, and that became interesting because it started applying to my own paintings as well. It was the glazes on top of rich impasto, and it was the way they seemed to shine through underneath. And the various techniques that nobody else was using at the time as well, like using his own hands and fingers and such, instead of brushes and rags. There was evidence of that in the paintings as well. That was the side, you know, the techniques, that influenced me.

Anne-Marie spent a long time in the Courtauld Institute studying Manet's *The Bar at the Folies-Bergère* but just studied one of the corners:

> It was the way he had created a bottle . . . the paint was so sort of fluid. It wasn't like paint. It wasn't like he was trying to make the paint become a glass bottle. It was just paint, and if

95 96

you just took a little tiny section it wasn't anything . . . He just seemed to enjoy using the paint and to get it to describe something as well seemed just an extra plus in its favour . . . he had seemed to enjoy putting that paint on the canvas so much that I thought, 'Well why not just use the paint . . . why not just love putting it on instead of worrying about what it stands for and whether it will describe something adequately'.

Anita, Anthony and Anne-Marie are all describing how they arrived at solutions to their own particular technical problems through the study of other artists work to which they were individually attracted because of the affinity which each felt for particular artists. All the 'How to do it' books – and there are many of them – concentrate almost exclusively on technique and make the easy assumption that the same techniques applied in the same way are of equal relevance to all. Each of the three students, by comparison, is 'taking' from another artist something which is of particular relevance to them as individuals at that time. This process has been a natural and

Plate 96 *Painting in a 'sort of mixture of Cézanne's style and Seurat', Anita discovered that she could keep the colour fresh, sharp and pure without it becoming muddy. (Detail.)*

important part of the formative stage of the majority of artist's development. Lucien Freud now expresses regret at his lack of flexibility in this respect and feels that, by working in too great an enforced isolation, there was a period when mannerisms developed in his work:

> I always felt that my work hadn't much to do with art; my admirations for other art had very little room to show themselves in my work because I hoped that if I concentrated enough the intensityof scrutiny alone would force life into the pictures. I ignored the fact that art, after all, derives from art. Now I realize that this is the case.

As has already been illustrated, these types of beneficial influence are not restricted solely to techniques and processes but can also relate to subject matter, content and ways of seeing the world, to formal properties of organisation and to moods and feelings conveyed by works.

Mark demonstrates some of these wider influences. He had a special interest in Stanley Spencer, admiring the strength and forceful reality of his works. His grandfather also grew a number of apple trees,

> . . . and at that particular season there are all these apples all over the place and there are people coming after these apples. So I thought, 'Why not do one of this!'

He had not seen the *Apple Gatherers* painting by Spencer in the original, but it was a work which he knew about and admired in reproduction form and so he decided to call his painting *Apple Eaters*, imagining it to be a kind of sequel to *Apple Gatherers*. He still thinks that Spencer's work is brilliant, but a TV drama-documentary 'exploded the myth' of the artist for Mark. Nevertheless, at the time of *Apple Eaters* he was regularly buried in the Stanley Spencer 1980 Royal Academy catalogue and, in keeping with Spencer's methods, he deliberately made use of 'non-perspectival space, distortions of scale and form, and a new stress on the picture surface'. One of the things he does, for example, is tilt the bucket of apples forward so that the contents would show far more clearly than if he simply drew it in correct perspective with a much narrower elipse. This device also reflects the interest which he was developing in Cézanne:

> I'd been doing Cézanne in Art History and probably this had subconsciously affected me. So I was thinking, 'Well, apples – perfect really. Big, juicy red apples!' . . . I wanted the apples tilted as though they were taking up most of the picture space,

so they would be the main thing in it. The apples came out better than I thought, actually. I like the Cézanne's, and Cézanne's way of treating those apples certainly affected me.

Amongst those he had seen on slide, 'there was a little detail of one apple that was like a painting in itself really', and after completing the painting he has 'looked at a few Cézannes since'. He included his brother and mother in the painting, the brother with strangely thin arms, 'and an imaginary figure in the middle, the little one with its tongue out – just to add a bit of humour, I suppose'. Mark had taken so long over the drawing he made for this painting, that the apples he had been working from all went bad and so he thought that it would be amusing to suggest that this young child had plucked an apple out of the bucket, taken a bite and then discovered that he was eating a bad apple. Another explanation be gave was that the child was feeling sick from having eaten too many apples! Finally, another strange feature of the design is that there is a large hand coming into the picture at the top left hand corner. It is holding an apple and symbolises the grandfather, the person responsible for all the apples being there and offering up yet another. Mark wanted his painting to be on canvas, in keeping with the artist's works which he had been so impressed by. It is rich in colour and strong in tone and was painted in oil paint, mainly at home. Though it is formally striking, Mark reveals that the high content level was an important feature in shaping its overall design.

Subject matter was also important to Viv, as has already been illustrated in the sketchbook section (see p.71) where she describes what it was that attracted her to a dead tree. This is one of numerous tree studies which were to form the basis for an eight foot high triptych, each section comprised of one tree. At the sketching stage, ideas about colour were influenced by a Vlaminck painting:

> ... when I began to think about possible colour schemes for these paintings, a Fauve painting of a number of red trees came back to my mind. The use of raw colour could create a harsh, violent mood which would increase the atmosphere of pain and frustration in the images.

At the October stage of the Upper-Sixth year she had not actually started work on the triptych, but was thinking about it and having further ideas with regard to the colour:

> I would like to expand these drawings onto a much larger scale, with the tree mainly in black and white, with some subtle colour, and placed in a brightly coloured, lively environment so that the solid, static form of the tree will be contrasted with the plant-life around it. It would be interesting to introduce a cloud

effect into the sky to highlight the dark silhouettes of the branches. The last tree in the project as it stands at the moment is similar to the first tree in this group, with its huge, solid, tube-like limbs and rings of bark.

By December she was well on with the project, having devoted every available lunchtime and free period, in addition to officially time-tabled sessions, to the three panels:

> The left-hand side of the triptych was completed first, followed by the right-hand side. I am currently working on the central part of the triptych. Now that it is nearing completion, this piece of work appears to represent progressive stages in the development of the tree when viewed from right to left. The right-hand side depicts a vigorous, aggressive tree, with strong supple limbs and sharp angular twigs. The left-hand side, when compared with the right, seems limp and lifeless, drained of life's energy and devoid of emotion. The passivity of this side of the triptych counteracts the hostility of the opposite side.

These concerns for the expressive characteristics of the trees themselves led Viv to change her original intentions. She drew them in black chalk and charcoal, with paler modelling within, and silhouetted them against a white sky, eliminating all thoughts of colour:

> The trees on each side curve outwards away from the centre of the composition, commanding attention in their own right rather than focusing the eye on the straight diagonal form in the middle of the triptych. This central form can be regarded as an intermediate stage between the enthusiastic right-hand side and the weary left

Standing out starkly against the pale sky, each tree became, in effect, an imposing icon. The taut outward curves of the flanking trees were in marked contrast to the straightness of the central diagonal tree; all were related but each had its own identity. Viv said of the central section:

> Whilst working on this part of the composition, I have tried to exaggerate and emphasise any shapes and contours involved within the texture of the bark, thus creating a more abstract design across its surface. An offshoot from the tree or fallen limb passing across the front of the scene will be more detailed than the tree behind it so that it will appear to be closer to the spectator while the tree recedes beyond this limb. As there are larger amounts of foliage from the bushes in this drawing, I am trying to introduce more tonal variation from the top of the bush to the bottom, which is overshadowed by the tree.

Plate 97 *Mark's 'Apple Eaters' combined admiration for Spencer with a response to Cézanne's still-life paintings.*

Plate 98 *The bucket of apples, top tilted to reveal its contents, has a distinctly Cézannesque feel.*

Plate 99 *One particular slide contained 'a little detail of one apple that was like a painting in itself really'.*

Plate 100 *Viv's tree triptych, hanging floor to ceiling on the main display wall during its execution, dominated the art studio.*

She contrasts the organic qualities of one of the trees against a manufactured structure, and wrote about the preparatory sketch,

> The third drawing in this series also features a pylon. Here the sharp angles and irregular forms of the tree are contrasted with the rigidity and regularity of form involved in this immense structure. The pylon appears to be much smaller and less important than the tree – is technology overtaking nature or vice versa?

To Viv, each tree she chose seemed to possess as much personality and character as a person, but important though content is to her, she vividly explains how her thinking revolved around the formal qualities which each of these three interrelated compositions posed. Incidentally, post A–level, she used the art department facilities to realise her Fauve ideas, producing a series of brilliantly coloured and boldly executed monoprints.

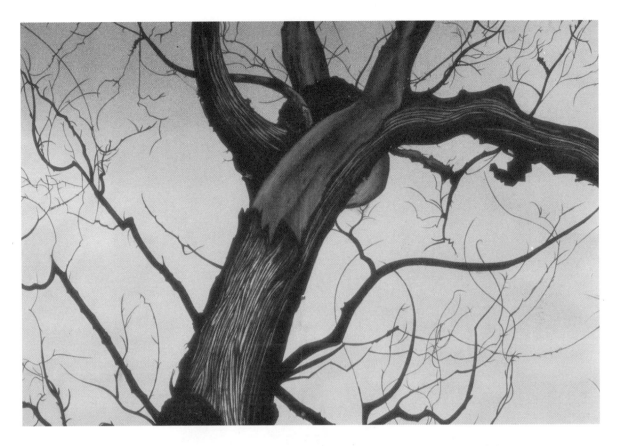

Plate 101 *The 'enthusiastic right hand tree', curving away from the centre of the composition, commanded attention in its own right.*

By comparison, Alan's work seems to be devoid of content. His abstract wooden constructions are built up out of found objects. Since he became involved in making these he has gathered a large collection of materials to use, and some of these suggest new works to come while others naturally find their place in existing works. The inspirational experience which set Alan on this course can be clearly marked. He went to an exhibition at the Turnpike Gallery, Leigh, called 'Applied Impressions' which was of works by Paul Ryan and Ian Walton:

> I got interested in Ian Walton and there were a couple of the pieces I particularly liked where he went walking along a beach and picked up stuff. Then he made a sculpture, like a low-relief picture out of the pieces that he had. There was a workshop there where it was suggested that you choose objects and you might like to put them together. The first one was really bad, it didn't work at all.

Plate 102 *Alan's first assemblage sculpture produced in college after the unsuccessful but invaluable gallery-based Ian Walton workshop.*

Plate 103 *The factory sculpture maquette complete with chime bars, etched metal section and wind propellors, made to a Design Brief.*

In his terms, that gallery-based workshop piece he did was a complete failure, but the experience had been stimulating and thought-provoking:

> It got me interested, though, and I came back to College and I started tinkering about. I found a lot of old wood behind the wood department, the C.D.T. department, and I started playing about with this wood and I started finding it was working better if I kind of focused my mind on some sort of image and just played about trying to create that image.

Though the works are completely abstract in appearance, Alan realised that, for him at least, it was important that he had some image in his mind in order to enable him to create the necessary relationships between the various component pieces:

> So for the first one, the one with the wooden struts, I was thinking of some sort of town or village or a city, and I created a kind of landscape with all the buildings, and I thought, 'O.K., but I think it needs something else.'

It was on a board and so he added another piece to represent the sky, but this did not work because sky and landscape did not connect together in any formal way:

> I found a pole, like a thick wooden dowel, and then I got a curved piece of wood and I put this down, and these did help connect the two together. It was all on a big frame and I thought it was still missing something. I thought, 'what else is there in a town on village?' It was raining at the time and I thought, 'Oh, that looks pretty good'. It was just splattering on the window, and so I put struts down to produce an image of rain.

These were angled representing driving, slanting rain but, unless informed that they were rain, the casual observer would only see them and the sculpture as a whole as being of an abstract nature:

> It's not what they're meant to be that's important. It's what they look like that matters. It's more looking at the shapes and the movement in them than looking for pointers as to what they actually are. At the moment I'm interested in movement, like the interweaving movement in and out of things.

As he became more involved in his constructions, he became increasingly aware that 'there's all these materials around you to be exploited', rather than art just having to be produced with clay or a pencil. He admires many of the drawings which he sees other students producing, but he likes to draw more freely.

> ... and I tend to let the materials dictate more, because using
> found objects you can adapt but only to a certain extent,
> because if you cut them all up you would be destroying the
> whole idea of found objects, but I would adapt a shape to the
> movement. It's the initial shape that attracted me to that object
> and made me pick it up in the first place.

It therefore has to be treated with respect as far as Alan is concerned.
Rather than modify it to make it fit into a predetermined design,
reducing its size in order to do this, he would let that object form the
basis for another maybe larger work.

Another beauty of these constructions, as far as he is concerned, is
that the forms do not restrict him to rectangular works:

> I like things spreading out more, rather than just be confined
> within the shape of the rectangle. I like the shapes of things
> jutting out.

His latest piece is a maquette for a factory sculpture and, in addition
to being irregular in shape, it also makes use of actual movement and
sounds. It is intended to be constructed on the actual building and
incorporates pipes to carry away the factory steam. Propeller-type
blades are turned by the wind and, in the maquette, closely related
copper tubes act as chime bells. The length of each piece of copper
tubing has had to be determined by its visual relationship to the
other elements of the design and by the actual sound which it
contributes to the chimes.

Alan, then, has become extremely inventive, imaginatively
exploiting the many possibilities suggested by the various objects
which he collects. He entered into this world quite suddenly
through contact with Ian Walton's work and, in the process, he has
certainly moved a long way away from conventional notions of what
A-level Art is about. His works do have content to them, but not in
an obvious way, and are carefully thought through in formal terms
but, first and foremost, Alan has learnt that a whole set of
constructional possibilites are opened up by allowing the materials
themselves to suggest how they might be utilised.

The factory maquette was made to a Design Brief, but Alan made
full use of the skills he had already acquired in making his previous
constructions. Though designed in a considered way, it benefited
from Alan having already worked in a deeply involving and
personally satisfying related way. Designing too often becomes an
impoverished activity, to the detriment of society as a whole. Design
skills, however, revolve around the extraordinary ability possessed
by human beings of being able to envisage that which does not yet
exist and to then realise it through a planned sequence of activities.

104

105

Plate 104 *Mandy's project displayed in Drumcroon to show the developments from the interlocking clay heads through the large drawing and on to the cane and wire heads. The project is both expressive and to do with problem-solving.*

Plate 105 *One of the cane heads showing the expressive qualities and the consummate skills of craftsmanship involved.*

Many examples of design-related thinking and working appear throughout this book, and Art and Design is the perfect subject to develop design understanding and awareness in a personally involving manner. Mandy further illustrates the point through a project relating to the humorous teenage drawings of Michael Rothenstein, recalling,

> I was inspired to work using clay after seeing Christine
> Merton's ceramic work (*Love Knot* in particular) at Drumcroon. I
> decided to work towards a 3-D project using the Michael
> Rothenstein project as a starting point in the summer holidays. I
> took caricature as my theme and made a series of interlocking

clay heads. The heads are distorted. The distortion came about from my looking at the prominent part of the people's faces that I used. I acquired new technical skills during the project and now I think that a 'perfect' face is rather boring and I can accept and even prefer a face with more character in it.

Expressive though her writing is, the project also led her through a whole sequence of problem-solving activites. Starting with the interlocking heads in clay, she then moved onto a large black and white on grey paper drawing which provided the basis for a series of cane heads which will eventually become one interrelated construction. Many design activities require special skills of craftsmanship and Mandy became extraordinarily adept at manipulating the cane and joining one piece to another with fine wire so as to realise the complex three-dimensional head forms, complete with distortions, which she envisaged.

All students should be educated to become more design conscious and, not surprisingly, many of the students featured in this book proceeded to Design courses in higher education to train as architects, fashion and textiles designers, in television, film and design animation, carpet design, and making three-dimensional studies. Craftsmanship and clearly-expressed design intentions are characteristics of the case studies which conclude this section. A painting example is included, emphasising that craftsmanship is essential to a wide range of art and design activities and is not restricted to those known as the 'Crafts'.

Caroline is another student who is inventive and experimental in her use of materials and processes and, in much the same way as Alan has exploited movement and sound, she has made conscious use of the play of light in an examination textiles piece which she has constructed. In an accompanying statement to the work, she wrote.

> The lighting is crucial to this piece of work as the piece is in relief. The lighting creates shadows which are important in creating form and colour on this piece.
> Also shadows are created on the white paper background which add to the feel of the piece.

She experimented with many nuances, angles and strengths of lighting, eventually becoming absolutely specific and clear as to how this should be taken account of:

> This piece of work, *Shell Bay*, should be ideally mounted in a perspex window box with the light coming from the NNE direction in the form of spotlights.

106

Plate 106 *Part of Caroline's 'Shell Bay' study sheet illustrating how she developed her ideas in an experimental yet methodical way, and the varied use to which she put her hand-made paper, combined here with embroidery, Caran D' Ache, watercolour, sequins and collage processes.*

Plate 107 *The irregularly-shaped 'Shell Bay', its relief forms shown to best advantage, Caroline thought, if seen through perspex and lit from a NNE direction.*

107

Like Alan's constructions, Caroline conceived of this piece as being of an irregular, rather than a rectangular shape:

> The shape of my final piece is not geometrical as I wanted to create a completely natural environment where you would find the shells, so I therefore brought into my piece the idea of pools of water and seaweed.

It was also constructed in relief, with some of the forms projecting forwards, and was particularly appealing to Caroline because she likes 'to work from nature with natural forms as I like the natural

colours, shapes and textures which can be seen on them'. The project gave her the opportunity to make her own hand-made paper, formed into natural shapes and utilising the kinds of natural colours found in pools of water. In the process she evolved some unusual and distinctive methods of working:

> The shell moulds were made by painting latex onto the shell and letting it set. Then I peeled off the mould. Into the mould I placed paper pulp of different colours or I dyed the pulp once it was in the mould. Then I squeezed the pulp into the mould to get the surface impressions of the shell. This was then left to dry. Once it was dry I coloured the paper shell with Caran D'Ache pencils and sewed it with threads and beads. The above shell and mould is only a small example of the techniques I used.

In Caroline's work, the experimental, constructional and assemblage qualities which characterise Alan's sculptures find their equivalence through a variety of textiles processes.

The experimentation involved in making these wooden and textiles assemblages can be readily appreciated, but when Anne-Marie attempted to make a watercolour painting heightened with drawing as her A–level examination piece, there was a risk factor right up to the last moment. This was because she was seeking to bring together, in the one work, two opposite aspects of her temperament and personality; one to do with firm, decisive drawing, the other with mystery, ambiguity and allusion. Now in higher education, she finds it frustrating that her textiles tutors frequently advise her to play safe and, 'stick to one':

> I find I still have to do what I have to do, because otherwise it's not my work. It's a surprise all the time, even now. You can have preconceptions to a certain extent, but you should let something else take over.

To this day she sees that A–level painting as marking an important stage in her development and as relevant to what she feels she is attempting at higher education level:

> I always go back and think of the piece that I did for my A–level, and I really enjoy that process that I went through. I still find that I come back to certain ideas that I had in that piece. I can still become motivated from that point because I felt that it was me and mine because I gave expression to ideas that I hadn't thought of before. I don't think it felt felt like an exam because it was something else that I was doing, like a kind of

expression of my development. Even though we were restricted on time, I just did what I wanted to do Actually, the fact that it was an exam put pressure on the piece to resolve itself.

Her painting was in response to a passage from a Shakespeare sonnet which featured the rays of the sun. She chose to represent these symbolically:

> The way I thought of doing this was by using a candle and incorporating the rays and the glow that you get from it to represent the sun's image. And by having the girl holding the candle, it was like humanity holding the sun, which obviously can't happen. It was like capturing the sun and having it trapped behind glass, putting it in a bubble, in a capsule. I was trying to create the impossible by having this.

In the preliminary studies, the two aspects remained separate. One study was a firm and decisive pencil drawing of a figure. It began as a study of her sister's hands holding the candle to which she then added beads and lace, finally resolving it into a complete piece in its own right by completing the figure by incorporating a self-portrait staring directly out of the picture. The second preparatory piece was an extremely delicate watercolour study of a window. This was viewed from outside so that the main features were the reflections of garden and sky, the study creating uncertainty as to whether particular parts were reflection or what was actually through the window:

> I thought this was an ideal opportunity to combine the two qualities and make them into one. I did this with washes of colour, adding to them with a pencil and then coming back to do a third thing by working again on top of what I'd got, resolving some areas and leaving others I highlighted the eyes, so that they became a dominating part that the viewer could look at and focus on the person holding the candle Then by actually having the two, the reflected image and this drawn figure, I was able to let things come and go so they weren't actually what they seemed to be, a straightforward image I brought things forward and let others go back so that your eye came in and saw the candle, and this was then broken up by the fluidity of the colour over it... I wanted to have some of the neally strong drawing qualities and the really washed-out effects in together. By having these two together I was able to come up with this third quality which was to do with homing in on areas so that your eye would focus on them.

Plate 108 *In the painting, Anne-Marie tried to give it 'a chance to talk back',
letting things 'come and go so they weren't actually what they seemed to be, a
straightforward image'.*

As she became more and more involved in this process, it was as if
the painting took on a life of its own to which she had to be
responsive:

> It was as if I was giving the painting a chance to talk back and it
> was as if it wasn't my decision. It was the reflectiveness of it

that I wanted to portray. The colour became really rich and deep and I bounded that with pencil so that an area became almost a little world on its own, and then it would fade off into old lace that the girl was wearing. Lace and curtain then mixed so that you didn't know if she was there or not. It was that uncertainty all the time, because I remember thinking, 'This is not going to work, this is not going to work!' When finally it did resolve itself, I felt I was just watching it happen, even though it was me who was doing it It just gelled in the time that I worked on it. I'd leave it and I'd come back to it and it was as if somebody else had worked on it, because I thought, 'I've not done that!' The two elements combined to form a third, a mix and match like a jigsaw and it was how I'd slotted them together to come up with this.

Each viewer could approach the resulting painting differently each time according to their mood of the moment:

What draws your eye in? Is it the detail or the vagueness? It's to do with whatever is in you; depending on how you are feeling will determine what you actually pick out.

Her art history knowledge played a crucial part in shaping her approach to this painting. Her A−level Personal Study was about the medium of watercolour and in this she made an in-depth study of both William Blake and Turner's handling of watercolour. She came to understand that qualities in their work paralleled the two opposite elements in her own:

I'd really got interested in Blake and his use of line, and the strength he gave to line and the power that he thought that line had on every decision that he made. I really took that in and didn't realise how much that did influence me. By looking at him and seeing the strength that he used, I could translate that back into my own work and tie up the looseness that Turner had given to colour and combine them to give me my effect in the end.

The first preliminary study with its firm, decisive drawing related to her love of Blake and the watercolour study with its subtle layerings of colour washes relected her love of Turner:

Blake wanted to capture what he'd done by flooding with colour and letting it override the line, but then giving it a boundary where he was putting the mark. He made the decision as to where he wanted the eye to stop. It was almost as if he wanted to section it off and what was outside wasn't of any importance. But I found that was important to me – the fact that

the colour had its own mind and could extend the line combined with the way that Turner worked with colour. His looseness and the richness that he gives to colour, getting the colour to work for him. Combining both together allowed me to develop, like, into a third person. It's like allowing both sides of me to develop by themselves, but then they come together to create something that I've not thought about. It's that, the surprise in the end, that I really enjoy.

Many artists can readily relate to what Anne-Marie describes, for they too work in a similarly open-ended manner. However thorough their preparation might be, the actual execution of a painting frequently leads to uncertainties as particular brushstrokes and marks open up possibilities and alternative directions which could not even be envisaged at the outset. These, in turn, give the painting 'a chance to talk back', as Anne-Marie expresses it. This is quite a sophisticated approach to painting at the A–level stage, particularly when it is considered that this student only began the course after dropping Biology in the December of the Lower-Sixth year, meaning that her course was, in reality, only of one year and one term's duration prior to her making this painting.

Stuart took his A–levels following an even more compressed course, for he only began his art studies at the end of the Lower-Sixth year after dropping another subject and feeling rather disillusioned. Nevertheless, he soon developed a positive interest in Japanese prints and the work of, in particular, Van Gogh, and he rapidly developed proficient printmaking skills of his own, cutting the lino block with great precision and expressiveness. He was immediately attracted to an A–level question which cited Van Gogh's chair as an object which was imbued with the characteristics of its owner. Candidates were invited to make their own studies of a chair and to endow it with similar attributes as the basis for printmaking. Stuart felt that this provided him with an ideal opportunity to produce a print which gave expression to some of his deeply felt social concerns. He drew his grandfather's chair and wanted to emphasise that it was that of an elderly person living in our materialistic society in which old people are becoming increasingly disadvantaged. In the process, he made use of newspaper headlines to give expression to his concerns about the developing under-class of neglected people generally. The chair back had eyes and almost made a face, and he accompanied his print with this statement:

> The lettering at the top of the print was taken from a *Morning Star* headline about the eviction of homeless people from Goverment buildings in Bromley. Originally the actual

109

110

Plate 109 *Anne-Marie's decisively drawn, first study of the girl holding the candle, in pencil on coloured paper, combined her sister's hands with a self-portrait.*

Plate 110 *As well as being technically accomplished, Stuart also sought to use his linocut as a medium through which to make a strong statement about contemporary issues and values.*

newspaper was incorporated into the print design but I decided that the design would be more in keeping with the decorative qualities required within a print if just the lettering was used.

The headline was used to try and show the contrast between the traditionally poor working class and the people who are now even poorer as a result of (the) return to 'Victorian Values'! I have tried to keep a feeling of underlying anger in the rest of the print, particularly in the eyes, again trying to contrast the safe comfortable surroundings of the chair to the escalating anger and violence in the streets.

The social concerns to which Stuart is giving expression are not dissimilar to those which Alan has addressed in his writing about the *Cable Street Mural*, already dealt with in the Critical Studies section.

It will be recalled that, even though he is dealing with a mural about the political conflicts of 1936, he frequently equates those with 'the tensions behind the present social unrest'. (See p.116).

Art is one of Alan's three A–level subjects, but it has come to mean by far the most to him, mainly because it provides such scope for personal involvement and expression of ideas:

> I think it's more personal than other subjects. In other subjects they don't give you a chance to find out about yourself and about other things. Everything is written down, and so that's how it is, that's how it's got to be you just read about something and you have to take it in and then perhaps use it in a question sometime or perhaps never use it at all. But with Art everything comes together and sooner on later you're going to use what you see. Everything you do gets stored up somewhere, just like a collection of experiences. You might see something that will trigger something else off in you which you want to use Art is more expressive as well. You can't express yourself in other subjects as you can through drawing or building sculptures, or things like that. In other subjects it's all writing and talking; you can't actually do something physical to say what you mean. In Art you're using your own ideas more I think that Art people are a lot more interesting because the other people, unless they have something else outside College, I don't think they notice as much or are as individual in the way they think.

Inevitably, therefore, a percentage of art and design students are going to give expression to some of the social and political issues of the day which are of concern to them.

Compared with screen and lino printing, the woodcut is less commonly practised at sixth-form level, but in becoming an adept practitioner, Robert acknowledged his own college's tradition and such gallery exhibits as those of Michael Rothenstein, a leading exponent of the process:

> Ideas for technique when cutting the wood have come mainly from students previously at the college, though Drumcroon has also recently displayed a selection of woodcarvings and prints.

His first such print was based on a sketchbook study he had made of the landscape visible from the art department:

> The preparation sketch contained much detail and was therefore very helpful later on. There was in fact enough information in the one study. The tone values were mainly worked out doing the preparation, making later life easier.

He used a plywood offcut acquired from a timber-yard and had to overcome a number of problems, particularly at the printing stage:

> Many difficulties have arisen using the wood block and so far all have been solved – the main one being getting the print itself. The wood is too big to put under a press, so a wooden spoon was used instead. This took a lot longer and was a bit boring, but it was worth it seeing the end result. Another will be registration, as we will have to use the naked eye to get as near perfect as possible.

To ensure precision, two people had to be involved at the registration stage. Robert used the same block for each colour, a method known as the 'elimination' process. After printing one colour, the same block has more surface cut away to be rolled up for the next colour to be overprinted, and so on. Some were printed onto his own hand-made paper which, 'being so big, made the process clumsy and longer but again worth it'. Strings and grasses, added at the pulp stage, became an integral part of the paper as well as becoming a feature of the landscape being depicted. Even at a relatively early stage in the print, Robert had become sufficiently involved to write, 'I am enjoying the work and planning future projects in printing', noting that for the next print, 'a lot of thought has gone into how each part will cut at the same time as it is being drawn'.

Marnie was similarly affected, as Carole had been (see the Critical Studies section), by the Japanese and Chinese works displayed in the Victoria and Albert Museum. Her resulting work was in mixed-media, but again prominently featuring wood block printing combined with observational work. Her sketchbook,

> . . . helps me to discipline myself into constantly observing things and to really know how the human body works, especially the face I am now working on a self-portrait. I drew it first as a study and I'm going to to transfer it into oils on pastels on A4. I'm going to make a circular wooden frame and carve into it and make a print for a border.

She cut her frame out on the jig-saw, and the left-over central circular piece immediately suggested another printing block, leading to two obviously related but distinct pieces of work. One had a printed centre piece and pastel-drawn border, the other a printed border with the self-portrait, executed in pastels, in the centre. The latter was not achieved without worries because,

> I'm quite apprehensive of working in colour, since I've been safely sticking to pencil so far, except for one drawing I did in

pastels. It worked quite well but was a bit lacking in dimension and life. I found it quite difficult to get the right colours. I put too much blue in it and made it look quite colourless.

Learning from the experience, she achieved considerable richness in the circular version. The border design was based on a Chinese plate motif, and her print quality had obvious relationships with the Japanese prints she had seen. The self-portraits all owed a debt to the Pre-Raphaelites because their paintings,

> . . . interest me greatly, I love the colour and detail, especially in the faces. I like the way Burne-Jones paints large, doe eyes that capture emotion; I try to capture that in my drawings; one drawing I did in my sketchbook was very Pre-Raphaelite influenced – bare shoulders and face with large flowers around the bottom edge and growing up the sides.

Her two circular works were therefore quite complex in the strands which they brought together, as well as combining pastel and relief print in a strikingly original manner.

Even at sixth-form level, it is not uncommon for a medium like lino printing to be regarded simply as a technique, with its potential as a vehicle for the communication of ideas ignored. Weaving is even more frequently seen in terms of process and technique, but Debbie demonstrates that it, too, can be approached in a broader spirit when it relates to sketchbook work and to her wider interests in the subject involving her responses to the work of other students as well as to that of more mature artists. Her testimony demonstrates how the alert student can pull together and utilise stimulus from a variety of sources to help her in the construction of a 100 × 90 cm woven hanging. This piece incorporates wool, cotton material, sisal, raffia, yarns and strings, and metal and netting along with plastic string were used to make knots, tufts and bobbles. Some parts were crocheted and she dyed all the materials herself as appropriate!

> The idea for the weaving began with my first A6 sketchbook. I had visited the Manchester Degree Course open-day Textiles and saw how people's ideas began in tiny sketchbooks full of colour studies, knitted or woven art forms and endless drawings and patterns. My own sketchbook began with a drawing of my goldfish *Chester* done with wax crayons, blusher brushes and highlighters. I was fascinated by the reds, oranges, yellows and pinks which seemed to mingle as the fish moved. From this one study the ideas just flowed and I found myself using all kinds of media: netting, onion bags, gold/yellow and white packing from melons (which I got from work) incorporated with silver

buttons, wood and material, all the time stretching the idea and working the colours in. The vegetation in ponds, etc. also blended into the habitat of the fish and exploring this became interesting.

The next sketchbook, the A5, was concerned with the tropical fish. I took my sketchbook to my brother's one night and the colours of the fish were such that I just had to get them down. The colours are more important, I think, in this sketchbook whereas in the 'A6' movement (along with colour) seemed to take priority. From these tropical fish I used machine embroidery on to the paper along with fleece, wool and paint.

At the time the College had an artist-in-residence, Angela Cusani, who showed Debbie how to blend the wool and thread together by using machine embroidery:

The paper had a textural effect due to the build-up of ripped up paper, wool and etching. They also had irregular shapes with applied inks. I found you could actually draw with the needle. The effects were very different from anything I had achieved earlier. I then began on the weaving itself by setting up the loom and dyeing the warp. My third sketchbook consisted of lots of colour studies and miniature pictures of how the weaving was to be designed. Angela showed me how to represent plain weave, tufts, etc. in a type of square grid. I like this idea for designing the weaving but for ordinary sketches I find it very off-putting as it makes me feel as if I have to be confined to drawing inside this square. The knots in the weaving were an idea that a lady called Carolyn Felton, seconded teacher artist-in-residence at the Drumcroon Education Art Centre made for her weaving. However I experimented with sisal, netting and gold/silver packing in the notebook. I did come across problems with the colour of the weaving and I found I needed to go back to the sketchbook and simplify the colour studies more. While I am very pleased with the colours I feel sometimes that Angela's influence (very bright, shocking colours) is all a big part of the colour scheme and, if I had made the weave without her help at all, my chosen colours would have been more subdued and darker. Yet not as eye catching an effect perhaps? As it is, with Angela's help I understand a lot more of what will work and what won't.

On reflection, she acknowledges how important seeing that work by the Textiles students had been to her, particularly in the way that they compiled information:

I do think that visiting Manchester and learning that

Plate 111 *A section of Debbie's 100 × 90 cm weaving conveys something of its richness of colour and texture and variety of treatment.*

sketchbooks can be fun, that you can make mistakes in them, whereas before I had this impression that the sketchbook was supposed to be page after page of wonderful drawings, has helped me to produce more and more work and perhaps not think of it in that way.

I can see the improvement I've made from the weaving I began last term and I am becoming more and more interested in 3-D effects in weaving.

Her investigative approach, involving her in the making of many preparatory studies and in the combination of a wide variety of materials, eventually led to the production of a large, impressive and texturally-rich hanging. This was matched by a harmoniously coloured weaving made by her friend Kathleen who, unlike Debbie, had no previous interest in textiles. Like Debbie, though, she also communicates the importance of the preparatory stages which she takes us through in graphic detail. Her involvement in textiles was stimulated by the presence of Angela Cusani as artist-in-residence at her college:

Plate 112 *Kathleen's sketchbook researches into plant and flower forms led to her use of varied weaving techniques, many of them experimental, in order achieve the necessary variety.*

I began work at the beginning of the term with our
artist-in-residence. This involved textile work: lots of colour,
texture and uneven surfaces in weaving, paper making, batik,
embroidery and collage. Her work was striking, interesting and
attracted my attention. I can't say that I had any interest in
weaving and such like previously but this time I wanted to try
out these new techniques, so I started from scratch and a little
imagination.

Before I strung up my frame I had a colour theme in mind
first of all. I wanted to use the varying shades of blue and green
with a dash of yellow. Therefore, I followed that through with a
subject matter, or rather hint of subject matter, of garden
growth: shrubs, buds, blossoms, blooms, tufts, hangings, etc.

She was already making sketches of gardens and plant forms and so
naturally built on this theme with the weaving in mind. She
describes five stages and sets of procedures which she goes through
in making her weaving preparations:

a) Beginning with a pencil sketch, I recorded the shape, form
and size of the woven matter. A cluster of knots, spirals, twists
and buds alongside the right and a slightly more open, less
busy, left-hand side with large flower heads and hangings. I also
thought about having hints of insects amongst the plants and
also glimpses of dew or spider's web along the top. I generally
wanted a busy bottom growing upwards, crossing and tangling
towards a softer and more subtle upper part of the weaving. The
shape was to be a long strip, a rectangle.
b) Next I jotted down my colour ideas. Blues merging into
green, areas of pale, lemony yellow, series of bottle greens, pea
greens and turquoises surrounding a patch of rich blue,
ultramarine. A garden-fresh, vegetably look, not that of a
scorched and dried plant life, but a well-watered, tropical
rain-forest sort of shrubbery.
c) Then came a study of everything put together. A full design
in colour leaving no patches of white on the page of the
sketchbook. I remember thinking at the time that this was
totally irrelevant to the weaving I was to begin. This was
probably because I hadn't yet thought about how I was going to
make all these grasses and buds and tufts. I am actually very
pleased now that I have these two studies. They were extremely
necessary before actually beginning to weave. I found that once
that obstacle was overcome, all that was needed was some
imagination, a sense of design and colour.
d) Any other ideas and inspirations were from there onwards
jotted down and made into a preparation study. So there now

follows a series of colour studies of the weaving together with sketches of what certain growths would look like. I found that the ideas and inspirations were most important and then the attempt at incorporating them into something like a weaving. What doesn't really matter is whether or not your finished piece looks anything like the studies. The idea was there and the attempt was made – an experiment is being carried out.
e) In my sketchbook I wrote down and tried to record all the types of material I would use, what I would do with them, what colours and where each tassle, bump or shrub would go. I wanted to use, as near as possible, all natural materials – sisal, wool, fleece, string, cotton and raffia, etc. Now and then I dye the wool and raffia and the material strips. To me, weaving has a different meaning now; the materials I use are knotted, knitted, twisted, hung, screwed up, spiralled and then woven into the loom. There seem to be no rules, therefore no pressure, tension or uncertainty. I'm very glad of my little sketchbook now, although I scoffed at the idea at first. I still intend to put more information in as I continue with the weaving. I need to include samples of the fabric and materials and colours from the dye that I've been using.

The ground thoroughly prepared, Kathleen began weaving, though not initially with relish because of her uncertainties about the process and whether or not she should be concentrating her energies on other aspects of the course to which she also felt drawn:

I was slow to begin the weaving. Probably unsure whether I was doing the right thing or not with the wool, raffia and the other materials. Also unsure whether doing a weaving in the first place was the right thing and interested me! I found it difficult to organise my time and motivate myself, finding that I had just begun to get into my work when the bell would ring for another lesson. I still haven't overcome that problem now, though I'm understanding what and how I must do things in order to make time.

As the work developed, though, she was increasingly able to capitalise on the thoroughness of her preparation:

The actual piece of work is not very large, just a long strip, rectangular in shape. I am trying to keep to my ideas. I have my sketchbook studies out when I work and refer to them regularly. The garden theme, to me, is working and it seems as though the coils and tufts are growing upwards, around and to the sides. I'm working slowly but I think solidly also. Even when I finish the length of weaving I intend to go back and go

Plate 113 *Jen's batik and machine-embroidered still-life grew naturally out of a series of studies she made in the art studio from a grouping set up there.*

114

115

Plate 114 *Renu wearing her batik and embroidered top, the pearls and sequins added at home adding to its natural fusion of European and Asian qualities. It combines padded silk, batik, dyes and embroidery with the beads and sequins.*

Plate 115 *Having already studied Maths and Sciences to A–level, Renu returned to College to study Art and Design. A few weeks into the course and she was able to wear the felt and machine-embroidered hat and glove embellished with threaded beads which she had designed and made.*

Plate 116 *By February, she had designed and made a salvaar kameez which she is wearing here, seated against Alison Taggart and Irene Bobkiewicz embroideries from the Wigan Schools Loan Collection.*

116

over, add to, sew onto and build again on top of what I already
have. At the moment the appearance of the work is fairly busy
but big and thick – in other words, I want to sew on, tie on all
the little details, little intricacies such as filaments and stamens,
antennae and wings, tiny bobbles and buds inside, and on the
larger flower forms. I want to make the effect finer and more
delicate.

As she became more and more involved in the weaving, so it became
more rewarding, even though the pull towards other areas of study
remained – typically, she lays the blame at her own door:

> The weaving is enjoyable and also fulfilling. In my previous
> work I've liked to involve texture with paint and doing a
> weaving makes it possible to get in touch with surfaces, rough,
> smooth, holey, soft, spiky, and to organise them into a
> composition that suggests a particular theme. I do, however, feel
> a need to do some drawing, i.e. painting in watercolour or oils. I
> feel disappointed that I haven't, as yet, got that under way.
> That again is probably due to my lack of organisation and
> sorting out of time.

Nevertheless, on completion, the weaving was strikingly original
and revealed a whole variety of inventive solutions as to how to
produce woven equivalents of flowers and plants. In addition to the
examples of Angela Cusani's work that Kathleen could see in the
department, she also had opportunity to study a group of weavings
by Tadek Beutlich. Some of the techniques she incorporated are
obviously based on those he used, but through experimentation she
has evolved equally satisfactory techniques of her own.

Another extraordinary textiles project arose from Angela's
residency being announced in the College bulletin with an invitation
to non-art students to work with her in the art department at
lunchtime. Renu was one who responded. She had lived in England
from the age of one, having been born in India, but she had done no
art in the previous two years. There was an inevitable tentativeness
about her first designs on paper, but as they developed Renu
communicated a clear idea of the shape, patterns within and colour
range which she wished to employ in the blouse she aimed to make.

Once she began actually working in textiles, she revealed a natural
sensitivity, the first batik sampler being beautiful in colour and
pattern. This provided a firm basis for the blouse itself, which Renu
worked on every lunchtime. She combined batik with machine
embroidery, eventually enhancing the textural qualities by padding
certain sections to give relief.

She began taking it home each evening and each day, on its
return, it had become more Asian in 'feel' as Renu embellished it

with sequins, beads and pearls. It became more and more personalised in the process until it could actually be worn. Nobody seeing Renu wearing this blouse could doubt for one moment that she had done more than imaginatively wed together a variety of textiles processes – in the process she had also unusually brought together and combined values and qualities from the European and Asian cultures with which she is familiar in the different areas of her life.

Like Kathleen, Jen also felt a tension between the time demanded by her textiles work in relation to her desire to work in other media. Though she enjoyed 'the freedom and spontaneity and boldness achieved by textiles', she felt that she did not have to push herself as hard as when she was figure drawing or painting. Nevertheless, she was making a large batik picture and, though she found applying the batik very boring and time consuming,

> Adding the inks was my favourite part, as I love experimenting with colour, especially bold, purer colours The final stages of the batik will bring the form more into perspective by adding shading and highlights by a method of cross-hatching, by applying more wax in the appropriate areas.

By using machine embroidery, added colour and textural effects were achieved while the addition of padding gave the finished piece a 'quilted bubbly feel'. The initial stimulus was a 'boring still life', but the patterns and shapes of these textiles processes gave it a 'lift'. She also found weaving 'very relaxing and therapeutic', but the thing which she found most demanding but rewarding was a detailed drawing of a textural piece of wood. Like Anne-Marie, she felt a frustration that she could only give expression first to one aspect of her personality and then to another. Like Anne-Marie she felt a desire to reconcile the two and therefore decided,

> . . . to concentrate more on fine art and then develop a balance afterwards between the two, so I won't feel that I'll be losing out.

This resolve led to her producing a trio of portraiture studies, executed in pencil, which formed the basis for a larger scale development. She described the stages and processes involved as follows:

> After the London visit in November 1986, I became very interested in the Pre-Raphaelite Brotherhood, mainly because of their jewel-like colours and immaculate detail. They showed much dedication in their work. At the start of my 3rd year at

Plate 117 *Jen was one of a number of students who, following A-level examinations, returned to the art and design studios to work as artists-in-residence as a liaison exercise with local schools. Her triple portrait forms the background to her studio area.*

College, the Art Department employed Angela Cusani as Artist-in-Residence. Working closely with Angela, my interest in a textiles approach grew and I wanted to combine textiles approaches, along with decorative detailed drawings, without one or the other taking over. I have tried to put this across in my recent work. The idea behind the work was to work along the lines of the very detailed Pre-Raphaelites and to include also a decorative Gothic style.

She observed that 'the art history lessons are inspiring students to read and use books therefore helping them to observe things such as relationships and their knowledge of style', and in referring to a decorative Gothic style she is thinking, in particular, of the fourteenth-century Sienese artist Duccio. She also makes use of

118

119

Plates 118 & 119 *The head of the wife (on the left) and that of the mistress illustrate Jen's use of mixed-media, incorporating Caran D'Ache, hand-made paper, collage, emboss, knitting, print, watercolour, embroidery and sequins. They also illustrate her love of detailed drawing and how she has used the flowing, rhythmic qualities of hair as a unifying element.*

qualities she finds in an artist of more recent times, Gustav Klimt. She continues,

> Also, in keeping with the Pre-Raphaelite approach, there is a moralistic view behind my work. The work consists of three heads – the first is the one of the wife. She represents mixed emotions of love, anger and sadness, for her husband's (middle figure) feelings are split between his wife and his mistress (the third figure). The husband is also smothered between the two. The mistress whilst fighting her own tormented feelings inside, is also being attacked by the comments and pressures of society. The never ending cycle of this 'affair' is also symbolised by the links and rhythmic qualities in the drawing (e.g. hair flowing into the next drawing).

The work was executed in a variety of media, and in it Jen was at last able to reconcile the two diverse aspects of her personality.

> I enjoyed doing this piece of work as it was a challenge and it also allowed me to express myself in two areas which I enjoy— textiles and detailed observational drawing. These two aspects are very often separated. Also a piece of work on this scale allowed me to incorporate different techniques such as printing, batik, knitting and emboss. It was interesting to involve these various techniques and combine them in a variety of ways. This is what I think art is all about.

As with so many of the student testimonies utilised in this book, Jen is handling quite complex concepts and ideas. She makes considerable demands on herself in order to develop the appropriate practical skills necessary to give expression to them. In the process, she also utilises her wider knowledge and awareness of art and artists. Because she has something genuine and personal to say, she can also find the appropriate words to articulate her ideas about art and design and what she is about.

Most of the books aimed at art and design students are of the 'How to do it' type. They will always fail their readers, because adolescent students are not the 'empty vessels' waiting to be filled up with art in the step by step technique-orientated way that the 'experts' who write them decree. By comparison, this book contains a wealth of information for students by students. It reveals their frustrations, aspirations and achievements and, as such, should have relevance to other students' needs. What a sixth-form student thinks art is all about is therefore an appropriate note on which to conclude.

POINTS REGARDING THE DEVELOPMENTS SECTION

1 This section includes work of a wide variety of processes and media which draw upon the skills and learning acquired by the students in their studies relating to all the previous sections.

2 Their work and testimonies illustrate that work of real depth and personal worth is possible within the confines of A-level examinations and courses, and that successful work does not have to be within examination moulds.

3 Examination set work can arise out of, and even be the culmination of, course concerns. Future emphasis on coursework assessment should make it easier for you to deal with direct interests and concerns.

4 It is possible to build up a coherent body of work based on worthwhile ideas and concepts which utilises your developing practical skills, and contextual and critical knowledge of art and design.

5 The Content, Form, Process and Mood model is as relevant to your own practice as it is to the study of other artists' work.

6 Art and design can provide you with an ideal vehicle for expressing your attitudes about life, including your social, cultural and political concerns.

7 It can also enable you to work through complex problems and to arrive at satisfactory solutions, the process being heightened because the risk factor means that failure is a possibility throughout.

8 The design aspect of art and design can develop methods of working which draw upon personal concerns as well as dealing with externally-dictated problems and needs.

9 Skills of craftsmanship should constantly be developed and practised in order that you realise your ideas more fully and satisfactorily.

10 Thorough reasearch, investigation and preparation invariably repays itself because it helps to develop and realise often complex ideas, special to adolescence, expressed through many techniques and processes.

11 The students' testimonies , as well as their practice, illustrate their ability to utilise their responses to artists and their work in relation to their own practical needs.

12 Arising as they do out of actual course concerns, the Personal Appraisal statements genuinely record achievements, and also highlight future needs and possible directions which work might take.

13 The rigorous yet personally involving approaches outlined, equip students for a wide variety of higher education needs which embrace the whole field of art, craft and design courses on offer.

CONCLUSION

...the sort of excitement I have now is really very similar to the excitement I had when I was eighteen. There was that tremendous life out there, and you were hurrying towards hundreds of things that excited you and interested you. Each event was felt as a doorway opening on infinite possibilities ... at twenty a given landscape or a particular Bruegel winter scene, for instance, could evoke a wonder quite beyond the reach of normal comprehension.

Michael Rothenstein

At the age of eighty, Rothenstein reveals that he is still sensitive to those intense feelings and sensations of adolescence which, unfortunately, many adults have forgotten about or recall only fleetingly and dimly at certain moments. Adolescence can be marked by feelings of futility and depression alternating with idealistic aspirations born out of the belief that the world really could still become a better place. It is a period of intensely felt passions and ideals which, when they find expression in their art illuminated by that clarity of observed wonder which Rothenstein can still recall, can give rise to work which is quite distinctive and special. Yet most of the books about 'Child Art' peter out once the earlier teenage years have been reached. They usually give some warnings about the problems of the crisis of adolescence with such generalised recommendations, for example, as introducing an ever-changing variety of processes and media in order to distract the pupils from the realisation that they lack the necessary skills required to produce the kind of adult art of which they are now aware. An alternative approach is to give them access to a variety of techniques centred around copying processes aimed at making them believe that they have skills which, in reality, they cannot then use at will. Another side-step is to lead them into the making of 'abstract art' in order to

avoid all these problems, or they have to 'slap it on' and be gestural at all costs. This book, however, contains an abundance of student insights and viewpoints alongside practical work which makes it crystal clear that there is an important, if frequently neglected and often unrecognised, area of art and design education – that of 'Adolescent Art'. It is worthy of consideration in its own right and should not be seen as being just an inferior and less competent form of adult art. True, its practitioners are constantly aspiring to the adult state and looking to adult exemplars in the process. Equally though, a girl holding a candle to symbolise humanity capturing the sun, bolts driven into pork alongside the study of actual feet complete with cochineal-painted stigmata as data for a crucifix, gorged figures satiated with apples encircling a still-full bucket; these are not adults' ideas but are those of adolescence. Similarly, the descriptions included in these pages of, for example, Turner's *Dido Building Carthage*, Martin's *The Great Day of his Wrath* and Spencer's *Map Reading* are redolent with that 'wonder quite beyond the reach of normal comprehension'. However familiar we are with the works in question, these young writers make us feel that there is far more in them than we had ever realised before. When they are involved in these ways, they frequently surprise themselves and startle us at the depth of their responses and insights. For too long, therefore, students' work has been marked, judged and assessed according to adult criteria and values without due consideration being given as to what was in their minds.

To rectify this, the necessary mutual understanding can only be achieved through negotiation, and there has never been a more appropriate time for this to begin to happen. On the one hand, there are all the recording of achievement initiatives currently taking place, aimed at addressing how a more comprehensive student picture and profile can be compiled than through examination results alone. On the other, A/S levels have been introduced and A–levels reviewed in line with G.C.S.E. principles and criteria. This provides an opportunity, undreamt of only a few years ago, of course work becoming more important in examination assessment terms and of there being clear criteria which can be shared and understood by examiners, teachers and the students themselves. In the past, if examiners did have any clear assessment criteria, these remained a well-guarded secret. In turn, many teachers ran courses based on guesses as to what examiners wanted, often modified annually according to the previous year's results as an attempt was made to find rhyme or reason in them. The road ahead is likely to be a long one, though, because to share criteria means the relinquishing of power and increased accountability and vulnerability. A further problem is that much of the thrust of recording of achievement

relates to certain demands such as those of the parent or the employer, with the assumption that teacher-student dealings are in order and can be taken for granted. In these circumstances, the first and most vital step can be missing.

By contrast, the Personal Appraisal material used throughout these pages starts at that point. All the student attitudes and perceptions revealed are full of implications for teachers and everybody else at each link in the recording of achievement chain. Significantly, this model arose not out of recording of achievement demands as such, but rather from a diagnosis of course needs in the light of current critical studies thinking. Perhaps its very significance resides in the fact that it was generated in this way, as opposed to being a response to yet another set of external demands. Similarly, the resulting student testimonies reveal the extraordinary potency of art and design as a vehicle for dealing with many of the concerns which are currently being grouped together under the heading of Personal and Social Education (PSE) which are increasingly being separately timetabled. It is highly unlikely that, in this form, students will be able to fully come to terms with issues of vital concern by internalising them as they reveal they are capable of doing within a rigorous art and design context. No one subject can claim a monopoly on these issues, but it is sad that we seem incapable of harnessing and building upon the really significant achievements which have already been made.

In order that the full breadth of the visual arts might be embraced within its title, that of 'Art, Craft and Design' has been suggested. Increased emphasis on assessment through coursework should lead to larger (and smaller) scale work in a wider range of media with the possibility of developments in areas like video, photography and computer graphics, fashion and textiles, and three-dimensional studies. Nevertheless, the discerning reader of *Approaching Art and Design* can already find sufficient evidence of skills in craftsmanship and design thinking contributing to students' development and practice to suggest that all that is implied by 'Art, Craft and Design' is attainable in the immediate, rather than the distant, future.

All the above issues need to be taken account of in order to achieve relevant and balanced courses and to enable students to negotiate within the security of a clearly understood framework such as that which determines the format of this book. Our experience suggests that any student who has come to terms with the principles which underpin this text, and who can then rely on the support of any equally aware teacher, should be well equipped to cope with most A—level requirements. More so, in fact, than if the book had attempted to set out a step by step formula and accompanying tips for each of the syllabuses on offer.

120

121

122

123

Plates 120, 121, 122 & 123 *Now an established artist of some repute, Tony Lysycia began sketching as a sixth-form student thirteen years ago, and still possesses and makes use of the wealth of information which all his sketchbooks now contain. He also began relief printing during his A−level course, and relief print and carving techniques are still central to his work. The factory sketch, below opposite is in his first sketchbook, compiled in 1975, and the linocut, top opposite was executed in 1976. The 1987 carved door and detail, above, illustrate clearly how Tony is still drawing and building upon key formative experiences from his sixth-form years.*

A sound A–level course with all the dimensions described above is of worth in its own right, and many of the students who so benefit retain a lifelong interest in the visual arts whatever their chosen career. For the many who go on to study the subject further in higher education, though, the issue of continuity is a vital one. What do these students take with them to this next phase? Those whose work and ideas have developed in line with the student examples recorded, and who then move on into the charge of tutors who understand what has already been achieved and how this can be built upon, are extremely fortunate. The natural transition from Adolescent Art to more sophisticated and mature forms of response is then more likely to take place in a smooth and coherent manner, as opposed to their less fortunate colleagues whose next tutors insist on 'wiping the slate clean'–an all too common approach for too long. Let us conclude by returning to Michael Rothenstein once more, for he was fortunate in this respect. In adolescence, his humorous caricature drawings were produced with ease and his output was vast. On discovering the work of Cézanne, still not widely accepted in this country at the time, he recalls that his artistic struggles began in earnest, but can nevertheless say that:

> The joyful clown who had walked along with me from early
> years, whose antics induced the jovial exaggerations of the
> comic drawings, was quietly withdrawn from my side. Under
> the weight of new excitements, in the stride towards the future,
> he suffocated unnoticed.

Brief details of artists referred to in text

Many of the artists mentioned are sufficiently well known for the enquiring student to have little difficulty in finding out more through the use of local libraries and similar services. There is no substitute for a personal book collection, though, and many have been begun at the sixth-form stage. In the interests of brevity, artists are briefly dealt with in one or two sentences, simply to enable the student encountering a name in the text for the first time to know when that artist worked plus the odd representative detail.

The artists are listed alphabetically, the surname first. The country of birth and dates are also given in brackets.

AGAM, Yaacov (born Israel, 1928). Best known for his paintings on corrugated steel panels, arranged so as to change their appearance as the spectator shifts viewpoints because projecting sections are painted differently on each side. He designed a whole room including coloured glass movable walls and specially woven carpet for the Pompidou Centre in Paris.

ANUSZKIEWICZ, Richard (born USA, 1930). His works, usually comprising brightly coloured geometric shapes, are designed so that they affect the retina of the eye and appear to move and create after-images.

ARCIMBOLDI, Giuseppe (Italy, 1527-93). Best known for his paintings of fantastic heads composed of fruits, vegetables, flowers, landscape fragments, and so on. Claimed as an ancestor by the Surrealists.

BEUTLICH, Tadek (born Poland, 1922). Settled in England after the war. Rapidly established himself as an innovative weaver moving, in recent years, to off loom weavings which are brilliant in colour and made by simply knotting and tying the materials together, then joining sections by a seemingly endless variety of means.

BLAKE, William (England, 1757-1827). Poet and artist, his watercolours are also firmly drawn and are unusually small in scale. They are of a visionary and mystical nature, often of biblical subjects. The anatomy and poses of his figures reflect his studies of Michelangelo and Gothic sculpture, rather than his observations of the natural world.

BONNARD, Pierre (France, 1867-1947). He painted sun-drenched landscapes and gardens, interiors of people and dogs sitting at meal tables laid with bowls of luscious fresh fruit or of women towelling themselves or stretched out in deep-filled baths. The blobs and dabs of Impressionist-like paint, all luminous purples, pinks, apricots and blues, with intensely coloured shadows, appear to have been applied with ease, all the struggle having been concealed.

BOTTICELLI, Sandro (Italy, 1445-1510). One of the great Renaissance painters, he worked for the Medici faimly, the powerful rulers of fifteenth-century Florence. His classical mythological works, like *Primavera* and *The Birth of Venus*, are characterised by gracefully flowing lines and elegant elongated figures. Under the influence of the preacher Savonarola, his later paintings became imbued with a personal form of powerful religious intensity.

BOYLE, Mark (born England, 1934). Choosing locations at random, sometimes by the throw of a dart into a map, he then finds the site and recreates an area of approximately two meters square, by using moulding and related techniques. His whole family often participates, and the concerns include the ecological.

BRUEGEL, Pieter the Elder (Flanders, c1525-69). His paintings of peasant people and ordinary events contain extraordinary detail yet are full of striking and evocative atmospheres. His panoramic landscapes of the different months and seasons, of which *Hunters in the Snow* is the best known, have unusually high viewpoints, giving them a feeling of universality and the vastness of nature.

BURNE-JONES, Edward (England, 1833-98). A founder member of the second Pre-Raphaelite grouping, he produced murals, tapestries and stained glass as well as the watercolours and canvas paintings by which he is possibly best known. These romantic works have a strange, dreamy air and look backwards to an idealised medieval world.

BUTLER, Paul (born England 1947). A main contributor to the Cable Street Mural, his easel works depict ordinary people in everyday situations, most frequently executed in monochrome and characterised by his strong, sound draughtsmanship.

CASSATT, Mary (USA, 1844-1926). The first American artist to contribute to an avant-garde movement of international importance, she worked and exhibited in Paris with the Impressionists,

producing intimate scenes, often on the mother and child theme. Her use of oil and pastel and her powers of draughtsmanship reflect her close association with Degas.

CÉZANNE, Paul (France, 1839-1906). By treating tone and colour as one, he was able to impose a sense of form and structure on Impressionism and, in turn, influence Cubism. He worked in a slow, analytical manner, leaving many works unfinished. He raised the status of still-life painting and, returning to Aix-en-Provence where he was born, he produced many remarkable versions of the nearby mountain of Sainte Victoire.

CHARDIN, Jean (France, 1699-1779). The outstanding eighteenth-century French painter of genre (small pictures of everyday life and surroundings) and still-lifes of the most ordinary objects, such as pots and pans, which he painted in solid colour and unusually rich tones.

CLAUDE, Gellée, known as Claude Lorraine (France, 1600-82). One of the first painters to concentrate specifically on landscape, which he ordered according to classical principles. He led the eye inwards in a zig-zagging manner by the way he placed trees or buildings on each side of the cavas, to light-laden distances.

CONSTABLE, John (England, 1776-1837). The East Anglian landscape along the Stour Valley provided him with a narrow range of subject-matter which dominated his life's work. He captured nuances of English weather, even making cloud studies with wind strengths and directions recorded on the reverse and, though contemporary tastes tend to prefer his small on-the-spot studies with their painterly freedom, the *Haywain* is one of the handful of most popular paintings.

COTTAM, Ken (born England, 1941). His paintings and charcoal works of gnarled tree forms were displayed at the end of his year in residence in the Drumcroon Education Art Centre's 1987 'Treescape' exhibition.

CUSANI, Angela, now Cusani-Turner (born England, 1962). Former St. John Rigby student and founder member of the Artists in Wigan Schools Scheme, she was artist-in-residence at Winstanley College, 1986-87. A textiles artist, she weaves, felts, embroiders, uses batik and hand-made paper, often combining various processes and techniques.

DADD, Richard (England, 1817-86). In a fit of madness he murdered his father in 1843 and was institutionalised for the rest of his life, but continued to paint and draw. His best known work, *The Fairy-Feller's Master Stroke*, in the Tate Gallery, is small in scale and admired as an extraordinary detailed work of fantasy.

DAUMIER, Honoré (France, 1808-79). A superb draughtsman, he produced thousands of lithographs, many ridiculing the politicians of the day, for publication in periodicals. His subject matter was usually of the life and issues of the time reflected also in his small output of paintings, the best of which have a rarely equalled monumentality.

DAVID, Jacques-Louis (France, 1748-1825). The Neo-Classical painter of the French Revolution and then of Napoleon's triumphs, his works are severe in style with colour demands subordinated to those of drawing. The 1785 *Oath of the Horatii* anticipates the Revolutionary cause and the epic scale of his work is epitomised in his *Coronation of Napoleon* which contains over one hundred portraits.

DEGAS, Edgar (France, 1834-1917). A woman caught unawares towelling herself, a laundress in mid-yawn, a young ballerina momentarily scratching her back set within daring compositions, often with figures cut-off by the canvas edge, denote the influence of photography and the asymmetrial designs of the Japanese print on the artist. An associate of the Impressionists, he was a print-maker, sculptor, photographer and a supreme draughtsman whose handling of pastel became increasingly bold and rich in colour as his eyesight progressively deteriorated.

DUCCIO di BUONINSEGNA (Italy, c1260-1318/19). Two predella (lower edge) panels from his *Maesta* are in the National Gallery, London, but only hint at the true majesty of the whole altarpiece in Siena. Now divided into two, one side is of the Madonna and Child in majesty and the other of twenty-six episodes from the New Testament. The elegant rhythmical figures and their environments are set against richly glowing gold backgrounds, the whole painted in tempera on wooden panels.

ERNST, Max (Germany, 1891-1976). First a Dadaist and then a Surrealist, he nevertheless remained a highly individual artist whose constant collage and frottage experiments often led to imaginative works in the Germanic tradition of landscapes with dense, dank foliage and night atmospheres and moons.

FELTON, Carolyn (England). A Wigan teacher and lecturer, she was the Drumcroon Education Art Centre artist-in-resident, 1985-86. Her woven works incorporating perspex and tye-dye rounded forms featured in the June 1986 Drumcroon 'In the Round' exhibition.

FREUD, Lucian (born Germany, 1922). The grandson of Sigmund Freud, his family moved to England in 1933 on the rise to power of Hitler. His paintings of portraits and nudes are unsentimental and of unusual candour, the meticulous detail of the earlier ones recently giving way to a broader treatment which conveys the qualities of flesh while retaining the psychological overtones.

GAUGUIN, Paul (France, 1848–1903). Best known for his Tahitian landscapes and paintings of native women in luxuriant tropical settings, his advice to aspiring artists was to 'dream in front of nature'. As a stockbroker, he befriended and collected works by the Impressionists and then began painting in an Impressionist style himself, eventually giving up his job to devote himself fully to art. He evolved a boldly patterned style in which colours were intensified, shadows eliminated and objects endowed with symbolic significance.

GÉRICAULT, Theodore (France, 1791-1824). In rebelling against the Classicism of David, he became a founder of the Romantic movement. Many of his small number of works show his knowledge and love of the horse, but his most celebrated work, the huge *Raft of the Medusa* of 1819, was of a shipwreck that caused a political scandal in its day.

HIROSHIGE, Ando (Japan, 1795-1858). One of the great woodcut artists, he designed daring compositions which combined a strong pattern sense with unusual viewpoints, exerting a strong influence on European art. Van Gogh, for example, made copies of two of his prints in oil paint.

HOCKNEY, David (born England, 1937). Britain's best known artist, his talents were recognised as early as the 'Pop Art' paintings of his student days. He is an accomplished portraitist and, following his move to Los Angeles, he producedcd his most famous works, those of swimming pools. A versatile artist, he has produced paper-pulp works and photographic assemblage collages, while his skills as a linear draughtsman have led to many fine drawings and etchings.

HOGARTH, William (England, 1697-1764) . His literary approach found its natural expression in cycles of paintings. The moral and story of *A Harlot's Progress* unfolds over six works and that of *A*

Rake's Progress, over eight. These marked a new departure in English art, and by making engravings of them, Hogarth found that he could still retain the combination of realism with satire and a moral message, yet reach a wide audience.

HOKUSAI, Katsushika (Japan, 1760-1849). A supreme landscape artist, he could impose formal patterns onto the disorder of nature while retaining the sense of actuality in his woodcuts. His *Thirty-six Views of Mount Fuji* led to artists thinking in terms of series of works both in Japan and Europe. One of them in particular, *The Wave*, has become a universally admired image.

INCHBOLD, John (England, 1830-88) Associated with the Pre-Raphaelites, he produced a number of sensitive and delicate landscape paintings under the strong influence of Ruskin's teaching.

INGRES, Jean (France, 1780-1867). He continued the Neo-Classical style of his teacher, David, working from life in a realistic style with all evidence of brushwork eliminated. He produced some of the finest nude and portrait studies in the history of art, not least the many drawings in which form is realised through his extraordinary use of line.

KANDINSKY, Wassily (Russia, 1866-1944). Russian motifs were a feature of his work after he had moved to Munich and Paris, but he gradually freed his painting from its links with natural appearances, arguing that the art of the future would be abstract. He believed that there was a visual language of forms and colours as potent and expressive as that of music.

KLEE, Paul (Switzerland, 1879-1940). Essentially abstract in nature, his unusually small drawings and paintings, often in watercolour, are made up of signs, symbols and some motifs paralleling nature. He played the violin and some works are direct translations of whole lines of music. They reflect a microscopic world, but also suggest vastness and infinity.

KLIMT, Gustav (Austria, 1862-1918). He painted women mainly, sometimes erotically but at others as remote icons. A popular work, *The Kiss*, has the rhythmically stylised figures on a carpet of flowers and decorated in a mosaic-like pattern of colours heightened with gold. People are subordinate to decorative richness, though realism and decoration become equals in the portraits while landscapes of trees become pretexts to treat the whole picture surface decoratively.

LAUTREC. See Toulouse-Lautrec.

LE CORBUSIER, a nickname meaning 'the crowlike one'. Real name Jeaneret, Charles-Édouard (Switzerland, 1877-1965). One of the pioneering architects in the use of concrete, he believed that the form of a building should be determined by its plan and he imagined ideal cities in which every inhabitant looked out onto greenery. He evolved a modular system of measurement based on the human frame and scale, and was also a painter.

LEONARDO DA VINCI (Italian, 1452-1519). Excelling in all aspects of the arts and sciences, he has come to epitomise the ideal universal Renaissance man. Many of his inventions derived from his scrutiny and analysis of virtually every aspect of nature and life; to him there was no artificial division between science and art. With such wide-ranging interests and activities, his paintings are relatively few in number and none of his sculptures survive, but the *Mona Lisa* and the badly damaged *Last Supper* are amongst the best known handful of paintings in the world.

LOWRY, Laurence (L.S.) (England, 1887-1976). His paintings epitomise for many their notions of how the industrial north, particularly Salford and Manchester, looked until recent times. The simplifications of colours and forms of buildings and people signify sophistication to some and naivety to others (matchstick men, etc.).

LYSYCIA, Anthony (born England, 1959). A former St John Rigby student, Royal College of Art printmaker and a Rome Scholar, he paints, prints, draws and carves in stone. In addition he also paints from the barrels, chests and doors which he carves and turns into art works themselves. His imagery is drawn from his numerous sketchbooks, which stretch back to A-level days.

MANET, Édouard (France, 1832-83). When first exhibited, his *Olympia* and *Déjeuner sur L'herbe* caused scandals, and the public saw him as the leader of the Impressionists. In reality, his studies of art and artists meant that his works evolved naturally from existing traditions and, contrary to much Impressionist practice, he maintained a love of the colour black, which he used to great effect by playing it off against fresh flesh colours and white, eliminating shadows by the device of using frontal lighting.

MANTEGNA, Andrea (Italy, 1430/1-1506). Working in Padua and Mantua in Northern Italy, he established a reputation as a superb draughtsman with a mastery of perspective which enabled him to

construct complex compositions from unusual viewpoints. The *Dead Christ* (now in Milan) is a particularly striking interpretation of the theme, the setting being stark and austere with the recumbent body receding away from us in the most dramatic foreshortening.

MARTIN, John (England, 1789-1854). Regarded as a genius in his lifetime he then fell into neglect but is again arousing interest because of the flamboyant nature of his English Romanticism, full of cosmic splendour and apocalyptic disaster as represented in the three large *Judgement* paintings, one of which is *The Great Day of his Wrath*.

MATISSE, Henri (France, 1869-1954). His long career runs in parallel with that of Picasso, spanning half this century from the shock of Fauvism to his late paper cut-out works. He established himself as a great colourist with a remarkable ability to simplify forms, sometimes by making many versions of an image, reducing them to their most telling decorative shapes.

MERTON, Christine (born Germany, 1928). She has worked in England since the war and her sculptures, many of interlocking separate sections, frequently combine ceramic forms with related natural materials, their powerful emotional force sometimes relating to painful formative experiences in Nazi Germany, the artist being half Jewish.

MONET, Claude (France, 1840-1926). Working well into his eighties, his lifelong commitment to painting out-of-doors directly from the motif established him as the leading exponent of basic Impressionist principles. He worked in all weathers and seasons, devising a system of rapidly applied and visible brushstrokes, using a palette often devoid of blacks and browns. Later he worked in series, such as those of Rouen Cathedral and his waterlily garden which he created at Giverny.

MOORE, Henry (England, 1898-1985). Britain's greatest sculptor, the initial hostility which his monumental carvings aroused has been replaced by at least one being sited in almost every major city in the world. His daring simplifications are now seen as relating his works to long-standing classical traditions and practices. His wax resist wartime drawings of sheltering figures sleeping in the London Underground also form an important aspect of his work.

MOORE, Lynne (born England, 1944). A BBC 'Artists in Prints' series increased interest in her meticulous cardprints. She cuts a

sheet of card into the component shapes of the design and then prints them one at a time, often using colour blends, gradually rebuilding the design in the form of a kind of printed jigsaw.

MUNCH, Edvard (Norway, 1863-1944). His expressive use of colour and paint influenced the German Expressionists and reflected a morbid personality influenced by the effects on him of his mother and two sisters having died of tuberculosis. This is reflected in such subjects as *The Sick Child* and deathchamber paintings. His depiction of isolated, lonely figures found its most powerful expression in the terror of *The Scream* in which the swirling colours of landscape and sky convey the state of mind of the foreground figure.

NASH, Paul (England, 1889-1946). Brother, John, was also a painter. Paul's paintings of landscapes devastated by the destruction of First World War fighting are amongst the most unforgettable and haunting of all war images. Having painted in a Surrealist manner between the wars, he again became an official War Artist during the Second World War.

NEILAND, Brendan (born 1941). Painter and printmaker of the modern cityscape, his reputation was initially based on abstracted paintings of car bonnets which have now given way to upward perspectival views of the glass facades of modern office blocks and their reflections. He builds up his works by the use of stencils and airbrush.

NEVINSON, Christopher R.W. (England, 1889-1946). Best known for his Great War paintings initially in a Futurist style, Nevinson being the only British disciple of this movement, he later reverted to a more realistic style, painting in a more personal manner reflecting how he had been affected by what he was witnessing.

NEWMAN, Barnett (USA, 1905-70). A founder member of the non-gestural wing of the New York School or Abstract Expressionists, his large canvases often consisted of a great expanse of one pure colour, which could engulf the viewer, usually offset by a single narrow stripe of contrasting colour and tone frequently at the canvas edge.

PICASSO, Pablo (Spain, 1881-1973). The dominating artist of the twentieth century, his work embraces many media and subjects and moves from the sentiment of the Blue and Rose periods at the turn of the century, through Cubism and many changes of style, frequently initiating new developments in art, sometimes reflecting them. Key

works such as *Les Demoiselles d'Avignon*, *Three Dancers* and *Guernica* are markers of twentieth-century development, the latter being one of the great protests against war in reaction to the Nazi bombing of the town of that name.

QUINN, Anne-Marie (born England, 1961). Former St. John Rigby student and a founder member of Artists in Wigan Schools Scheme, her long-standing interest in the figure combined with her responses to Venice in her recent Turnpike Gallery exhibition. She has worked as an artist with all age ranges.

REDON, Odilon (born France, 1840-1916). A contemporary of the Impressionists, he resolutely stood apart and worked in a highly personal manner all his life, relying on his imagination, sometimes stimulated by the microscope—and working in a symbolist manner. His pastel studies of flowers strike a calmer note and have since become extremely popular.

RENOIR, Pierre Auguste (France, 1841-1919). His vision is one of the most optimistic in the whole history of art, with his boating and luncheon parties and dancing Parisian figures amongst the most joyous celebrations of life. A close friend of Monet's, his Impressionist canvases are painted in a translucent manner, reflecting his training as a porcelain decorator. In later years he applied a more classical discipline to his treatment of his favourite subject, the female nude.

RODIN, Auguste (France, 1840-1917). Probably the major nineteenth-century sculptor, his *The Kiss* and *The Thinker* are amongst the best known of all sculptures. In his desire to convey the movements of real life in sculptural form, he moved towards an increasingly bold 'Impressionistic' technique, leaving the moulding marks of his hands clearly visible in the clay, accompanied by a series of rapidly executed line and wash studies of models caught in mid-movement.

ROTHENSTEIN, Michael (born England, 1908). A printmaker who has used photographic means, his reputation is largely founded upon his relief prints with their gestural qualities and ranging from non-figurative to figurative works which rely strongly on the use of metaphor. Colour in the recent works is through hand-tinting and he has also returned to painting at the age of eighty.

ROTHKO, Mark (Russia, 1903-70). A naturalised American and founder member of Abstract Expressionism. His seemingly simple canvases, divided into large colour areas arranged in parallel planes, arouse unusually powerful feelings and emotions in many viewers, galleries often arranging his works so as to surround the spectator. The Rothko Room in the Tate (and/or Tate Liverpool) is a particularly dark and brooding example.

RUSKIN, John (England, 1819-1900). Social reformer, critic, artist and man of many interests, he is particularly known today as the ardent champion of Turner's art, his admiration frequently finding expression in glorious, vivid prose.

SEDGLEY, Peter (born England, 1930). From circular paintings which actually moved and were illuminated by colour filters, he eventually created an environment (1969) which made use of a light programme. Static paintings such as *Yellow Attenuation*, made up of horizontal stripes, appear to move because of the way they affect the eye and the after-images they induce.

SEURAT, Georges (France, 1859-91). Though he died very young, he left a small but significant and influential body of work which broke new gound. His use of a pointillist technique aimed to bring a scientific order to the use of Impressionist colour and his compositions had a classical order governed by his ideas about vertical, horizontal and diagonal lines relating to order, calm and life respectively. These are complemented by a series of brilliant conté drawings, very black but full of feeling for light.

SICKERT, Walter Richard (England, 1860-1942). Sickert spent a considerable amount of time in France, living in Dieppe and associating with artists like Degas in Paris, introducing, in turn, new attitudes towards subject matter, composition, colour handling and painterly qualities into England. He founded the Camden Town Group in 1911 which, with a group of artists adopting similar approaches to subject matter and technique, was as close as the British have come to forming a movement.

SUTHERLAND, Graham (England 1903-80). The Coventry Cathedral tapestry, *Christ in Glory*, and his portraits are well known works. The Churchill portrait, in particular, has achieved notoriety having been destroyed by either the sitter himself or his family. Most typical of his art, though, are probably the series of surrealist-like studies of gnarled and mis-shapen trees, branches and hedges which constantly threaten to metamorphose into heads, faces,

limbs, birds and strange creatures, and which place him firmly within the British Romantic landscape traditions.

TOULOUSE-LAUTREC, Henri de (France, 1864-1901). A dwarf-like figure of stunted growth, he has left a vivid picture of Parisian night and low-life, depicting brothel, cafe and music-hall scenes in bold compositions and with biting wit and observation. He drew incessantly on any available surface and, when painting, often worked into absorbent cardboard. He raised the poster as an art form to new heights through his mastery of colour lithography, drawing skills, and bold use of arabesque and pattern shape.

TURNER, Joseph (J.M.W.) (England, 1775-1851). Possibly the greatest of all British painters, he avidly studied and portrayed the most extreme moods of nature, travelling extensively in the process and working ceaselessly in sketchbooks and in watercolour and oils. His later works eliminate all expendable detail and are usually constructed around a vortex shape, the free handling of oil paint reflecting his mastery of watercolour and anticipating the Impressionists with their high-key and purity of colour.

VAN GOGH, Vincent (Holland, 1853-90). The brown tonal paintings of his Dutch phase celebrate peasant life, but gave way to Impressionist colour and techniques once he moved to Paris. On moving to Arles in the south of France, he intensified his colours, using them for expressive purposes as well as to represent nature. The example of Japanese art led him to paint in flat planes of colour, shadows and neutral colours being eliminated in the process. His brushwork became more agitated as his mental state deteriorated, but his output remained prolific.

VAN EYCK, Jan (Flanders, 1395-1441). Coming from a tradition of manuscript illumination, he is able to imbue his paintings—many small in scale—with minute detail without losing any feeling of unity and overall design. Often attributed as being the inventor of oil paint, he was certainly its first master, using it in layers on his wooden panels to achieve unusual luminosity and jewel-like richness of colour. His attention to the detail of nature achieves a spiritual plane in the Ghent Altarpiece with its abundant foliage and plant life.

VLAMINCK, Maurice (France, 1876-1958). One of the key exponents of Fauvism, he was greatly influenced by the brushwork and pure colour of Van Gogh, whose work he saw in a 1901

exhibition. He used these two elements to produce violent works of strong emotional force in which colour was freed from representational demands.

VUILLARD, Édouard (France, 1868-1940). His use of distemper paint gives his works a matt, dull surface and the freshness of fresco. He treated his intimate interiors in such a highly decorative manner that imperceptibly into their surroundings, often characterised by flat, bold wallpaper designs.

WALTON, Ian (Born England, 1950). He assembles his works from combinations of found and discarded objects which he collects. He prefers ones which have a worn quality and are characterised by weathered and peeling surfaces, giving the resulting works the feeling of paintings, but ones put together with nails and glue.

WARD, James (England, 1769–1859). A landscape and animal painter who brings both themes together in his most famous work, the vast *Gordale Scar, Yorkshire* canvas (131″ x 166″) in the Tate which was painted in response to the challenge that the Scar was unpaintable. The herds of deer and cattle in the lower section are dwarfed by the sheer craggy planes of the Scar which dominate through their size and dramatic chiaroscuro treatment.

WINNER, Gerd (born Germany, 1936). A printmaker, he is best known in this country for his evocative Kelpra Studio screenprints of depopulated warehouses and the environs of London's East End dockland area. The architectural facades are often depicted frontally, moving objects whose function has ceased. His use of photographic and handcut stencils enables him to combine a bold realism with decorative strength and simplifications.

Brief details of the movements and developments referred to in the text

The following periods, groups, movements and terms describing particular forms of art are also referred to in the text. To assist those students wishing to undertake further study, some of the leading associated artists are named, where appropriate.

ABSTRACT ART arises out of the belief that forms and colours have aesthetic value independent of subject matter. It is to be found in Moslem countries, where depiction of the human form is prohibited. In this century, many artists have argued that the work of art should exist as an entity entirely in its own right (see Kandinsky).

ABSTRACT EXPRESSIONISM grew out of the Surrealist reliance on the subconscious to produce expressive shapes and involuntary dribbles of paint, etc., leading to a combination of abstract art and expressionism. The first United States movement of international significance, it included Newman, Pollock, Rothko, de Kooning and Kline.

CUBISM proper lasted from 1906 until 1914, but its influence is still felt in various ways. It began with Picasso and Braque's attempts to represent the three-dimensional on a flat surface with intellectual discipline. They would combine several viewpoints of one object in order to convey its whole nature and structure, often incorporating collage material and lettering. Negro and primitive art were important influences, and Gris, Léger, Villon and Delaunay were also exponents.

DADA see Surrealism.

EXPRESSIONISM is the term for those painters who sought great emotional impact through distortion, brushwork and exaggerated use of colour. The influence of Van Gogh and Munch affected such German Expressionists as Jawlensky, Kirchner, Schmidt-Rottluff, Nolde, and other artists like Ensor, Soutine and Kokoschka.

FAUVISM, a short-lived movement from 1905 to 1908, was also expressionistic. The name 'Wild Beasts' was coined by a critic at their first exhibition because of their violent colour schemes,

unrelated to natural appearances, flat patterning and bold brushwork. Matisse, Derain, Vlaminck, Marquet, Dufy and Roualt all produced Fauve works.

IMPRESSIONISM was the first major Modern art movement, its principles being consistently practised between 1870-80. It involved working out of doors on relatively small canvases, choosing ordinary everyday subjects and recording passing light effects and fleeting moments. Their use of spectrum colours, without earth colours, led to higher key works than was usual and their freely-applied brushstrokes offended the public of the day. They used complementary colour schemes and depicted shadows as opposite in colour to the light source (e.g. yellow sunlight produces purple shadows). Monet, Renoir, Sisley and Pissarro were all exponents, as was Manet for a short period. Degas was an associate and the movement produced two notable women artists in Cassatt and Morisot.

NEO-CLASSICISM marked a return to the classical values of order and harmony, looking back to ancient Greek and Roman civilisations. A controlled approach to drawing and design took precedence over colour, brushwork, etc. Its effects were international and the-leading French exponent of the early nineteenth century was David, followed by his pupil, Ingres.

OP or **OPTICAL ART** persuades the viewer to see visual illusions because of the way the eye is affected by the optical effects exploited by the painter or sculptor. Static patterns appear to move because they dazzle the viewer, flat planes tilt towards or away from us, or seem closer than they really are. Anuszkiewicz, Vasarely, Albers, Riley and Sedgley are all exponents in varying ways.

POINTILLISM (or DIVISIONISM or NEO-IMPRESSIONISM) involved the application of small dots or dabs of paint so that colours mixed in the viewer's eye at a certain distance from the canvas, e.g. blue and yellow dots register as green. The technique enabled artists to paint with greater freshness and brilliance of colour than when the effect had to be actually mixed on the canvas. It was pioneered by Seurat and practised by Signac, Luce, Cross and Van Rysselberghe.

POST-IMPRESSIONISM is a vague term used to group together the various artists who reacted to Impressionism to develop it in a variety of ways. Seurat and the Pointillists are often included, as is Cézanne for his imposition of solidity of form and structure on

Impressionism along with Lautrec, Van Gogh and Gauguin for the expressive and symbolic uses they made of it. Even Monet's late series paintings and Degas' late bold use of pastel sometimes lead to their inclusion under the label.

ROMANTICISM began in the middle of the eighteenth century and is a term used to group together many varied artists who placed the expression of feeling, through the use of colour rhythm, brushwork and shared attitudes about the mystery and wonder of life and nature, above the formal approaches of Neo-Classicism. International in its impact, Géricault and Delacroix in France, Constable, Turner and Palmer in England and Friedrich in Germany are all notable examples.

THE PRE-RAPHAELITE BROTHERHOOD formed themselves in 1848, signing their work P.R.B. They attempted to create a purer art by emulating earlier artists than Raphael, a sixteenth-century Italian, whom they blamed for causing over-use of brown, insincere gesture, etc. In turn, they used brilliant colours on white grounds and reverted to medieval themes. Objects and details were painted directly from life and their works were full of moral significances. The first P.R.B. artists included Hunt, Millais and Rossetti, and the movement eventually led to the making of furniture, stained glass and many forms of craft objects.

SURREALISM shared the anti-art tendencies of its immediate 1914-18 war predecessor, DADA, which reacted against the preservation of art works at a time when human life was so cheap, plus a new preoccupation with the subconscious. Some exponents used highly detailed illusionistic techniques so as to make dreams, the fantastic and macabre, and the hallucinatory as convincing as possible. Others made use of bric-à-brac and displayed found objects both singly and in strange juxtapositions, used random processes, frottage, and 'taking a line for a walk'-type techniques. Its effects are still felt today in aspects of certain artists' approaches and commercially in advertising, window-dressing, etc. Main exponents included Duchamp, Miro, Tanguy, Ernst, Magritte, Arp, Man Ray and Dali.

Glossary

ASSEMBLAGE A work of art constructed out of, or linking together, found objects.

ASYMMETRICAL A work designed in an irregular manner.

BATIK A Javanese word for a resist process of patterning cloth, normally through the application of hot wax.

CHARCOAL Soft drawing material made of charred wood, usually willow or vine twigs.

CHIAROSCURO Means light and dark in Italian. The balance of light and shade in a painting or drawing to produce an effect of modelling.

COLLAGE Taken from French word 'coller' (to stick). Practice of pasting various materials onto a surface, begun by the Cubists in 1912.

COMPLEMENTARY COLOURS There are three primary colours – red, yellow and blue. When two are mixed together, the resulting colour complements the third. (YELLOW + BLUE = GREEN which is complementary to RED, etc.). When juxtaposed, one complementary intensifies the other.

CROSS-HATCHING Technique of shading using parallel lines that cross each other at an angle.

DONOR Person who, having commissioned a work of art for the church, appears in it in a recognisable form; amongst earliest portraits.

DRYPOINT Method of working directly with a point into a metal printing surface.

EARTH COLOURS Range of colours made from pigments which exist naturally in the earth in the form of clay, rock or earth.

EMBOSS Method of raising a design or motif in relief.

ETCHING Process of printing on metal by drawing lines through a thin coating on the surface, usually of wax, then allowing acid to bite into the exposed metal to produce the areas to be printed.

EYE-LEVEL Sensed line on a picture enabling the viewer to understand where the artist was in relation to the subject-matter.

FIGURATIVE Realistic representation of nature.

FORESHORTENING Use of perspective to make figures or objects appear three-dimensionally, with protruding objects like outstretched hands appearing very large.

FROTTAGE Taken from French word 'frotter' (to rub). Process of producing rubbings through paper from surfaces with textural patterns such as wood.

GOLDEN SECTION Particularly satisfying balance of proportions within a work which are arrived at by a mathematical system based on geometry on a ratio of approximately 5 to 8.

GOUACHE An opaque, water-based paint.

HAND-MADE PAPER Special paper made by mixing pulverised rags or plants or paper already used once, with a glue-size solution until it breaks down to pulp. A layer lifted out of the liquid on a fine mesh dries out to form the paper.

ICON A sacred image of Christ, the Virgin or a saint, which is a focus of attention.

IMPASTO The thick, layered application of paint or pastel on a surface.

LITHOGRAPHY Form of printing by drawing with a greasy substance on stone or a zinc plate to which printing ink then adheres, after cleaning and preparation of the surface.

MAQUETTE A small model which serves as a kind of three-dimensional sketch for the sculptor.

MIXED or MULTI-MEDIA The process where more than one medium or material is used to make a work of art, e.g. acrylic and gouache paint with pastel added.

MONOCHROME A work in which only one colour has been used, form and shape being rendered through lighter and darker tones of that colour.

MONOPRINT A unique print taken from an inked glass or metal plate, printed by hand or through a press.

NEGATIVE SHAPES Areas of empty space or background formed by surrounding objects and shapes, and therefore of importance to the overall design.

PALETTE (1) A surface used by artists on which to set out and mix paint, and (2) the colours used by an artist.

PASTEL A drawing and painting material in the form of a stick of powdered pigment held together by a gum binder; rather like chalk.

PERSPECTIVE A linear system which enables artists to produce an illusion of depth and three-dimensional space on a flat surface. (Aerial perspective is when the depth is created by attention to atmospheric effects, with less detail in the distance with the colour becoming bluer.)

PHALANGES Bones of the fingers and toes.

REGISTRATION Correct positioning of one colour on another in colour printing and printmaking.

RELIEF PRINTING A process which involves a raised surface receiving ink.

RHYTHM Element which relates one part of a work to another and leads the eye around in a curving or flowing manner.

SKETCH Preliminary drawing, painting or model used as a basis for general composition of the planned work of art. Also a means of noting essential features of a place or subject, usually as information for some future use.

SYMBOL A line, form or object which acts as a sign or emblem to represent something else.

TACTILE VALUES The three-dimensional qualities, or illusion of form, which makes the spectator want to touch the work in question.

TEXTURE The nature and feel of the surface of a work of art, particularly the way its appearance stimulates the spectator's sense of touch. (See TACTILE VALUES above, as well.)

TONE The range of light and dark of any colour. The artist makes use of tone to render form by noting where an object is lightest and where and to what degree it moves into shade.

TRIPTYCH A three panelled painting or relief screen, most frequently used as an altarpiece and hinged so that the outer wings can close over the central section.

WOODCUT Relief print using a block of wood, out of which the design is cut.

INDEX

NOTE: *Mature artists are linked by
surname followed by a first name or initials and students are
listed by first names only.*

C

I

J

K

L

M

N

O

P

Q

R

S

T

V

W

Y

Picture Acknowledgements

Plate 11 The Raft of Medusa. Theodore Gericault 1819. Oil on canvas. Musee du Louvre.

Plate 38 Page from Sketchbook, 1813 & 1814. John Constable Victoria & Albert Museum, London.

Plate 63 Dido Building Carthage. J M W Turner. 1815. Oil on canvas. 1.556 × 2.318 cm. The National Gallery, London.

Plate 64 The Great Day of His Wrath John Martin. 1852. Oil on canvas. 196 × 303.2 mm. The Tate Gallery, London.

Plate 65 Waterlilies 1905. Claude Monet Oil on canvas. 78.7 × 96.5 cm. National Museum of Wales, Cardiff.

Plate 66 Yellow Attenuation. Peter Sedgley. 1965. Acrylic on board. 121.9 × 121.9 mm. The Redfern Gallery, London.

Plate 70 Kirifuri Falls. Katsushika Hokusai. c. 1883. Colour woodblock print. 37.2 × 25.8 cm. The Manchester City Art Gallery.

Plate 75 Eve. Barnett Newman. 1950. Oil on canvas. 2388 × 1721 mm. The Tate Gallery, London.

Plate 76 Norham Castle, Sunrise. J M W Turner. 1845-1850. Oil on canvas. 91 × 122 cm. The Tate Gallery, London.

Plate 77 Paths of Glory. C R W Nevinson. Oil on canvas. 459 × 612 mm. Imperial War Museum, London.

Plate 79 Holland Park Avenue. Study. Mark Boyle. 1967. Relief on acrylic/plastic resin or similar. 2388 × 2388 × 114 mm.

Plate 82 Map Reading. (detail). Stanley Spencer. 1932. Oil on canvas. 213.4 × 185.4 cm. National Trust, Sandham Memorial Chapel.

Plate 85 Winged Messenger. Christine Merton. 1986. Fired clay, lime and beech wood. 1.20 × 1.15 × .95 m. Photo: Michale Barnett. c Christine Merton.

Extracts taken from:
P1 John Reed in *Arena*, BBC2 1985; P24 Arts Council of Great Britain catalogue, *Vincent Van Gogh*, 1955–56; P24 gallery caption, Lowry Centenary Exhibition, Salford Art Gallery, 1987; P28 John Rewald, *Paul Cézanne*, Spring Books; P32 Robert Hughes in *The Shock of the New*, BBC, 1980; P33 John Rewald *op. cit*; P42 John Rewald *op. cit*; P44 Arts Council of Great Britain catalogue, *Henry Moore at the Serpentine*, 1978; P48 Robert Hughes, *op. cit*; P50 Irma A Richter, *The notebooks of Leonardo Da Vinci*, OUP, 1977; P52 Arts Council of Great Britain, *Max Ernst, Histoire Naturelle*, 1982; P53 Herbert Reed, *Education Through Art*, Faber, 1958; P56 *Illuminations*, Channel 4, 1987; P59 Kenneth Clark, *The Romantic Rebellion*, Omega, 1976; P60 Pierre Cabanne, *Degas*, Zwemmer, 1958; P60 Edinburgh International Festival catalogue, *Degas 1879*, 1979; P64 John House, Monet, *Nature into Art*, Guild Publishers, 1986; P68 John Sutherland, *Constable*, Phaiden Press, 1970; P70 caption, Lowry Centenary Exhibition; P88 Tate Gallery catalogue, *Turner*, 1974; P95 John Berger, *Ways of Seeing*, BBC, 1972; P98 Andrew Mortimer, 'Approaches to the Teaching of Critical Studies', *Critical Studies in Art and Design Education*, Longman, 1989; P103 Eric Newton, *European Painting and Sculpture*, Pelican, 1967; P103 Tate, Liverpool brochure, *Starlit Water*, 1988; P114 Art and Design, Draft Grade Criteria Report, SEC, 1988; P123 *Impressionism, Réalités*, 1977; P135 South Bank Centre Catalogue, *Lucien Freud Paintings*, 1988; P135 Royal Acadamy of arts catalogue, *Stanley Spencer RA*, 1980.